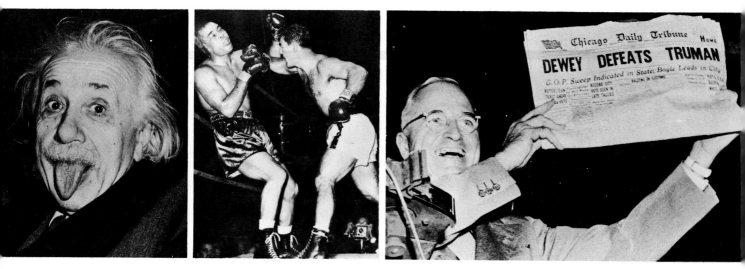

GREAT NEWS PHOTOS
and the Stories Behind Them

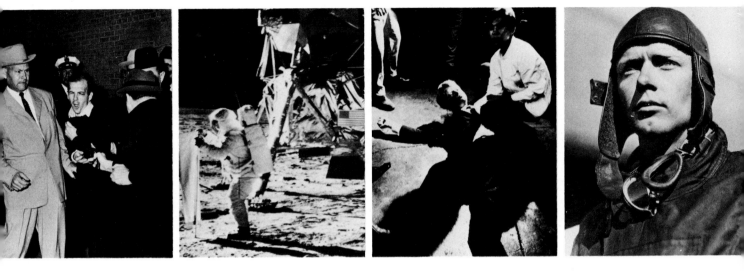

by JOHN FABER

Historian, National Press Photographers Association

SECOND, REVISED EDITION

DOVER PUBLICATIONS, INC.
NEW YORK

DEDICATED TO

my wife Gertrud,
and my son Erich; whose
devotion, encouragement, and
consideration made
this edition possible, and to the
Members of the
National Press Photographers Association
who helped create this book
and 32 years of
my professional life.

OTHER BOOKS BY JOHN FABER

Industrial Photography (1947)
Humor in News Photography (1961)
Travel Photography (1972)

Copyright © 1960, 1978 by John Faber.
All rights reserved under Pan American and
International Copyright Conventions.

Published in Canada by General Publishing
Company, Ltd., 30 Lesmill Road, Don Mills,
Toronto, Ontario.
Published in the United Kingdom by Constable
and Company, Ltd., 10 Orange Street, London
WC2H 7EG.

This Dover edition, first published in 1978, is
an unabridged, enlarged and revised edition of
the work first published by Thomas Nelson &
Sons, New York, 1960. For this edition thirteen
items have been added, as well as a Bibliography.

International Standard Book Number: 0-486-23667-6
Library of Congress Catalog Card Number: 77-27723

Manufactured in the United States of America
Dover Publications, Inc.
180 Varick Street
New York, N.Y. 10014

Contents

Preface

During the past twenty-eight years I have had the opportunity to visit and work with news photographers of nearly every major newspaper in the United States. Usually, between assignments, we'd sit around in the photographic department and swap experiences. We'd talk about the "old days," laugh a little, argue a point, and feel good about being in this profession.

Many of the great stories about news photography were repeated again and again all over the nation. Because they were so widely and uniformly appreciated, I felt they were important and should be recorded before time distorted the facts. I started to collect the great news pictures and the interesting anecdotes about news cameramen.

In February of 1956, the National Press Photographers Association granted me the honor of becoming its Historian. I began organizing the N.P.P.A.'s Historical Files, and writing a monthly column about the great moments in news photography. "On The Record," my column in the *National Press Photographer*, the Association's official publication, provoked considerable interest. Many letters were received, suggesting a collection of the columns be made available in book form. This is the result. Now, the "newspaper reader" as well as the members of the N.P.P.A. can enjoy the factual behind-the-scenes accounts of great moments in news photography.

My only regret is that I cannot include so much more of the outstanding work remembered by the profession. I have tried to select that which I personally considered to be the most memorable.

Information contained in this book is accurate so far as I have been able to determine. Each of the stories was researched by tape-recorded interviews, telephone conversations, correspondence, and discussions with as many people involved as it was possible to locate. The majority of the contemporary photographers are personal friends of mine. In the case of those photographers who have passed on, my information was gleaned from records in national archives, from original newspaper sources, and when possible, through correspondence with the man's friends, associates, and relatives.

Assembling this book has provided a series of unforgettable experiences for me. I listened again to my tape recording of Joe Rosenthal describing, in his humble way, the day he made the Iwo Jima Flag Raising picture. Ralph Morse speaks so enthusiastically of his work that just talking with him is an inspiration. Many hours were spent with Harold Blumenfeld, former Executive Editor of United Press International, as he spun one exciting story after another. I made a photographic print using Dr. Erich Salomon's original glassplate negative of Hoover and Laval. Seeing the images of the men appear in the developer, I experienced the same sensation Salomon must have the first time he made the print. Tom Howard told me, "That gal [Ruth Snyder] was the best public relations woman I ever had." Vicariously, I flew the atomic bomb mission of Hiroshima as members of the crew of the B-29, the *Enola Gay*; General Charles W. Sweeney who piloted the *Great Artiste* on the Nagasaki mission; and Jerome J. Ossip, the 509th Composite Group's Chief Photographic Officer, explained their operation. I had the pleasure of chatting with Charlie Duprez, hearing about the days of Teddy Roosevelt, and early news photography.

At the N.Y. *Daily News* in 1963, thirty-five years after its first use, the mystery camera Tom Howard used for the Ruth Snyder electrocution was unveiled to me

and the photographic staff. I strapped it to my ankle, running the long cable release up the inside of my trousers into my pocket. I simulated and sensed Tom Howard's experiences. Walter Ranzini, then Picture Editor of the newspaper, gave the camera to me to be carried to the Smithsonian Institution in Washington, D.C. It is displayed there as part of the National Press Photographers Association's Historical Archives.

Alfred Eisenstaedt's professional career began in 1929. He totally captivated me as he related his early activities. Born in West Prussia, he photographed Hitler's Germany until he fled to the United States. In 1936 he joined the prepublication staff of *Life* magazine as one of the original four staff photographers. We relived those early days of *Life* as my friend "Eisie" recounted his more than 2,000 picture stories for that great publication. Over the forty-eight years of his career he has documented the outstanding news stories of our times, never once losing his youthful enthusiasm.

I have known Eddie Adams most of my professional life. I was fortunate to witness his growth from a young aspiring small-town newspaper photographer to a Pulitzer Prize winner working for the Associated Press. Through all the years he shared his dreams, problems, fears, and good times with me. I learned what the word "courage" really means from Eddie. He strongly dislikes, and seldom talks about, the making of the Saigon execution picture.

Boris Yaro, telling his experience of the Robert Kennedy shooting, stressed a fact seldom realized by the reading public—the vital responsibility of the news photographer to document history in the making. As a historian I have found differences in stories reporting the same event occur because they were experienced by different people. Some of this also takes place in the rewriting of a story. However, a news picture freezes that instant in time, becoming a single, permanent, visual source of information which cannot be revised. The news photo is understood by all people of all nationalities because photojournalism is a universal language.

I could sense the fear and frustration Laurens Pierce went through fighting the instinct of self-preservation and the uncontrolled swarm of people around Governor George Wallace during the attempted assassination in Maryland. Dauntless, Pierce kept his television newsreel camera continually operating before, during the shooting (the gunman was almost next to him), and afterwards to record the complete story. These are only a few of the unforgettable experiences in which I became involved.

The process of photography, I find, is taken for granted by the public as well as by "news men." Yet it is one of the greatest gifts ever given to mankind. It is a universal language readily understood by all people of all nations. As a form of communication it is relatively new, having originated 138 years ago. A story appearing in the French *Moniteur Universel* on January 14, 1839, best explains the importance of this tool of communication. It reads:

"After fourteen years of research, M. Daguerre has succeeded in fixing the natural light on a solid surface, in giving body to the impalpable and fugitive image of objects reflected in the retina of the eye, in a mirror, in the apparatus of the camera obscura. Figure to yourself a glass which after receiving your image presents you your portrait, as indelible as painting, and much more faithful.

"By the courtesy of the inventor we have been able to examine his chefs-d'oeuvre, in which Nature herself is drawn. Each picture placed before us called forth some admiring exclamation. What fineness of touch! What harmony of light and shade! What delicacy! What finish! With a magnifying glass we can see the slightest fold in a stuff, the lines of a landscape invisible to the naked eye. In a view of Paris we can count the paving stones—we can see the dampness produced by

rain; we can read the name on a shop. All the threads of the luminous tissue have passed from object into the image.

"M. Daguerre has as yet only made experiments in Paris, and these experiments, even under the most favorable circumstances, have always taken so much time as only to enable him to obtain results of nature inanimate or at rest [average exposure about 20 minutes]; movement escapes him or only leaves vague indefinite traces. It is presumable that an African sun would give him instantaneous autographs of nature and in life. The discovery, as far as at present developed, to judge from the results which we have seen, promises to be of great importance to art and science."

It was a natural thing for photography, with its ability to capture permanently an instant of time for re-examination and evaluation, to find its way into the medium of news reporting.

JOHN FABER

Mountain Lakes, New Jersey
October, 1977

1. The Beginning

England and France had become allies of Turkey in a war against Russia in 1853. Gradually, the adverse reports of conditions suffered by the British soldiers at the Crimean front began appearing in the British newspapers. The public became indignant. Thomas Agnew & Sons, publishers, decided to put the new process of photography to use. Planning to exhibit to the public a display of actual battlefront scenes, they financed the photographic expedition of Roger Fenton, a solicitor who was both artist and a photographer of note, to the Crimea.

On February 20, 1855, Fenton sailed from England with thirty-six cases of assorted photographic equipment, food, and camping supplies. He also took a delivery wagon which he had converted into a photographic darkroom van. Photography had been invented only sixteen years before, and was still a highly complicated and cumbersome process. To assist him in his ambitious undertaking, he took along two helpers, William the handyman and cook, and Marcus Sparling as driver, and to look after the horses. He had trained both men to help in the darkroom.

Following his arrival at Balaclava, which he described as "one great pigsty," it was a week before Fenton was able to make his first pictures of the area. Two weeks later he began his trek from one encampment to another, photographing the troops, the officers, the living conditions, the battlefields. He made many friends, among them General Bosquet of the French Army, whom he photographed in the company of one of his officers.

When you consider the problems involved in taking a photograph at that time, it is remarkable that Fenton's subjects appeared so informal. He used the newly invented "wet collodian" process. It consisted of first coating a glass plate with an emulsion, running from the darkroom van, inserting the holder in the camera, making the exposure which ranged anywhere from three to twenty seconds, rushing back to process the glass plate negative before the emulsion could dry. Heat, dust, rain, high winds, even the breath of the photographer could ruin the plates. The entire operation took from five to eight minutes.

With the arrival of the Crimean summer, Fenton wrote, "It is impossible to work after nine or ten from the intense heat, which sends the stoppers flying out of my bottles, and spoils every picture." The van had been under Russian fire on numerous occasions. His photographic supplies were dwindling. In July, after four months of war, Roger Fenton returned to England.

From the many glassplate negatives he made of the Crimean War, Fenton prepared an exhibition of 312 prints. The *Illustrated London News* of October 27, 1855, urged the public to view the collection, and to acquaint themselves "with the excellence of photography as an art, with its uses as a recorder and illustrator of events."

Roger Fenton was the first of the photojournalists. He was financed by a publisher to photograph a news story—to bring a visual report of the occurrence to the eyes of the public. This was the beginning.

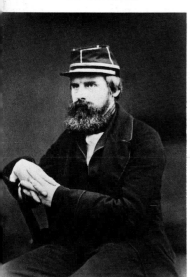

ROGER FENTON

GENERAL BOSQUET.—FROM THE EXHIBITION OF PHOTOGRAPHIC PICTURES TAKEN IN THE CRIMEA, BY ROGER FENTON.

2. Hon. Abraham Lincoln

Early in his career, the man decided that the success of his future depended upon creating a reputation as a photographer of famous persons. The first notables to come before his camera were Daniel Webster, Henry Clay, and John C. Calhoun. Public reaction was impressive. During the 1850's his dream of a "Gallery of Illustrious Americans" came true. The nation's leaders came to him to have their likenesses preserved in his collection of portraits. It became the height of fashion to have one's photograph made by Mathew Brady.

Brady recognized the value of publicity. Whenever he photographed a newsworthy personage, he gave a print to *Harper's Weekly* or *Leslie's Illustrated Newspaper*. The photo appeared as an engraved artist's drawing, then the only method of picture reproduction. The illustrations carried the credit-line: "Photographed by Brady."

One of Brady's most memorable experiences took place on February 27, 1860. A month before, he had opened the most magnificent of his studios, the National Portrait Gallery, located on the corner of Broadway and Tenth Street in New York City. On this particular day, two men entered the gallery. One was R. C. McCormick, in charge of arrangements for the Young Men's Republican Club of New York; the other was a tall, awkward figure of a man by the name of Abraham Lincoln.

Lincoln was in New York to give an address. It was three months before the Republican Convention, at which time the party's presidential candidate would be nominated. Abraham Lincoln had built his reputation in the midwest. When he was invited to lecture in New York City, he knew that the greatest test of his life had come: he was to be measured by the standards of the cosmopolitan world.

After the usual introductions, the 51-year-old Lincoln entered the camera room. Brady studied his subject. He saw a man who moved with a great deal of elasticity and awkwardness, indicating the rough training of his early life. He was well over six feet tall, and his legs seemed all out of proportion to the rest of his body. His face, while not handsome, was genial looking; good humour seemed to lurk in every corner of its innumerable angles. Brady pondered. How could he make this strange, quiet man impressive? "I had great trouble," Brady said, "in making a natural picture. When I got him before the camera I asked him if I might not arrange his collar, and with that he began to pull it up. 'Ah,' said Lincoln, 'I see you want to shorten my neck.' 'That's just it,' I answered, and we both laughed." Brady made several photographs, among them a standing view.

Lincoln's speech at Cooper Institute more than confirmed his reputation. Brady's pictures of him were in great demand. Currier and Ives made striking lithographs and distributed them. The newspapers used the portraits for woodcuts.

Just before the tumultuous election in November, *Harper's* had a wood engraving made from Brady's picture, to be used if Lincoln were elected. He was. Brady's "standing" shot of him appeared full front page of the November 10, 1860, issue of *Harper's Weekly*.

In the ensuing years, Lincoln frequently said, "Brady and the Cooper Institute [speech] made me President."

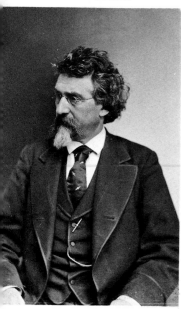

MATHEW BRADY

HARPER'S WEEKLY.

A JOURNAL OF CIVILIZATION.

VOL. IV.—No. 202.] NEW YORK, SATURDAY, NOVEMBER 10, 1860. [PRICE FIVE CENTS.

Entered according to Act of Congress, in the Year 1860, by Harper & Brothers, in the Clerk's Office of the District Court for the Southern District of New York.

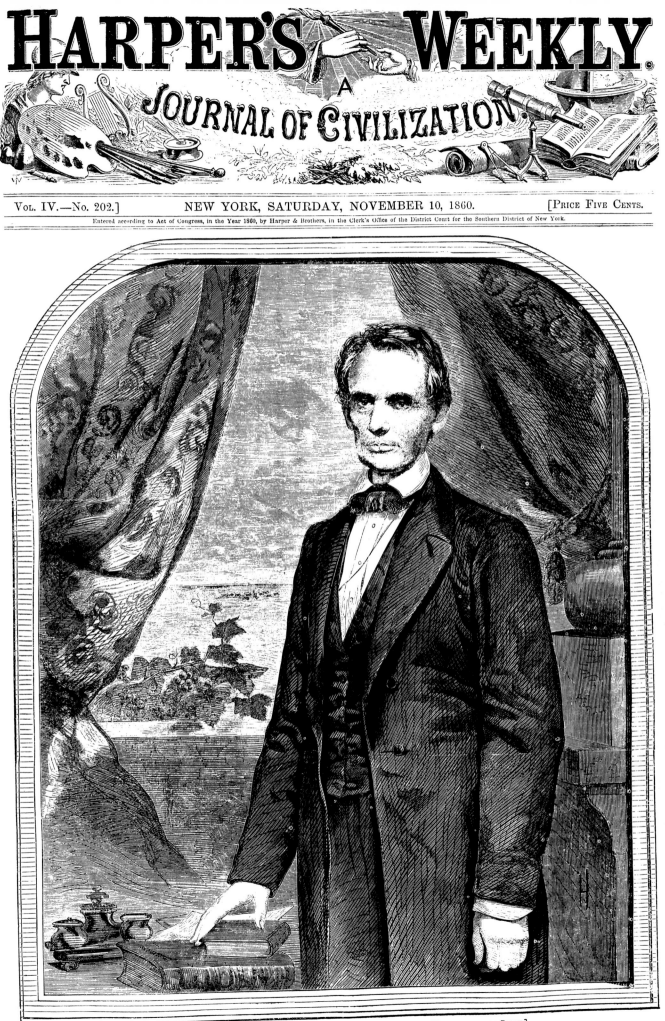

HON. ABRAHAM LINCOLN, BORN IN KENTUCKY, FEBRUARY 12, 1809.—[PHOTOGRAPHED BY BRADY.]

3. How the Other Half Lives

"With their way illuminated by spasmodic flashes . . . a mysterious party has lately been startling the town o'nights. Somnolent policemen on the street, denizens of dives in their dens, tramps, and bummers in their so-called lodgings . . . have in their turn marvelled and been frightened by the phenomenon. What they saw was three or four figures in the gloom, a ghostly tripod, some weird and uncanny movements, the blinding flash, and then they heard the patter of retreating footsteps and the mysterious visitors were gone." This story in the N.Y. *Sun* of Feb. 12, 1888, referred to police reporter Jacob Riis. He was the first to document his stories of slum conditions by using a camera and the newly invented flashpowder.

Periodically, almost every newspaper ignites civic responsibilities by using stark and shocking photos of the conditions under which some citizens are forced to live. The use of news photography for this type of campaign originated in 1888. Jacob Riis first concentrated the public's eye on the outrageous slum conditions by writing about them in the N.Y. *Sun*. When he was criticized for over-dramatizing with words, he turned to the use of the camera. People believed what they saw in a picture. His efforts started a revolution against degrading tenements and the political situations that permitted this misery to exist. Riis was able to have the city's police lodging houses abolished when he showed New York City Police Commissioner Theodore Roosevelt photographic evidence. The prints portrayed the poor unimproved conditions, as they existed unchanged over a period of years.

Jacob Riis

Riis also evolved the "flashpan." Flashpowder was introduced to be used as a cartridge fired from a pistol. The "toughs," gangs, and miserable souls he photographed would threaten any man carrying a pistol. Riis found safety in pouring the explosive mixture into an ordinary frying pan, then igniting it. He would set up his 4x5 glassplate camera on a tripod, open the shutter and set off the "flashpan." The blinding flash and smoke caused complete confusion. At that instant, Riis would gather up his equipment and run off before the dazed subjects realized what had happened. In time he compiled a documentary file of over 400 photographs. While working on *The Sun* he became so interested in the slum improvements that he left the paper in 1899 to become a lecturer and author. Two of his books, *How the Other Half Lives* (1890), and *The Battle with the Slum* (1902), both profusely illustrated with his photos, are famous.

Among the many friends Riis made, one of the closest was President Theodore Roosevelt. Through the years Roosevelt offered Riis several positions of high office. Riis declined, insisting he was too busy to enter politics. He led public movements on reform, and relentlessly drove himself to improve social conditions. He died in his country home at Barre, Mass., on May 26, 1914. In later years, housing projects and other civic developments were named in his honor. The camera in the hands of Jacob Riis became a powerful force that changed and improved the living conditions of thousands of people.

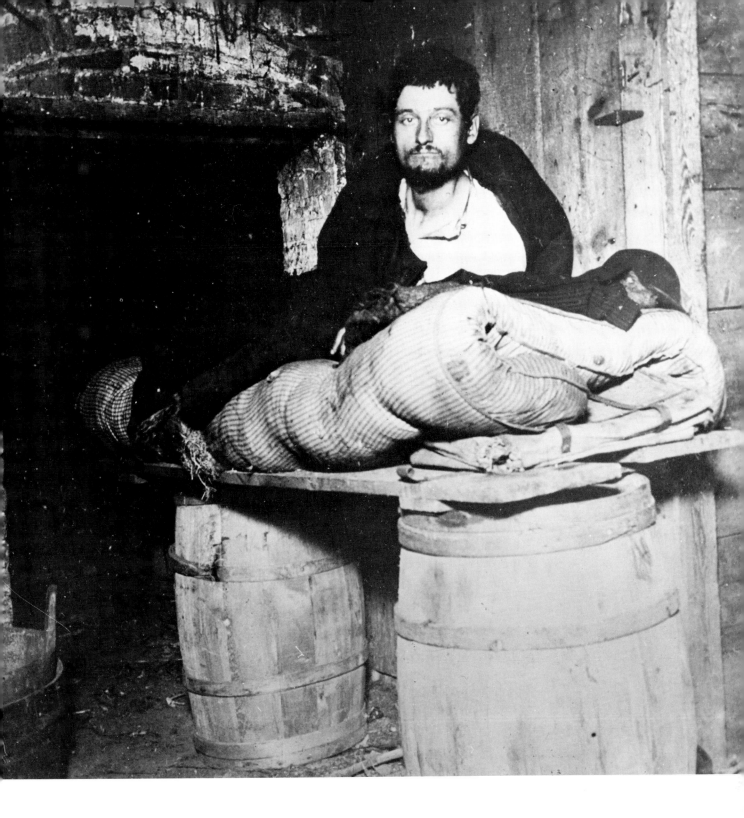

4. San Francisco Earthquake

The clock on the Union Ferry Depot building read 5:13 A.M. It had been a quiet night, this April 18, 1906. In a house on Market Street eight-year-old Sam Haskell was sleeping as were the people of San Francisco. The shock came without warning. As the earth shuddered, buildings swayed and collapsed, water and gas mains burst, electric cables short-circuited—the Great Fire began.

Sam's parents were killed during the first sixty seconds of the earthquake. They were among 452 who lost their lives during the days the fire burned its way through 28,000 buildings. It was a major disaster. It was a major news story.

Across the Bay in Oakland, Edward A. "Doc" Rogers was awakened by the shock. He dressed hurriedly, grabbed his 5x7 Reflex camera and glassplates and raced to San Francisco.

Wherever he went there was destruction. Fires blazed out of control, shrouding the city with a blanket of smoke. Hot cinders showered down on everything. In the streets, dazed survivors picked their way through rubble, hauling whatever treasures they had salvaged. The sound of the dying city, the dynamite explosions of the firefighters, and the crash of falling buildings, was terrifying. Martial Law had been declared. Federal Troops, standing guard, had orders "to kill any persons found engaged in looting."

Rogers recorded these scenes with his camera. When he returned to his paper, the *San Francisco Morning Call*, he found the building in flames. He fought his way through the confusion, across the Bay to Oakland, to reach processing facilities.

On the scene, other photographers were also photographing the disaster. Harry Coleman, of the *San Francisco Examiner*, made a shot of the wrecked Opera House. As he did, he recalled an assignment for that very morning, to "cover" the great Caruso, in a rehearsal of *Lohengrin*. A few blocks away, Caruso sat on a valise in the debris-littered street. He had escaped from the Palace Hotel, before it collapsed.

Photographers discarded all personal safety to make pictures. The *Examiner's* George Parmenter, George Haley of the *Chronicle*, the commercial photographers of San Francisco: H. S. Hooper, Arnold Genthe, Oscar Maurer, Shaw & Shaw, A. C. Pillsbury, O. V. Lange, R. L. Forrest, Tom Phillips, and others made visual records of the great devastation.

Standing in the ruins of the flower shops at Kearny and Market Streets, within the triangle formed by the burning *Call*, *Chronicle*, and *Examiner* buildings, eight newspapermen gathered. They had one idea in mind—to get the news into print. These men, reporters and editorial writers, found their way across the smoke-screened Bay to the presses of the *Oakland Tribune*. Here they put together a four-page combined issue of the *Call-Chronicle-Examiner*. It was brought back and distributed to the people of San Francisco. It prevented the lapse of a single day's issue of these three great newspapers.

"Doc" Rogers' photos were widely used. Among the many awards he received was a special citation from the California State Legislature.

EDWARD ROGERS

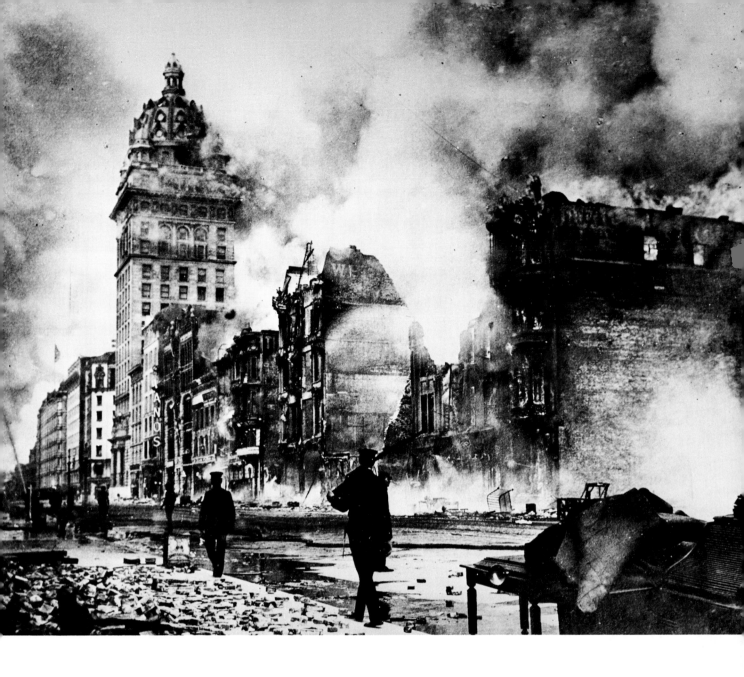

5. The Wrights Can Fly

As late as 1908 the American Public had not seen a news photo of the strange power-driven flying machine invented by the Wright Brothers in 1903. Many doubted the existence of such a contraption. Little factual information was known about the men and their experiments. Orville and Wilbur Wright shunned all publicity. What little flying they did during the intervening years always took place in remote areas away from reporters' eyes. In 1908, after two years of no flights, they resumed tests. The public's interest "perked up."

At that time *Collier's* was very news conscious. They decided to explore the "Wright Myth." Writer Arthur Ruhl and famed photographer Jimmy Hare were assigned the story. Their trip to Kitty Hawk, North Carolina, turned out to be an expedition. They rode railroads, steamboats, gasoline chug-chugs; they waded, climbed sand mountains, and tramped over miles of slippery pine needles to reach the tick-infested, sun-baked, sand-duned scene of operations.

En route, at Manteo on Roanoke Island, they encountered four newspaper reporters. They were Billy Hoster, N.Y. *American*; a local man from Norfolk, Va., named Sulley; Byron Newton, N.Y. *Herald*; and David McGowan, *London* (England) *Daily Mail*. They were headed for the same destination. Sulley had been covering the story for some time. He told the men that the Wrights would stop work immediately if anyone visited them. The group, therefore, decided not to go directly to the brothers. Instead they walked eight miles across hot sand dunes to find a hiding place in a clump of trees near where the flight pioneers were working.

Ruhl later described the adventure in the May 30, 1908, issue of *Collier's*. "From their ambush in the scrub timber, the attacking party gazed out across a mile of level beach to a lone shed. To the left of the shed, two black dots, which were men, moved about something set on the sand. This white streak and the skeleton lines beneath it was, in a way, the center of the world. It was the center of the world because it was the touchable embodiment of an Idea, which presently is to make the world something different than it has ever been before. The two little dots working out there in the sun knew more about this idea and carried it further than anybody else. The bedraggled men crouching behind the trees were the first uninvited, as it were, official, jury of the world at large to see the thing in action and judge its success. Really it was not newspaper reporters, it was the world's curiosity which was peering across the intervening sands.

"The propellers started, the white streak tilted and rose, and the hazy rectangle, with the two dots amidships, bore down across the field."

Jimmy Hare rushed out from the cover of the scrub trees and made the first news photo of man in a power-driven aeroplane. The flight lasted two minutes and fifty seconds, and covered two miles.

The reporters and Jimmy Hare returned to civilization to tell the story to the waiting world: the Wrights can fly. Jimmy Hare had the photo to prove it.

JIMMY HARE

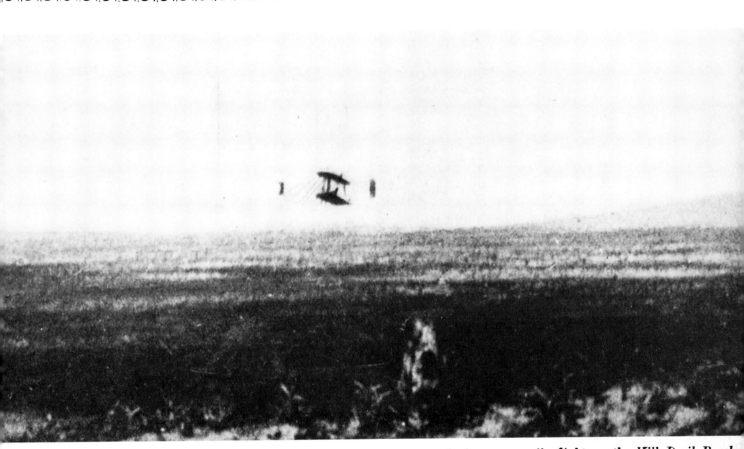

The Wright Brothers' aeroplane going at a speed of forty miles an hour during a two-mile flight on the Kill Devil Beach

6. The Great Fire Engine Picture

The Chief Engineer of the Studebaker Corporation was being interviewed by a reporter from *Automotive Industries* magazine. The reporter had come to gather information about this man who had been elected President of the Society of Automotive Engineers.

"What, among the many things you have done, are you proudest of?" the interviewer asked. He anticipated an explanation of some engineering feat. The eyes of the engineer twinkled for a moment, and he answered, "I once made a famous news picture." The answer was unexpected. The reporter listened attentively while Delmar Barney Roos related one of the great stories of early news photography.

In 1910, Roos was attending Cornell University, studying to become a mechanical engineer. That summer he obtained, as he had the previous year, a summertime job in photography. He was hired by Arthur Brown of Brown Brothers, New York. At that time, few newspapers had photographic departments, and depended upon independent news photo services for their pictures.

As one of his first assignments, Barney Roos was sent to New Haven, Connecticut, to make pictures of the Yale Commencement Exercises. There was one picture in particular, Arthur Brown told Roos, that he had to get. It was a photograph of Robert Taft, son of President Taft, in cap and gown, with diploma in hand. It didn't take Roos long to get his first pictures, but when it came to Taft it was a different story. Taft refused to pose. Roos made the rest of his shots, until he had exposed twenty-three of the twenty-four plates he had with him. He tried Taft again and received the same "no." Roos walked across the street to catch the trolley car back to the train depot. As he stood on the corner waiting, he heard a lot of commotion down the street. Coming toward him at breakneck speed was a three-horse-drawn steam fire engine, smoke billowing from the boiler. It was a dramatic situation. Barney Roos stepped into the street, and with his 5x7 Press Graflex recorded the moment.

BARNEY ROOS

Taft had witnessed the scene and, greatly impressed, came over to Roos and consented to have his picture made. It was one of those times a photographer dreads. Roos had exposed his last plate on the fire engine. He returned to New York City, dejected, expecting to be fired for missing the one important picture.

Roos wasn't fired. When he examined his pictures, he was impressed with the great fire engine picture he had made—impressed in two ways. It certainly had eye appeal. Secondly, standing in the background was the man who had refused to be photographed—Robert Taft. He was partially hidden by another spectator, but there he was in cap and gown, clutching his diploma.

Barney Roos never went back to news photography after that summer of 1910. The great fire engine picture he made was sold to many newspapers, and since has become a classic. In addition to Roos's many achievements in the field of automotive engineering, he designed and built the world famous "Jeep." In his last years he was a Vice-President of Willys-Overland Company.

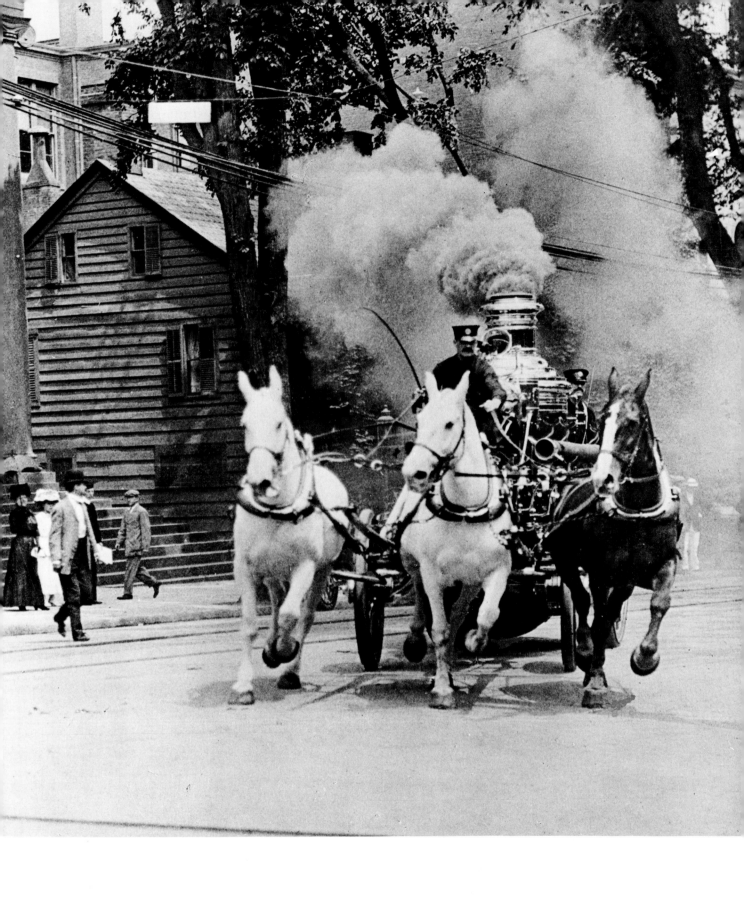

7. Shooting of Mayor Gaynor

It was one of those days, the kind that starts out with too many assignments and not enough photographers to cover them. The five-man staff of the *Evening World* were already assigned when another job came through. It was given to William Warnecke. The assignment—"cover" New York Mayor William J. Gaynor leaving on a European vacation. It was August 9, 1910.

Shortly after eight A.M., Bill finished packing his 4x6 ICA camera and glassplate holders. The assignment was scheduled for nine A.M. a few miles away, in Hoboken, N.J. Hughie O'Neill, another staffer, came in as Bill was leaving. He told Bill he was having trouble with a feature assignment. Bill said he'd help O'Neill, by making the shot on the way to his job.

What the City Desk wanted of O'Neill was a photo of a Fire Department horse, laughing. It was to be used with a story about the city replacing the animals with newly purchased, motor-driven fire engines. En route, Bill located a "fire horse." He tried every way he could to get the horse to "laugh." Finally, he fed the animal caramel candies. While the horse gummed the mess, wriggling his lips to free his teeth, Bill made the shot. It looked like a genuine horse laugh.

WILLIAM WARNECKE

But it had taken too much time. Warnecke was running late. When he boarded the *SS Kaiser Wilhelm der Grosse*, he saw the other photographers had gone. He made an overall "safety shot," and then another of the Mayor talking with three reporters. While he changed holders, to make "just one more," a squat, broad-chested man stealthily, almost unnoticed, joined the group. It was now 9:40 A.M. Robert Anderson, Gaynor's secretary, shouted a warning as the unknown man drew his pistol, and, holding it six inches from the Mayor's head, pulled the trigger. The gun failed to go off. The man pulled the trigger again, and the pistol flashed. The Mayor staggered with the impact of the bullet, and clutched his throat. "Big Bill" Edwards, 300-pound Street Cleaning Commissioner, grappled with the man as he fired another shot. The bullet intended for Edwards passed through his coat sleeve and struck Mayor Gaynor in the back.

The Mayor lurched as Robert Marsh grabbed his arm to steady him. At that instant, Warnecke made his "great picture." Edwards, a pier policeman, and other city officials, subdued the struggling would-be assassin, J. J. Gallagher. They bound his hands and dragged him off the ship, down the street into a waiting car. Bill ran ahead and made the picture. He got back in time to make a final photo of Gaynor being carried off the ship.

The *World*, on page one, carried a four-column "cut" of the Gaynor shooting. Two inside pages carried four other photos Warnecke made. Bill's pictures were exclusive, but there was no mention of his name. Yet, his credit line, as well as the name of an obscure Mayor, was written into history by one great photo.

8. Teddy Roosevelt's Smile

The election year of 1912 started out with a bombshell announcement from Ex-President Theodore Roosevelt: "My hat is in the ring!"

Roosevelt had not been active in politics during the Taft administration, and he wasn't expected to seek a third term. But Roosevelt was itching for a scrap; he felt that Taft had undone the reforms he had made. When the progressive Republicans urged him to run, he welcomed the opportunity. At the Convention, however, the conservatives railroaded the nomination to Taft. Infuriated, Roosevelt charged the Taft forces had stolen the nomination; he set out to form a third party. So began the split in the Republican Party that lost them the election.

On June 22, 1912, Roosevelt became the presidential nominee of the newly formed Progressive Party. The Party received its popular name during a press interview, when Roosevelt shrilled, "I'm feeling like a bull moose." The "Bull Moose" Party brought into political cartoons a new animal figure to cavort with the elephant of the Republicans and the donkey of the Democrats. The Democrats, at their Baltimore Convention, found an exciting candidate, the crusading Governor of New Jersey, and former President of Princeton University—Woodrow Wilson. The stage was set. The campaigns started.

In New York City, Arthur Brown of the news picture agency, Brown Brothers, had an assignment for new photos of Teddy Roosevelt. He called in his ace cameraman, Charles Duprez. "Charlie," he said, "I want you to go out to Roosevelt's home in Oyster Bay, Long Island, and get some good head shots. The arrangements are all made." Duprez packed up his 5x7 Graflex and a bunch of plateholders and left.

He asked Roosevelt to pose in front of the beautiful estate. There, in strong sunlight, Charlie Duprez made several shots of the Bull Moose candidate. While they talked, Teddy Roosevelt responded with one of his characteristic smiles, and Charlie caught it. Duprez said, "It all was routine. I couldn't remember what we said, or what I did. I didn't know I had a great picture until later, when everyone asked for it." The picture was sold to many newspapers. In the years that have gone by, it has become the representative picture of Teddy Roosevelt. Among the thousands upon thousands of photographs in the Brown Brothers files, this picture has sold more prints than any other.

As the three-cornered political campaign wore on, Teddy grew tired, and the voters bored. There was one flare-up in October in front of a Milwaukee hotel. Teddy was to speak that evening, and as he was leaving the hotel, a fanatic shot him. The bullet passed through his eyeglass case and a copy of his speech, and lodged in his right lung. Roosevelt made the speech on schedule. He told his audience, "There is a bullet in my body, but it takes more than that to kill a Bull Moose."

The outcome of the elections was: Roosevelt 4,126,020 votes; Taft 3,483,922; and Wilson 6,286,214 votes. Wilson had won. Teddy, contemplating the result said, "There is only one thing to do, and that is to go back to the Republican Party."

CHARLES DUPREZ

Brown Brothers

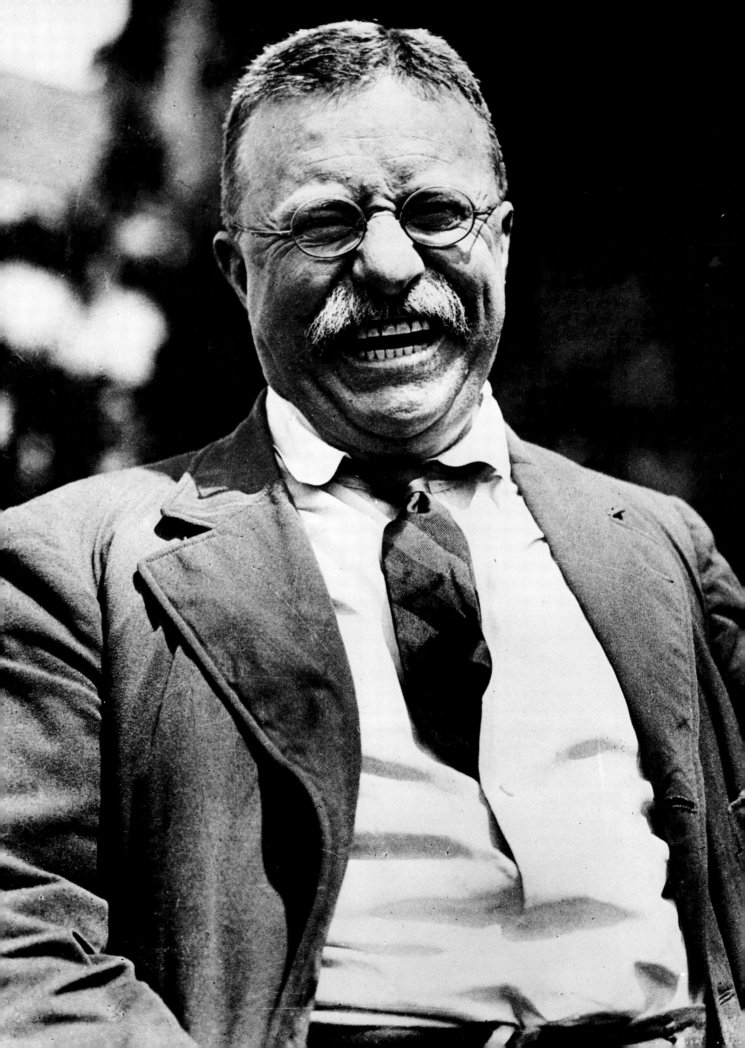

9. The Mad Bomber

People in many cities have been terrified, at one time or another, by the workings of a demented mind. In the annals of news photography there is a classic story of a "mad-bomber." It ran in the Nov. 20, 1912, *Los Angeles Examiner*.

"Carl Warr walked into City Jail on First Street shortly before 11 A.M. yesterday forenoon, carrying an infernal machine loaded with sixty sticks of the highest power dynamite made. He was grotesquely masked with a hideous goggle-eyed hood of a kind to excite laughter did it not enclose a mind seething with so terrible a purpose. Seating himself in a corner of Chief Sebastian's outer office, with his hand on the trigger of his engine of annihilation, Warr for seventy-five, minutes became a menace that figuratively made this city's heart stop beating. All the while Warr sat in his corner in the police office, alert, forbidding, a living instrument of sudden wholesale death; demanding the summons of the chief executive (Paul Shoup, Pres. Southern Pacific RR) of a great railroad system, that he might exact a promise of redress for fancied wrongs to its employees."

While the police chief and others talked with Carl Warr, the word went out to clear surrounding streets of all people. In the building prisoners were herded out of their cells, down the stairs, and outside into trolley cars that took them away from the City Jail. The news spread rapidly. Soon more than 10,000 people were banked against police ropes at First and Broadway, and at First and Hill Streets. Through the mob raced *Examiner* photographer E. J. Spencer. Up the stairs and into the room he went, where he saw the mad-bomber sitting in the corner with the infernal machine in his lap. Warr's left hand was inserted in the bomb clutching the trigger ready to explode the machine. Everyone warned Spencer of the danger, but he carefully placed his plate camera on a chair and made the picture. Warr kept threatening to blow up the place. Spencer picked up his camera and moved to one side.

Warr had been in the police station an hour and a quarter when Detective James Hosick and S. I. Browne, chief of the D.A.'s Detective Bureau, walked into the room and attacked him.

"Warr pulled the trigger setting the machine in operation. Browne seized the bomb from the crumpling figure. With Detective J. Fitzgerald helping him, both ran with the thing out of the room, into the hallway, down the steps into the street. The box was smoking and sputtering. Browne was tearing desperately at it. When to have delayed longer might mean death to hundreds and a million dollars of property destroyed, the detective tore the insides from the thing and threw the dead harmless residue into the street. The bomb had failed to go off."

The *Los Angeles Examiner* ran Spencer's photo on the front page with a special caption. It read, "Here is one of the most remarkable newspaper photographs ever published. It was taken by E. J. Spencer, staff photographer of the *Examiner*, who risked his life to make the picture." It credited the photographer as seldom credit has been given. It was deserved.

E. J. SPENCER

Los Angeles Examiner

AMERICAN FOR THE PEOPLE

IX—NO. 345 Registered in U. S. Patent Office. WEDNESDAY LOS ANGELES, NOVEMBER 20, 1912 PRICE 5 CENT

TEMPERATURES

Los Angeles71
San Diego70
Sacramento61
Spokane59
Tacoma47
Santa Barbara65

CALIFORNIA FORECAST
Los Angeles and vicinity:
Fair Tuesday, and moderately
warm; light north wind.
San Francisco and vicinity:
Increasing cloudiness Tuesday;
rain by night; brisk south
wind.

TY JAIL IMPERILED BY HUMAN BOMB

sked Fanatic Sets Off Dynamite Fuse as Officer's Blow Knocks Him Senseles

Wire to the "Examiner"
RK, Nov. 19.—The four
rged with the murder of
senthal were today con-
rder in the first degree.
nched its decision on the
after they had been out
es.
by their conviction, the
rs returned to the Tombs
nouncing Justice Goff and
ho were concerned in their
counsel at once served
appeal.
a great crowd outside
courts building was at-
pproval of the verdict by
departing jurors.
ttorney Whitman, in a
ment complimented the
ew York on the result of
which he declared was a
civilization and the be-
e end of gun rule in New

ement fulfilled, Jack Rose,
bber and Harry Vallon,
ased from custody tomor-
day. The indictment of
uffeur of the murderers'
testimony against the four
is declared to have de-
sue, will also be dismissed
hepps will likewise be per-
free.
van, last of the seven men
the Rosenthal murder,
ced on trial immediately
trial of Charles H. Hyde,
s tomorrow.

o Join Becker
convicted men will appear
e Goff tomorrow morning
r pedigrees recorded and
for sentence. While will
to make the customary
a dismissal of the verdict
nting of a new trial. It is
conclusion, however, that
be denied. Sentence will
passed a week hence, and
days thereafter the gun-
ave joined Charles Backer
g.
slow grind of eight days
Justice moved with swift
on the ninth. The morn-
en up to the charge of Jus-
brief and comprehensive
he proceedings by both
case.
e Tombs the four gunmen
y of their luncheon. The
ty Louie, white and hag-
acing the corridor outside
em. Knots of rough look-
od outside on the pavement
whispers. Then, at 2:05 p
at hand.
all was in readiness, and
accompanied by a spe-
were led into the police
om. The jury followed
s later. Justice Goff took
on the bench.

n First Degree"
rd what verdict had been
foreman paused for a momen
allowed hard. Then he spoke
nging voice:
murder in the first degree, as
said.
ers withstood the shock with
Like stone images they stood
them with glazed and un-
until the deputy sheriffs

Druggists Anxious to Quit Selling Liquors; Council Is Staggered

Long Beach Men Ask That 'Prescription Sales' of In-toxicating Drinks Be Taboo

LONG BEACH, Nov. 19.—The propri-
etors of thirteen drug stores in this
city today presented a petition to the
City Council asking that the new liquor
ordinance, about which there has been
so much recent controversy, be so
amended that while druggists will be
allowed to sell alcohol for scientific
and mechanical purposes, the clause of
the ordinance giving them the privi-
lege of selling intoxicating liquors on
prescription be stricken out.

The surprise of the members of the
Council on receiving a request, which,
if granted, will debar druggists from
engaging in what has always been sup-
posed to be a most profitable branch
of their business, was so great that
no immediate action was taken in the
matter.

If the amendment suggested is made
and the amended ordinance carries at
the election December 30, it will be-
come a part of the city charter, and
Long Beach will have the unique dis-
tinction of being the "dryest" of any
city in the country.

The druggists say in defense of their
request that the odium attaching to
the sale of liquor injures their busi-
ness.

JOHN SCHRANK IS INSANE

Alienists to Submit Report of That
Nature, Says Official
(By Associated Press)

MILWAUKEE, Nov. 19.—That John
Schrank, who shot Colonel Theodore
Roosevelt on the night of October 14,
is insane will be the substance of the
unanimous report of the five alienists
appointed by Judge A. C. Backus to
examine into the prisoner's mental
condition, was the statement of a
court official this afternoon.

Presuming that Schrank will be
found insane, it will be impossible to
try him on the charge of attempting to
kill Roosevelt.

"RUBE" DENIES CHARGES

Marquard Says Blossom Seeley Never
Loved Her Husband, etc.
(By Leased Wire to the "Examiner")

NEW YORK, Nov. 19.—That Blos-
som Seeley, the actress, never loved
her husband and therefore had no af-
fection for him which might be alien-
ated, was the startling declaration
made today by "Rube" Marquard,
Giant pitcher, in his answer to the
$50,000 alienation suit filed against him
by Joseph Cohen, also known as Joe
Kane, husband of the actress.

Marquard denies that he exerted any
influence over the actress and denies
all the other allegations set up by
Kane.

WILSON WILL HAVE A COW

$5000 "Mona" Goes to Next President
for White House Milk
(By Leased Wire to the "Examiner")

MILWAUKEE, Nov. 19.—William
Galloway of Waterloo, Iowa, a breeder
of Ayrshire cattle, who was in Mil-
waukee today, has decided to give
President Wilson a cow to take the
place of Pauline Wayne, the Wiscon-
sin cow given President Taft by Sen-
ator Stephenson.

The cow will be Mona of Avon, a
registered animal valued at $5000. The
cow was promised to Senator Cum-
mins when he became President.

The Modern Test

The modern test of business worth—
RESULTS. That's the basis of the
"Examiner's" popularity. It brings the
"Examiner" to you—it's good. Try a
"Want Ad" and prove it. You can

'EXAMINER' PHOTOGRAPHER HAZARDS DEATH TO SNAP THE DYNAMITER

HERE is one of the most remarkable newspaper photographs ever published. It was taken by E. J. Spencer, staff photographer of the "Examiner," who risked his life to make the picture. The photograph was taken in the Central Police Station and shows Dynamiter Carl E. Warr, seated in the corner of the chief's outer office. On Warr's lap is his infernal machine containing over two score sticks of explosive. Warr's left hand is inserted in the bomb as he clutches the trigger ready to explode it. Warr's other hand, which is seen in the picture, was painted red, also the infernal machine was of the same hue. Over Warr's head is the hideous brown mask or hood, with its green goggle eye-piece. Warr threatened to shoot anyone who attempted to take a picture of him, but Photographer Spencer, disregarding the maniac's threat, entered the room and calmly snapped the photograph which the "Examiner" reproduces here-with. It was shortly after this picture was made that Warr was overpowered and captured.

LOS ANGELES was thrille
terday with one of the mo
matic and fantastic ac
that has ever been written into
nals—one which threatened ac
lives and a whole city block w
struction. Carl Warr, a Germa
dicalist, anarchist or one men
disordered intellect, walked in
City Jail building on First
shortly before 11 o'clock yes
forenoon, carrying an infernal m
loaded with sixty sticks of the
power dynamite made.

He was grotesquely masked
hideous goggle-eyed hood of a
excite laughter did it not ene
mind seething with so terrible
pose.

Keeps Hand on Trigger

Seating himself in a corne
Sebastian's outer office, with h
on the trigger of his engine of
lation, Warr for seventy-five m
became a menace that figu
made the city's heart stop bea

All the while Warr sat in his
in the police office, alert, forbi
living instrument of sudde
wholesale death, and demand
summons of the chief executi
great railroad system that h
exact a promise of redress for
wrongs to its employees.

And finally after these 75
of agonizing suspense. Wa
rushed by three detectives—
Hosick and Fitzgerald, over
and his infernal machine, who
dealing powers he had set in
when attacked, was wrenche
him and torn into fragments
was taken to a hospital, the
dispersed and the currents of
resumed their normal sway.

Warr had been two months
over his infernal machine and
ornately fashioned aperture i
its sides he had thrust the s
his crippled left hand upon w
tificial fingers had been fitte

Dynamite Prevents Disa

Fate and even nature may
doxical. Warr was prepar
stroy with dynamite, but it w
mite that prevented destruct
In self-accusing terms the
fanatic explained after his a
he had inserted a bit of
dough" in the train that con
blank cartridge with the fuse
minating cap.

If this had not intervened
in the blank cartridge would
ploded a train of black powd
short fuse which Warr had car
burned to its end within a few
the cap would have explode
the same instant, sixty piec
80 giant powder would hav
ished the City Jail building
en the city.

This is the highest powe
made. A few sticks of this
the Los Angeles newspaper
year. But when set on
slowly.

Through it all, the knowe
was as open to conversation

10. The "Eastland" Disaster

The elevated train rumbled along, carrying *Chicago Daily News* photographer Fred Eckhardt to work. He was due at the office at seven A.M. Passing over the Chicago River Bridge on Wells Street, one block west of Clark, Eckhardt saw people boarding the excursion steamer *Eastland*. What he didn't know was that within the hour he'd be there, recording tragedy.

It was a bright, sunny summer day, this July 24, 1915, perfect for an excursion. Western Electric Company's Hawthorne Club had ticketed 7,000 people for a lake trip to Michigan City, Indiana. Five steamers had been chartered to carry factory workers and their friends to the picnic. It was first come, first sail, and the *Eastland*, preferred as the fastest of the steamers, was loaded to the rails with 2,500 early arrivals.

At 7:40 A.M. the ship moved away from the pier, then swayed back to almost even keel, and with slow deliberation, began to roll over. Without alarm, passengers swayed back and forth with the list. It increased until an icebox on deck teetered over and slammed down with a bang. Then terror reigned. The deck angle became steeper and steeper. Hundreds slid upon hundreds—an avalanche of human beings.

Below decks, the danger wasn't apparent until too late. People in the saloons extending the width of the ship, others in their cabins, slipped and slid to port until the hull halted the cascade of bodies. Walls became floors, and floors, walls. Water rushed in through every opening. Within minutes the *Eastland* had completed its quarter revolution and lay on its side in nineteen feet of water. Air escaping from the ship sounded like the last sigh of the dead. More than 812 people lost their lives.

At the *News*, the flash came through: "One of the tugboats guiding the *Eastland* had overturned." Eckhardt picked up his 4x5 Auto Graflex camera and ran the five long blocks from the office to the pier. What he saw was sheer bedlam. The *Eastland* itself had capsized.

"Arriving at the scene, and seeing I had no chance to get a good shot from river level," Eckhardt explained, "I ran to a nearby poultry building and from high up made my overall picture. Completing this, I went down to the river edge and photographed survivors as they were brought to shore. Soon as my plates were exposed, I ran all the way back to the *Daily News*, reloaded and returned to the *Eastland*, staying there until early evening. It wasn't until 10:30 P.M. that I finished up and took the elevated train home. In the dark, as we crossed the Chicago River Bridge, I could see lights and people working on the *Eastland* where she lay in the river. Just fifteen hours ago it had happened."

The tragedy of the *Eastland*, dramatized in reports by photographs, compelled improvements in life-saving equipment, fire and boat drills, naval construction, ship inspection regulations, and maritime legislation.

Fred Eckhardt's coverage of the disaster was extensive. Many photographers recorded the catastrophe, but Eckhardt's overall shot captured that moment of history as no other did.

FRED ECKHARDT

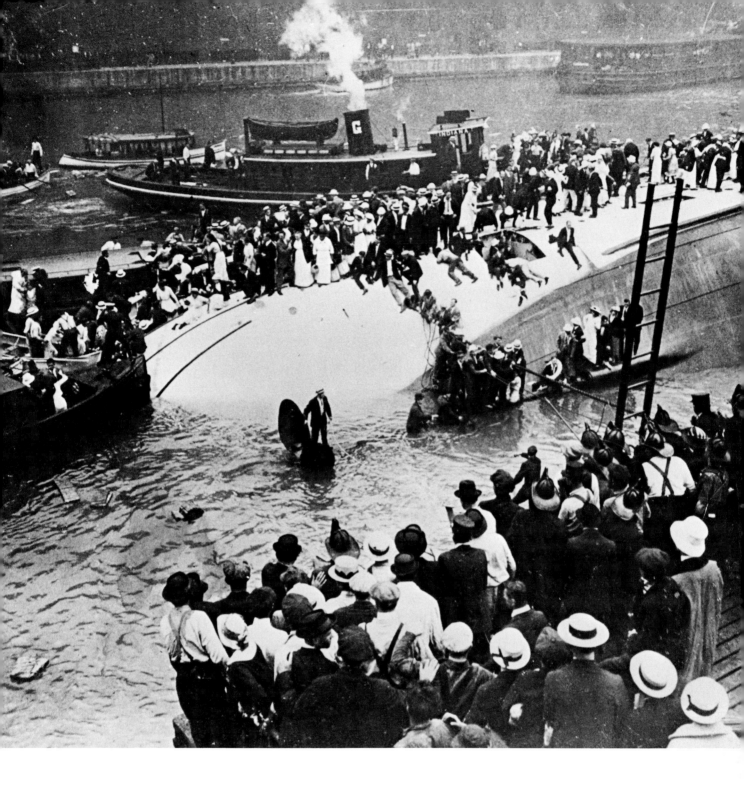

11. The Wall Street Explosion

The red wagon, drawn by a single horse, made its way slowly through the narrow street and came to a halt at the curb near the three-story limestone building that housed the firm of J. P. Morgan & Company. The driver alighted and walked off as a nearby auto containing several men sped after him, away from the wagon. As the horse stood idly, a bomb mechanism inside the wagon ticked away. It was close to twelve noon here at the geographical spot in the nation that could be called the financial center of the United States: Wall Street. It was September 16, 1920. On all sides of the vehicle of death were the buildings that represented private and government finance: the N.Y. Stock Exchange, the U.S. Assay Office, the Sub-Treasury Building, and J. P. Morgan & Company. They represented a system that was bitterly hated by the radicals.

A block away, N.Y. *Journal* photographer John Tresilian stopped to have lunch at Iorio's. The crowds on the narrow sidewalks overflowed into the streets. Well-dressed clerks were probably discussing the close pennant races; the Dodgers were in the lead, the Indians had just gone ahead of the Yankees. Stenographers strolled along arm-in-arm, chatting happily.

The scene disappeared in a sudden blinding flash of light. The detonation rocked the whole lower end of Manhattan. The bomb went off at one minute before noon. Wall Street was a shambles. Fragments of the wagon, and the carcass of the dead horse lay beside a huge hole scooped out of the street by the force of the bomb.

For a long moment nothing was heard but the groans of the injured and the still falling splinters of glass as they struck the pavement. Then pandemonium reigned. As if on cue, thousands of people spilled from the buildings into the street. There were screams as they saw the macabre scene. Dead and dying lay strewn about the blood-soaked street. A seeming avalanche of excited humanity gathered from surrounding areas.

Police arrived, along with fire engines and ambulances. Bodies were covered with burlap; the wounded were hurried off to hospitals.

When he heard the explosion, John Tresilian abandoned his lunch and rushed back to the office to get his camera. Photographers from the twenty-one New York newspapers arrived on the scene shortly after. George Schmidt ran to Wall Street from the N.Y. *Daily News* office at Park Place. He was among the first to arrive. He made his way through the debris. With his 4x6 Ica Trix camera, he recorded picture after picture of the disaster.

The explosion had taken the lives of thirty-nine people and injured some four hundred others. Ironically, the victims were not the financial giants of the nation, but rather the "little people": the clerk, the stenographer, delivery boys.

Detectives and Federal agents began an investigation that was to continue several years. Slugs removed from victims turned out to be window sash weights cut in two. Each minute bit of evidence was eventually tracked down, but to no avail: the case remains unsolved.

Georges Schmidt

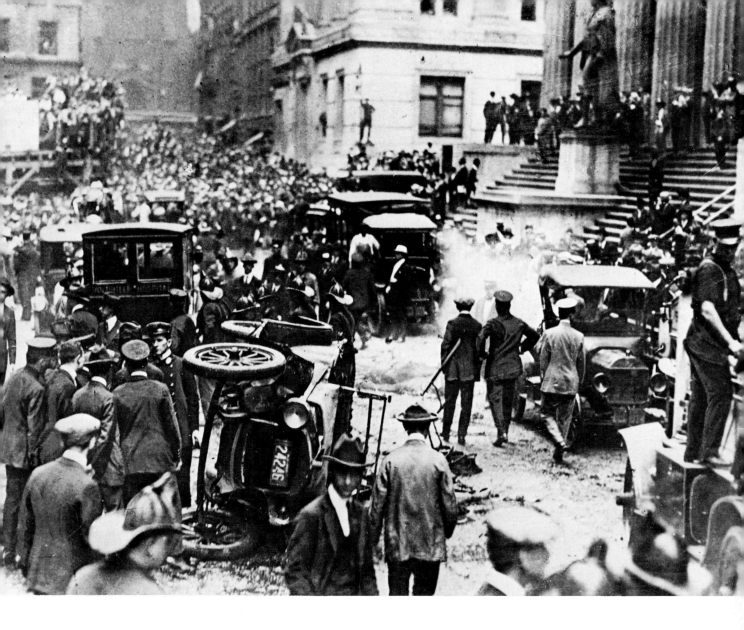

12. The First Flight Around the World

For over a month, correspondents of leading U.S. newspapers and news services waited patiently at Icy Tickle, Labrador for the arrival of the "Magellans of the Air." Nearly six months before, on April 6, 1924, four U.S. Army Douglas biplanes had left Seattle, Washington to fly around the world.

Each plane, carrying a crew of two men in open cockpits, was named for an American city: Seattle, Boston, Chicago, New Orleans. The *Seattle* was lost when it crashed into a fog-bound Alaskan mountainside. Major Frederick Martin and Sgt. Alva Harvey escaped with minor injuries.

The three remaining planes continued on. They crossed the Bering Straits to Japan, followed the Chinese coastline to Siam, then to Burma, India, Turkey, Austria, France, England.

Wherever they went, the six airmen were welcomed royally. At a luncheon given by the faculty of the University of Tokyo, they were honored for "being the first of men to connect the two shores of the Pacific Ocean through the sky." In Shanghai, "little girls in sweet little dresses led the way, strewing roses before us." In Calcutta "it took fifty policemen to hold back the mob." In Vienna, "Kodaks to the left of us, Kodaks to the right, front, rear." "On the outskirts of Paris we met more generals, ambassadors, cabinet ministers and celebrities than we had encountered in all the rest of our lives." In London they were mobbed "by photographers, and autograph collectors, for the crowd had broken through the police lines."

En route to Iceland, the *Boston*, flown by Lieut. Leigh Wade with Sgt. Henry Ogden, developed engine trouble and made a forced landing. While being towed, the plane capsized and sunk.

From Iceland, the *Chicago*, carrying Lieuts. Lowell Smith and Leslie Arnold, and the *New Orleans*, flown by Lieuts. Erik Nelson and John Harding, continued on to Greenland, then Labrador.

Among the newsmen at Icy Tickle was "camera-correspondent" Bob Dorman, assigned by Charlie Mathieu, manager of the newly formed Acme Newspictures. He recorded the landings, and photographed Flight Commander Smith as he again set foot on North American soil.

BOB DORMAN

The airmen left Labrador for the United States two days later. A fast U.S. Navy destroyer took the correspondents to Boston, arriving ahead of the flyers. There, Dorman transferred to a waiting boat, beating the other photographers ashore. At the airfield he hopped aboard a chartered plane. En route to New York, he carefully placed his exposed glass plate negatives and film pack in a previously prepared length of inner tube, sealed and inflated it. Acme Newspictures had done extensive planning to "score a beat."

Waiting in a boat in Manhattan's East River were Acme's ace photographer Frank Merta, and an enterprising N.E.A. reporter by the name of Harold Blumenfeld. Dorman's plane flew low over the river. He tossed out the "balogna"; Merta recovered it. Back at the office he opened it up. The fall had completely smashed the glass plates, but the film pack was still intact. Dorman had "beat" the other newspapers and news services.

The Round-the-World Flyers flew from Boston to Washington, D.C., and returned to Seattle September 28, 1924. They had flown 26,345 miles in 363 flying hours. "Other men," they were told, "will fly around the world, but never again will anybody fly around it for the first time."

United Press International

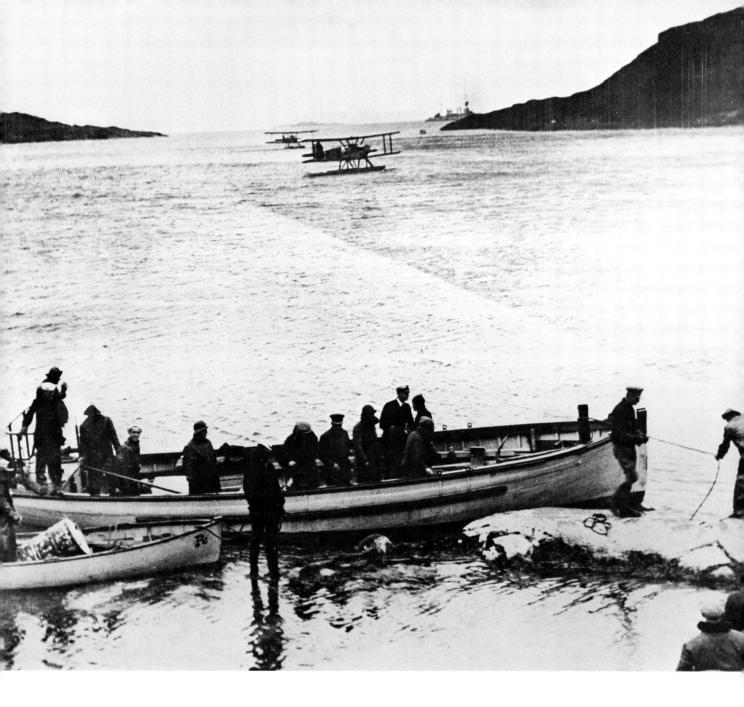

13. The Floyd Collins Legend

It was a little after six A.M. when Floyd Collins entered "Sand Cave." He'd been down the hole before. Now he was determined to follow it as far as he could go. He was hunting for a cave that would make a good tourist attraction, similar to the famous Mammoth Cave nearby. It was January 30, 1925.

When Collins didn't return twenty-four hours later, a friend, seventeen-year-old Jewell Estes, crawled into the cave's mouth and shouted for him. He heard a faint answer coming from the depths sixty feet below. Collins told him his foot was caught under a heavy rock; he was jammed tight in the narrow passage. Estes summoned Homer Collins. The brother reached Floyd by crawling and squirming down the dark, slimy, winding passage. Floyd seemed all right, so Homer returned to the surface to get help. Local correspondents notified their papers in Louisville, Kentucky. Soon, the wires of the press associations informed the nation of the fight to save the life of Floyd Collins. Newspapermen were sent to Kentucky to cover the story firsthand.

William Eckenberg of the *N.Y. Times* photo syndicate, Wide World Photos, was among the men representing twenty-seven newspapers at the scene. He arrived February 5, and remained there fifteen days. He photographed the family, the crowds of over a thousand people, the prayer meetings, the continuous digging.

First newsman to go down the tunnel was William "Skeets" Miller, cub reporter for the *Louisville Courier-Journal*. Though he was slim and small, he was barely able to squeeze through. He worked several hours trying to pry Collins loose. He pulled a string of electric lights down to Floyd, and by the light fed and comforted him.

One photographer, John Steger, of the *Chicago Tribune*, succeeded in working his way down the dangerous incline. The picture he made was of little value because of the halation of the light bulbs left there by Miller.

That there was a picture at all to illustrate Collins' plight is due to Bill Eckenberg's perseverance. Someone had told him that a farmer had made a picture of Floyd Collins ten days before in nearby Crystal Cave. Bill couldn't drive, so he enlisted the help of his friend, Eddie Johnson of the *Chicago Tribune*. Shortly after midnight, they struggled over ten miles of dirt roads to the farmer's house. Bill awakened the farmer, and told him the story he'd heard. The farmer produced an old box and took from it the picture of Collins. The newsman bought it for five dollars.

Knowing they had scored a beat on the other papers, the two men raced to the railroad station at Bowling Green, Kentucky. A train was due in at four A.M. Once there, Bill pinned the picture to the station wall and, using flashpowder, made four copies. He gave the original to Johnson. The stationmaster put their precious packages on the train. Both the *N.Y. Times* and the *Chicago Tribune* ran the photo.

Floyd Collins died before he could be rescued. His body was subsequently removed and placed, in a silver casket, on exhibition in Crystal Cave. Floyd Collins had himself become a tourist attraction.

WILLIAM ECKENBERG

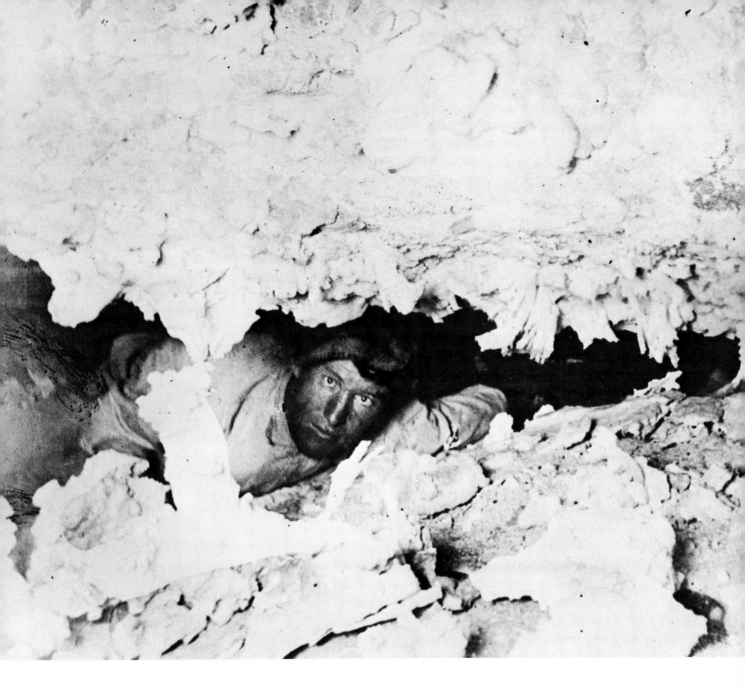

14. Mother Cat Stops Traffic

"Warnecke," called assistant city editor Cliff Laube, "a guy just phoned in a tip about a cat tying up traffic carrying a kitten across Center Street. Go over there and get a shot of the cats." Harry Warnecke, photographer for the N.Y. News, liked the challenge of a feature picture. Furthermore, he liked animals, so this assignment was right up his alley.

It was a sunny, summer afternoon, July 29, 1925. Harry located the owner of the cats, a man who operated a small machine shop on Center Street. The owner told him his cat had had the kittens a couple of blocks away, and had decided to carry them "home" that day. When the cat had tried to cross the street in front of the shop, the traffic was very heavy. The corner policeman, seeing the cat's predicament, had stopped the cars until the animals were safely across.

Harry first photographed the cat and kittens in her cardboard box, then asked permission to restage the incident. The owner agreed, "as long as the cats weren't hurt." Then Warnecke approached the policeman, asking him to hold up the traffic again. "Gees, I'd like to do it for you, but I'd catch it from downtown," he answered. "Nobody in New York would criticize you for doing a good deed like this," Warnecke insisted. "After all, you really did it before. Let's try it." The policeman finally agreed.

HARRY WARNECKE

Harry handed the cats to a man on the far side of the street. The owner stood directly opposite, in front of his shop, ready to call the cat. The policeman held up his hand, and traffic came to a standstill. The cat was released. Warnecke got ready to make his shot. Impatient autoists began blowing their horns. Instead of crossing straight over, the confused mother cat, kitten in mouth, meandered across diagonally, too far from the stopped cars to make an effective picture.

Undaunted, Harry set it all up again. He asked the policeman to stop the cars a little closer to the intersection. The cats were carried back. The perspiring cop held up his hand. At this point Center Street was jammed with irate motorists and fascinated pedestrians. The racket was awful: the cop was sure he'd lose his job. Harry stood in close, his 4x6 Ica camera ready, praying the cat wouldn't cross under the cars. The cat hesitated a long moment, then gingerly crossed directly in front of the halted cars. Warnecke made his picture. Onlookers cheered. Fuming motorists sped away. Cat and kitten disappeared into the machine shop.

No need to mention what the policeman said when Warnecke walked over and quietly said, "Now, we're not going to be satisfied with just that one shot, are we?" Harry Warnecke is a very persuasive fellow. The entire procedure was repeated once more. Harry was satisfied he had the photo he'd come for.

When the picture ran in the paper, the N.Y. News was besieged with letters and requests for prints. A few days later, the helpful, though harried, policeman called the newspaper to thank Harry Warnecke: he had received a letter of commendation from the Police Commissioner!

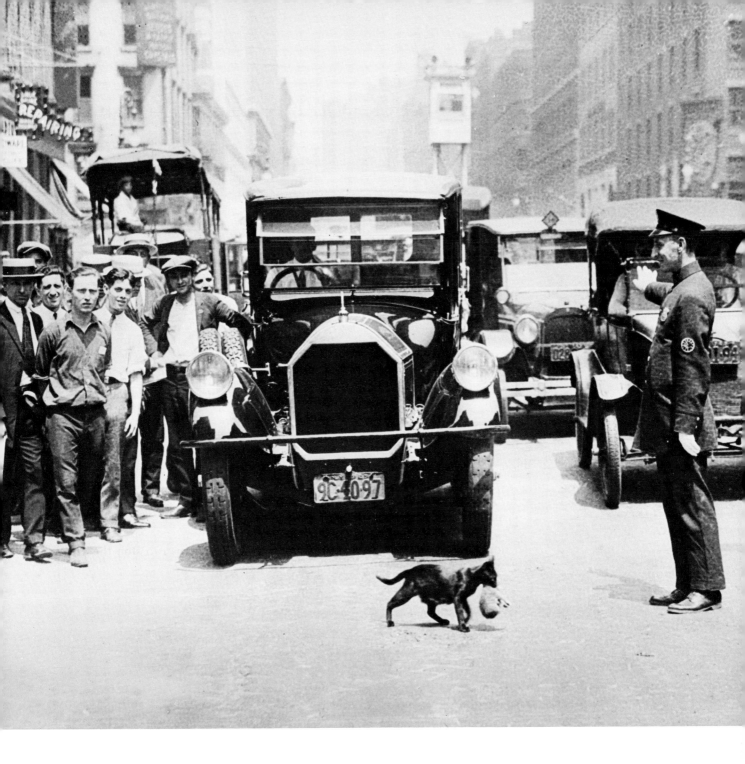

15. President Coolidge's Sit-down Salute

The powerful warships of the U.S. Navy steamed slowly through the waters of Hampton Roads, Virginia, this day of June 4, 1927. It was a great spectacle. Aboard the yacht *U.S.S. Mayflower*, stood President of the United States Calvin Coolidge, hand to forehead, saluting "the greatest armada the nation has ever assembled for review by a Chief Executive." Standing close by were Curtis D. Wilbur, Secretary of the Navy; Admiral E. W. Eberle, Chief of Naval Operations; and many news photographers.

Time dragged painfully on, and for several hours the proud U.S. Fleet passed in review. The President stayed at his post, saluting each passing ship. The photographers had made their pictures, there being just so many that could be taken of the event. Late lunch was being served below, and everyone rushed there. Everyone, that is, but the President, the Secretary of the Navy, the Chief of Naval Operations, and one press photographer—Andrew "Buck" May. "Buck" May worked for Harris & Ewing, Washington, D.C., news picture service. He felt he should stay on deck, just in case something happened. It did.

"Silent Cal" was a New Englander, noted for his exemplary propriety on all occasions. Human endurance, however, can stretch just so far, and after hours of saluting, the President was visibly tiring. Periodically, now, he retreated to a nearby sofa to catch a "breather." Tired as he was, he was determined to see it through. And so, each time a ship of war would move by, he came up with a salute, even if he happened to be seated at the moment. The salutes weren't quite as snappy, but the man was weary, the couch was comfortable. The dignity of "Silent Cal" was at low ebb.

ANDREW "BUCK" MAY

The lone photographer present, "Buck" May, saw this amusing situation and recorded it. He later said, "He saw me make the shot, and gave me a terrible scolding, adding that I was discourteous and should know better. I offered my apology. He did not order me to kill the picture. Fortunately there were no Secret Service agents nearby who could force me to destroy the picture. I waited patiently.

"By the time the other photographers came back on deck after a delicious luncheon, a seaplane had landed beside the Presidential yacht. It had been sent to pick up our exposed films and fly them back to Washington, D.C., for processing. We gathered up everyone's film holders and gave them to the courier. All the time I wondered if someone might stop me from sending in my picture of the President's sit-down salute.

"Standing with the other photographers on the aft deck of the *U.S.S. Mayflower*, I watched the seaplane take off and disappear in the distance. My film was safely on its way and I could breathe easy now. It was then that I told the other photographers of the shot I had made. You should have heard the commotion."

"Buck" May's picture was used in the *Washington Star* as well as by many other newspapers. It brought a chuckle to the reading public, and provided an amusing sidelight on a Presidential career.

Harris & Ewing

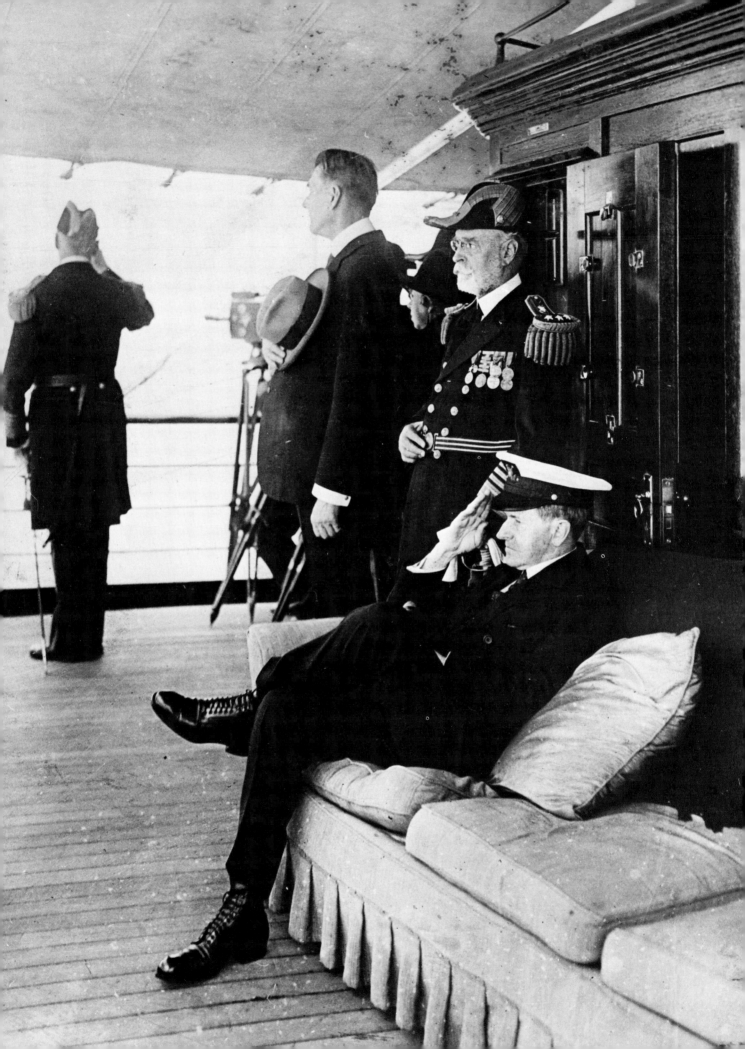

16. Lindbergh–the Lone Eagle

In the history of the city of New York there has never been a "hero's welcome" like that given to Charles A. Lindbergh on Monday, June 13, 1927. "Lucky Lindy" had flown solo across the Atlantic Ocean, New York to Paris. His feat had captured the public's fancy. During the days of receptions, parades, and celebrations that followed, the press made thousands of pictures. Yet, of all of these, one photograph recorded the spirit of "The Lone Eagle" and is still in constant demand.

From the moment Lindbergh was driven up Broadway in the shower of confetti, the reception committee had his every hour scheduled. He had one major problem. He had been unable to fly the *Spirit of St. Louis* to New York from Washington because of engine trouble. Within a few days he was to fly her to the city of St. Louis for the great reception there. Somehow, he had to get back to Washington and fly the "Spirit" to New York without disrupting the many commitments he had made.

Twice on Tuesday he rushed to Mitchell Field to obtain an Army plane to fly to Washington. The weather was so bad the Army refused his request. Wednesday night's schedule saw Lindbergh first attend a special showing of *Rio Rita*, and then at ten P.M. attend and address the Nungesser-Coli benefit at the Roxy Theatre. At two A.M. he slipped away, outdistanced the press in the fast car he was driving, and arrived at Mitchell Field. The same determination that had seen Lindy through the problems of raising money, building the Ryan monoplane, planning and making the Trans-Atlantic flight was working within the man.

FRANK MERTA

This time the Army "cleared" his flight plan. He still wore formal evening clothes over which he pulled on a borrowed leather flying suit. At 3:05 A.M., with Lieutenant Sinclair Street flying beside him in another Curtis P-1 Hawk pursuit ship, he disappeared into the night sky. They landed at Bolling Field, Washington, D.C. Within the hour Lindbergh was back in the air on the return flight—this time in the *Spirit of St. Louis*. Daybreak came, and at 8:05 A.M. the "Spirit" touched ground at Roosevelt Field, N.Y. He had arrived in time to fulfill his commitments of the new day.

Among the news photographers on hand was Frank Merta of Acme Newspictures. While most of the men used eye-level cameras, Frank had a reflex 4x5 Graflex camera, which was held at waist level. Lindbergh came out of the plane, and momentarily halted. His face still carried the look of determination of this past night's work. Merta made several shots. It was difficult because spectators among the newsmen were jostling and shouting. Then Lindbergh was gone.

At Acme's office, Frank Merta processed his glass-plate negatives, made a set of prints, and gave them to N.E.A. Bureau Manager Leon Siler. Siler immediately "picked" the dramatic low angle portrait of Charles Lindbergh. The great photograph, symbol of an era in aviation, was on its way to immortality.

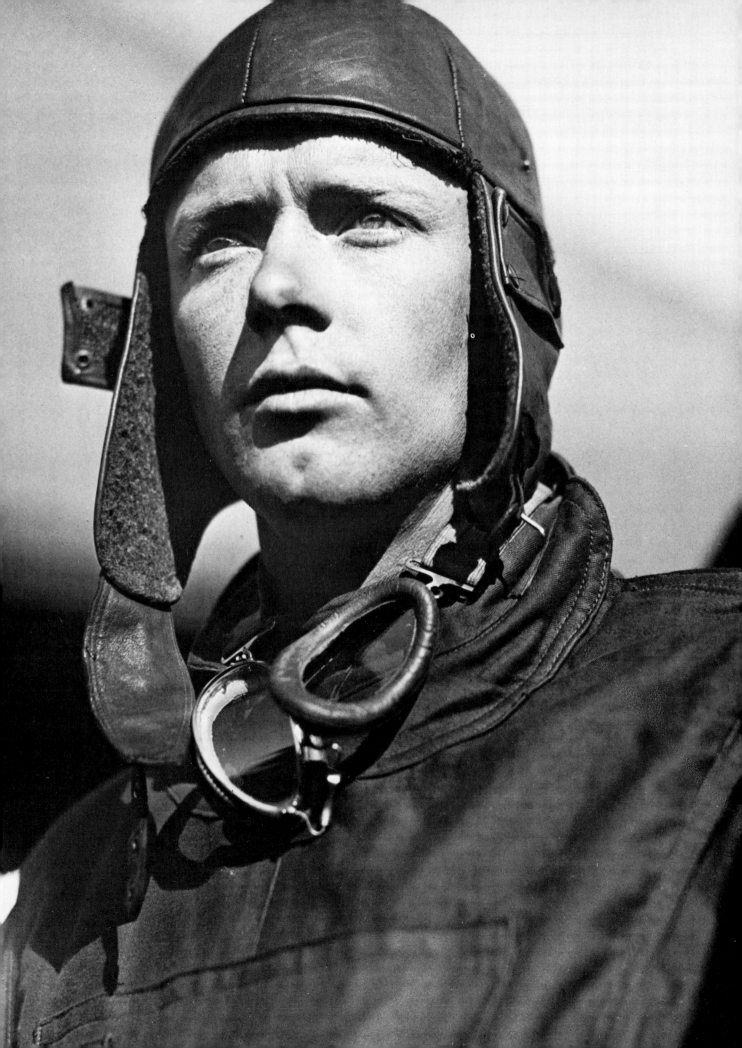

17. The Electrocution of Ruth Snyder

The picture shocked the reading public. To this day its publication is a controversial subject. It remains in the historical files of news photography, a reminder that the impossible can be accomplished by absolute coordination and cooperation of an entire editorial staff. It is also a reminder of an era in the newspaper business that has ended.

Ruth Snyder was to be executed in the electric chair on January 12, 1928, along with Judd Gray, for the murder of her husband, Albert Snyder. The word was out: "no pictures in the death chamber." The N.Y. *Daily News'* dynamic city editor, Harvey Deuell, felt if reporters could describe the execution, the public was entitled to see it. He turned to Ted Dalton, picture assignment editor, and his assistant George Schmidt. These three men masterminded the project.

First, they decided a miniature camera, fastened to the ankle, should be used. A frisking examination by prison officials would cover the length of the body, but eliminate the ankle. Then they assigned staff members to gather helpful information. The camera had to be pre-focused, so it was necessary to know the seating arrangement in the deathhouse. One man was assigned, and performed, the almost impossible task of obtaining blueprints of the room.

A photographer on the *Chicago Tribune*, Thomas Howard, was brought to New York City a month in advance. It was felt he would be unknown to local competing newspapers and prison officials. He stayed at a hotel, making test shots with a modified miniature camera. It carried only one glassplate (no film), which was a little larger than 35mm. Howard had to get the picture on the first shot. The camera, strapped just above his left ankle, would be aimed at the subject by pointing his shoe. A long cable release ran up the trouser leg into his pants pocket. To make the picture, he would have to lift his trouser clear of the lens.

The night of the execution arrived. Tom removed the darkslide from the plateholder before entering the prison.

Ruth Snyder walked calmly to the electric chair, and was strapped in. As she lurched at the first shock, Tom made an exposure. He immediately realized that a second, and perhaps a third, shock would be administered. He quickly closed the shutter and waited for the second shock, exposing as the switch was thrown. The exposure was approximately five seconds.

When the press witnesses were dismissed from the death chamber, Tom Howard rushed to a waiting automobile. The car, with a second auto following in case of mechanical breakdown, sped from Ossining, N.Y., to the *News* in New York City.

The plate was developed, and a satisfactory image appeared. Body movements at the time of death produced a slightly blurred effect, but the stark horror of the scene was recorded.

The picture ran full page of an "extra edition," of the *News*. The banner headline read "DEAD!" It was Friday the 13th.

TOM HOWARD

Average net paid circulation of THE NEWS, Dec., 1927:
Sunday, 1,357,556
Daily, 1,193,297

DAILY NEWS

EXTRA EDITION

NEW YORK'S ■ PICTURE NEWSPAPER

Vol. 9. No. 173 56 Pages New York, Friday, January 13, 1928 2 Cents IN CITY 3 CENTS

DEAD!

— Story on page **3**

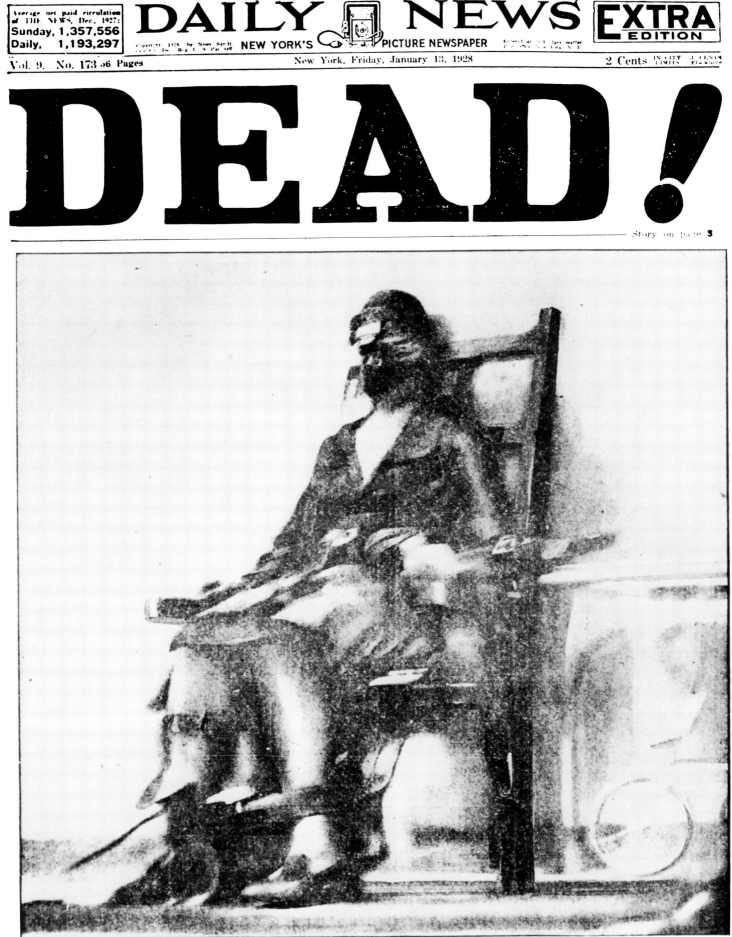

(Copyright: 1928: by Pacific and Atlantic photos)

RUTH SNYDER'S DEATH PICTURED!—This is perhaps the most remarkable exclusive picture in the history of criminology. It shows the actual scene in the Sing Sing death house as the lethal current surged through Ruth Snyder's body at 11:06 last night. Her helmeted head is stiffened in death, her face masked and an electrode strapped to her bare right leg. The autopsy table on which her body was removed is beside her. Judd Gray, mumbling a prayer, followed her down the narrow corridor at 11:14. "Father, forgive them, for they don't know what they are doing?" were Ruth's last words. The picture is the first Sing Sing execution picture and the first of a woman's electrocution.—*Story p. 3; other pics. p. 28 and back page.*

18. The Sinking of the S.S. "Vestris"

Friday evening, before his ship was to leave, Fred Hansen, crew member, shopped around for a camera. He bought an $8.50 folding Kodak and six rolls of film. Actually, he was buying a niche for himself in photo-journalism history.

The next afternoon at 3:30, Lamport & Holt Line's *S.S. Vestris* sailed from Hoboken, N.J., bound for Argentina with 129 passengers and 199 crewmen aboard. By ten o'clock Saturday night the constant pitching sent the heavy cargo of agricultural machinery and autos crashing through the wooden bulkheads which separated the cargo hold from the forecastle. The shift in balance caused the ship to list dangerously. Supposedly leak-proof "coaling doors," located amidships, began to gush water. Before long the second saloon on the main deck was waist high with water. Bailing pumps were started, but were soon jammed with soggy coal dust. Shortly after 10 A.M. Monday, November 12, 1928, Captain W. J. Carey sent an SOS. Succeeding wireless messages told the story.

At 10:52 A.M. "Hove to since noon yesterday. Last night developed 32 degree list. Starboard decks under water. Ship lying on beam end impossible to proceed anywhere." 11:03 A.M. "Oh, please come at once we need immediate attention." 11:07 A.M. "Rush help ship sinking slowly." 11:40 A.M. "It's Devil to work with this list. Getting lifeboats out now." 12:30 P.M. "We'll soon have to abandon ship." 1:25 P.M. "We are abandoning ship. We are taking to the lifeboats."

FRED HANSEN

Fred Hansen later reported, "When I got on deck I started taking pictures. Everyone was screaming and yelling. I stayed until we thought all lifeboats had been launched except boat #1. As that was being lowered I jumped into it after taking my last picture on deck. There were only three men in the lifeboat. We couldn't man it and pull people in at the same time, so we cruised over to boat #8 and yelled for two sailors to come aboard. It was filled with people yelling like bulls. Only one sailor came over. As we pulled away their boat began sinking. We picked up about thirty men and women from the water." The *Vestris* sank suddenly. That afternoon and night the helpless people tossed about the churning ocean in a sixty mile an hour gale, until rescue ships arrived. Many heroic tales were told of incidents in those shark-infested waters 240 miles off the Virginia Capes.

As rescue ships entered New York Harbor they were met by newspaper reporters and photographers. Among them was Martin McEvilly, picture assignment editor for the *N.Y. Daily News*. He had already assigned fourteen cameramen to various jobs covering the incoming survivors. A seaman told McEvilly about Fred Hansen. Mac located him, and quickly drew him away from rival newspapermen. They agreed on a price. McEvilly gave Ralph Morgan, of the News' Pacific & Atlantic photo syndicate, Hansen's films. Morgan rushed the rolls back to shore to the *News'* lab.

The photo of the passengers fighting for their lives aboard the sharply listing *Vestris*—made by amateur photographer Fred Hansen—has become one of news photography's all-time great pictures.

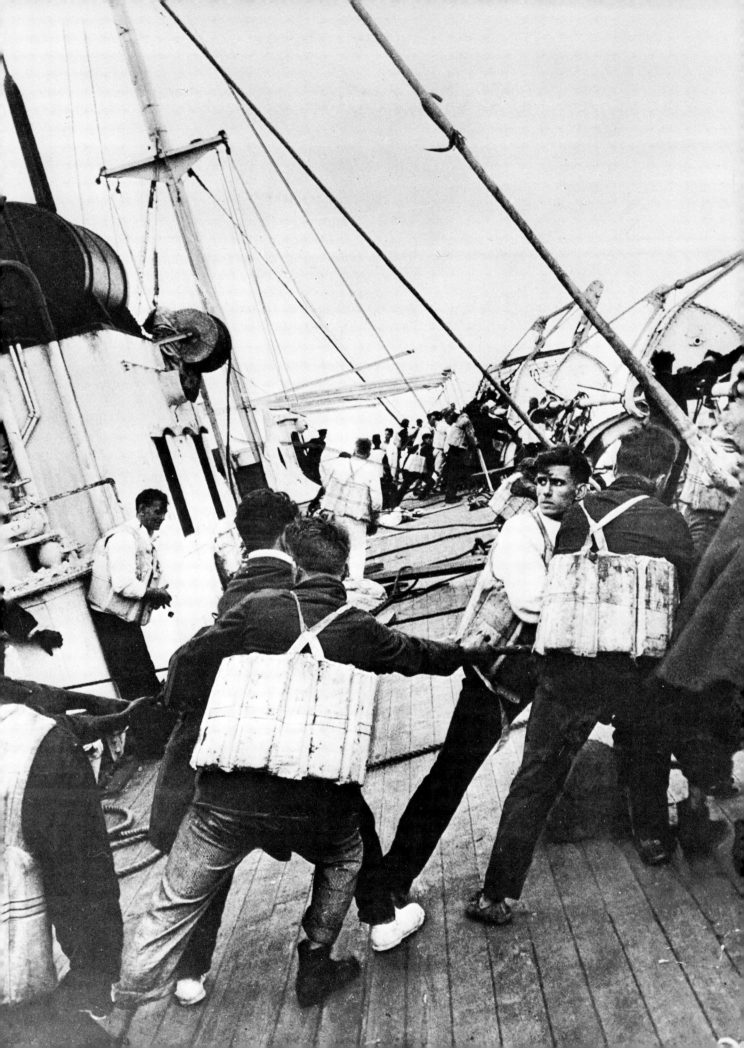

19. St. Valentine's Day Massacre

At 10:30 on the morning of St. Valentine's Day, February 14, 1929, a car skidded to a stop in front of the S. M. C. Cartage Company at 2122 North Clark Street in Chicago. Five members of the Al Capone gang stepped out, three dressed in police uniforms, two in civilian clothes. They entered the little one-story brick garage where six members of the "Bugs" Moran mob waited for a consignment of hi-jacked liquor. The bogus officers went directly to the large storage room at the rear of the building. The unsuspecting gangsters were quickly disarmed and directed to stand against the wall. Thinking it was a routine police raid, and they could get off easily enough, they did as they were told. The two men in civilian clothes then entered from the corridor and with sub-machine guns calmly proceeded to mow them down, including a young mechanic, John May, who worked in the garage. Their grisly mission completed, the "officers" then marched the two civilians back to the car. Passersby assumed it was simply another arrest. It was a remarkably ingenious murder, even for the crime-ridden twenties. The only living witness was a badly frightened young police dog who took refuge under a car.

John "Hack" Miller, of the *Chicago American*, was the first photographer on the scene. He tells the story.

"I was on assignment at Van Buren and Ogden Avenue, and had just called the office. They told me to go to Garfield and North Clark where there was a shooting. I got into my car, raced through red lights, and got there just as the first bunch of cops were going in. I went with them."

JOHN "HACK" MILLER

Sprawled grotesquely at the base of the bullet-riddled stone wall were six distorted bodies; a seventh lay slumped over a wooden chair. One of the officers called out, "This one's Pete Gusenberg, an ex-con and the chief gunner for the Drucci-Moran gang. Here's Al Weinshank, the North Side booze runner, and Artie Davis from the West Side mob. And this was James Clark, "Bugs" Moran's brother-in-law. Here's what's left of Doc Schwimmer." The other mobster was Frank Gusenberg, the only one still alive. He died within half an hour without giving the police any information.

Miller continues. "I must have been there about three minutes when Mike Fish of the *Chicago Tribune* came busting in. We climbed up on top of a rickety Ford sedan, bracing our 4x5 Speed Graphics, which were mounted on tripods, as well as we could on the soft top of the car. We worked together. One of us would count to three and open shutters. The other set off the flashpowder. We kept making pictures, and soon the other photographers arrived." Among them were David Mann, *Examiner*; John Steger, *Tribune*; Al Madsen, Underwood & Underwood; Tony Berardi, *American*, and Fred Eckhardt, *Daily News*. Smoke from the flashpowder soon filled the garage. The police clamped down and finally ordered everyone out. "Hack" Miller later took the quaking puppy home with him.

In the Twenties, more than 500 mobsters were killed in violent gang warfare in Chicago alone. Of the news picture record of the prohibition era, the photos of the St. Valentine's Day Massacre have become the representative illustrations of gangsterism and the violence of crime.

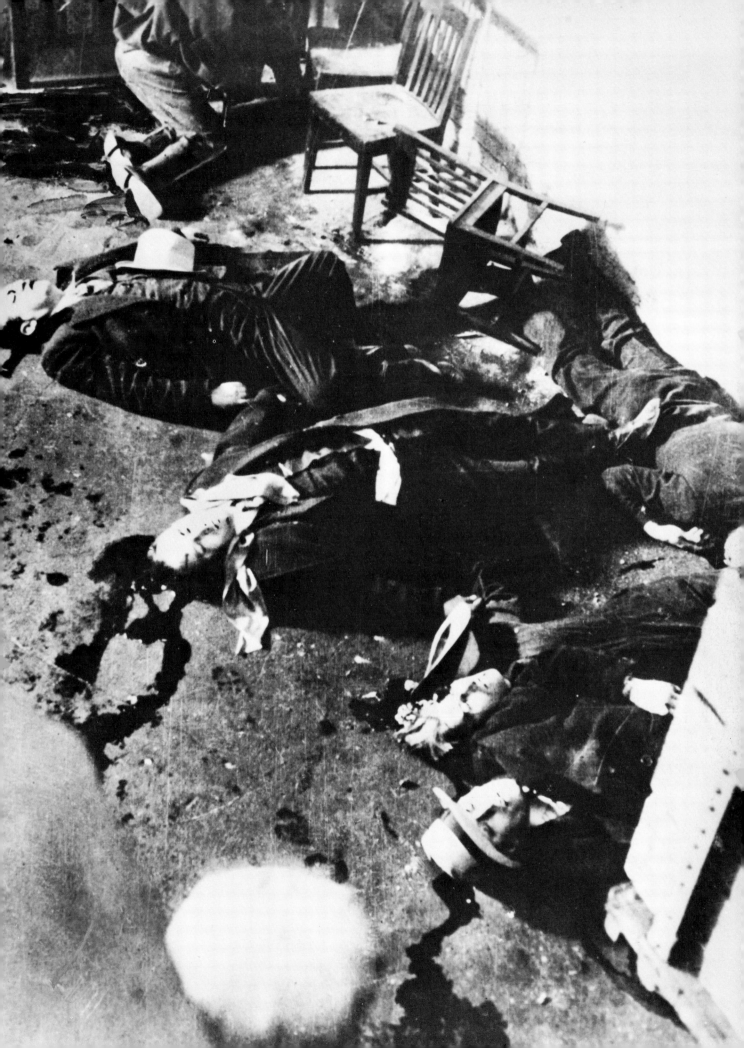

20. Football's Wrong-way Run

It was three o'clock in the morning, New Year's Day, 1929. Sam Sansone of the *Los Angeles Examiner* left his group of celebrating friends and headed for Pasadena, to locate a position from which to photograph the Tournament of Roses Parade. At eleven A.M. the parade was over and he headed, by taxi, for the Rose Bowl. Traffic was all tied up, and the four-mile trip took two hours. Before long, the heat and the exhaust fumes combined with the previous night's lack of sleep and too much celebration, began to take their toll. By the time Sam arrived at the stadium he was quite ill.

The Rose Bowl was jammed with 71,000 spectators who were there to see the University of California play Georgia Tech. Somehow, Sam covered the first quarter. Early in the second quarter he told Joe Mingo, another *Examiner* photographer, he needed time out. Carrying his camera, he walked slowly along the sideline behind the benches, down toward the California goalpost.

Suddenly the crowd screamed and jumped to their feet. Sansone turned around to see what the play was. A ball carrier was running down the field toward him. Automatically, Sam raised his 4x5 Graflex and made the picture. The rest of the photographers were, of course, at the other end of the field. Sam, without waiting for the details, returned to the office where he processed all the shots he and Mingo had made. He had no idea that what he had recorded was football history.

Roy Riegels, California center, had unexpectedly recovered a fumble on Tech's 35-yard line. It happened when "Stumpy" Thomason was viciously tackled by Schmidt and Phillips of California. The ball had squirted out of Thomason's grasp smack into Riegels' hands. The startled player ran right into a nest of Tech tacklers. He spun free and continued running for a touchdown. What he didn't realize was that he was now headed in the wrong direction. Stranger yet, two of his teammates sprang to his side to run interference. Riegels put on full speed. The Georgia players slowed down to watch. Benny Lom, running just behind Riegels, suddenly realized what was happening. He shouted for him to stop. When he didn't, Benny put on a burst of speed and tackled his teammate on their own two-yard line. Riegels had run sixty-three yards. This comedy of errors cost the California Bears the game: on the next play, Georgia Tech scored a "safety" for two points. The final score was 8–7.

When he had processed the 4x5 glassplates, Sansone put them into three piles: "good action; fair action; no good." Chet Keppel, sports makeup man, went through the "n.g. pile" first. He yelled, "We have it, we have it, print this for eight columns." Thinking he was being "ribbed" because he saw nothing outstanding in the Riegels shot, Sansone threw the glassplate negative into an old wooden Hypo keg under the sink. Keppel picked up the barrel and ran into the city room shouting, "Get that crazy guy out of here!" Luckily the glass negative hadn't broken. Sansone went home.

It wasn't till the next morning, when Sam read the story in the paper, that he learned what had happened the day Roy Riegels ran the wrong way into football history. If Sam Sansone had not been in the wrong place at the right time, he would have missed the shot!

SAM SANSONE

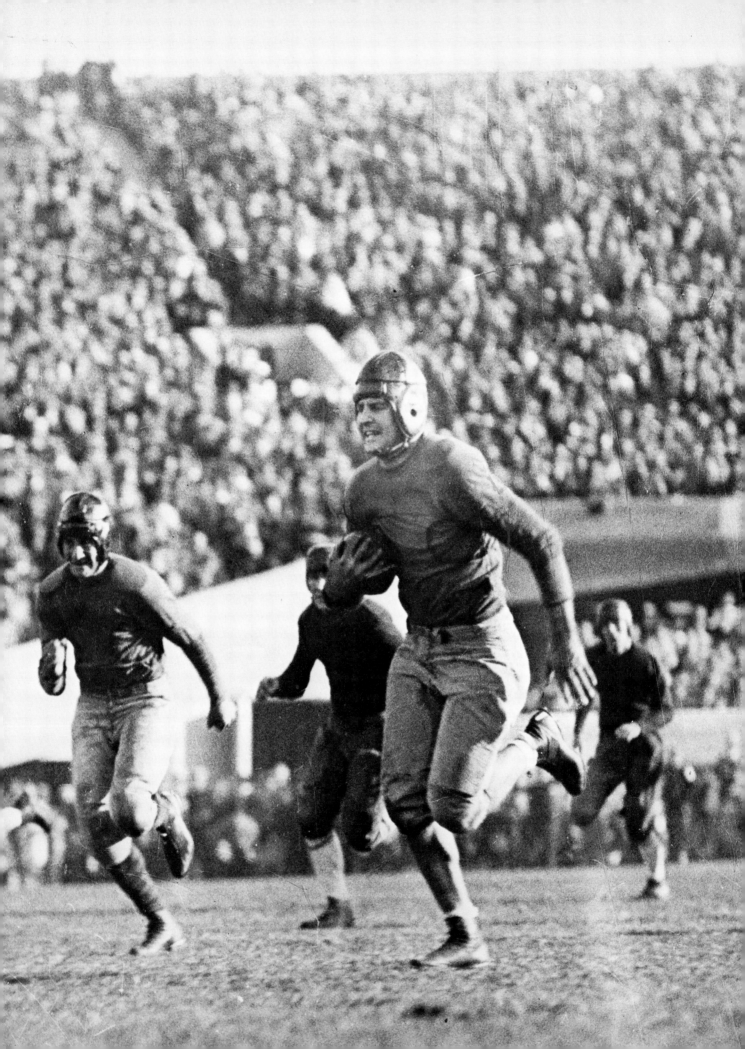

21. Candid Photo of President Hoover and Premier Laval

The short write-up seemed insignificant when it appeared in *Time* magazine dated Nov. 9, 1931. Yet it was a major "break-through" for news photography. It read, "President Hoover might never have allowed Dr. Erich 'Candid Camera' Salomon in the White House if Premier Laval of France had not politely insisted. Like Benito Mussolini (Italy), Ramsay McDonald (England), and Chancellor Bruning (Germany), Pierre Laval has become convinced that Dr. Salomon's spontaneous snapshots are historic human documents to be preserved for posterity and school-books." It recognized the historical importance of news photography. It opened the door of the White House to photographic news coverage.

Since 1928, Dr. Erich Salomon of Germany had earned an international reputation. His technique was different. He used a miniature camera, an Ermanox with an F 2. lens. He never used flash. His pictures were made with existing light indoors; therefore, few people knew they had been photographed. It was difficult, because photographic plates were slow in speed, and often he made exposures a full second or longer. He called himself a photo-journalist. When the *London Graphic* first published his unusual pictures in 1930, they coined the words "candid camera." The things this man did thirty years ago have become standard practice today.

He began his career in news photography at the age of forty-two. He had acquired a worldliness, a knowledge of languages, a charm and ease of manner. From the beginning he photographed the famous people of Berlin. When they saw that photos could be made without annoyance, or the disturbance of magnesium flashpowder, Salomon was granted entree to society and ambassadorial receptions. He photographed the Hague Conference of 1929. His output was both enormous and exclusive. His pictures appeared in newspapers and magazines in Europe and the United States. His intimate studies were in constant demand.

Visiting the U.S. in 1931, he accompanied French Premier Laval to Washington, D.C. Aboard a special train he asked Laval's help to obtain permission to photograph the President of the United States. M. Laval told his picture-historian friend, "First I must get acquainted with President Hoover, whom I do not yet know." On the final day of the Premier's visit, Dr. Salomon's wish was granted.

The President and the Premier posed stiffly side by side in the Lincoln Study of the White House. The photographer was dissatisfied with the pictures he was making. The polite but firm usher at his elbow whispered again and again to "make it snappy." At last, in the hope of capturing a more natural attitude, he asked the President in English, and the Premier in French, if they would for a moment talk together and forget the cameraman. They agreed. The Premier began to talk, and Dr. Salomon had the animated picture he was looking for. As he departed, he overheard M. Laval say, "I told you, Mr. President, how it would be. I know his ways."

Dr. Salomon is recognized as the father of candid photography. He died in 1944 in a concentration camp at Auschwitz, Germany. His historic photographic negatives of European and U.S. "greats" are now in the hands of his son, Peter Hunter of Amsterdam, Holland.

ERICH SALOMON

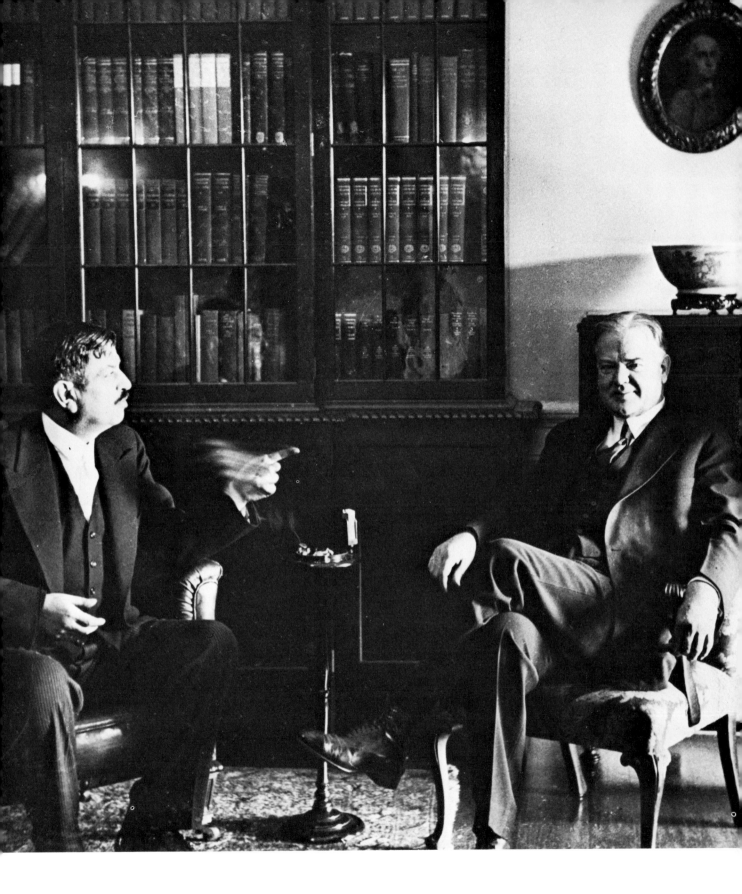

22. Bonus Army Marches on Washington

The country was in a depression, mentally as well as physically. For weeks the public read of the situation in Washington, D.C., where 10,000 veterans of World War I had gathered at Anacostia Flats. Here they threw up tarpapered shacks, greasy soup kitchens, and hand-dug latrines. Each and every man was determined to remain in the nation's capital until their demands on the government were met.

They had come to the city to force immediate payment of the $1000 bonus voted them by Congress. The government's plan, in order not to put an immediate drain on a badly strained United States Treasury, was to pay the bonus within a 20-year period. The American Legion had not endorsed the Bonus March. It expressed the feelings of most ex-soldiers. But this army of lean and jobless vets had marched from their homes to converge on Washington.

When Congress rejected their demands for immediate payment, many of the more respectable elements agreed to return home at government expense. More than 2,000 stayed on. Feelings were running high. It was July 28, 1932. Secretary of the Treasury Ogden Mills, fearing for President Hoover's life, instructed the Washington police to clear the Bonus Marchers from all government property.

The photographer stood talking to Superintendent of Police Glassford, near a corner lot on Pennsylvania Avenue. He had just returned from the airport, where he had shipped his first eviction photos back to his paper, the N.Y. *Daily News.* Suddenly a group of men appeared, led by a heavy-set fellow carrying an American flag. They were intent on repossessing the wrecked hovels. Glassford and his men rushed to head off the mob. Joe Costa, the news photographer, ran forward with them, camera in hand.

JOSEPH COSTA

One of the patrolmen tried to grab the flag from the hands of the leader. Stones flew. The air was filled with a barrage of bricks, lead pipes, and assorted pieces of plumbing. The hand-to-hand battle took but minutes. Costa kept shooting pictures until he found himself standing alone in the center of the battlefield. The police, seeing they were outnumbered, and with orders not to open fire, had already withdrawn, taking shelter behind the huts. Several police skulls had already been cracked. Now one flying brick hit Costa in the shoulder as he raced for cover.

Soon cooler heads prevailed, but the police had to recheck the wrecked buildings for marchers who had gone back in. As Superintendent Glassford entered one building, a bunch of sulking Bonus Marchers ganged up on a policeman. Other law enforcement officers fired, and in the scuffle two men were shot. When President Hoover learned of these things, he directed General Douglas MacArthur to restore order and drive the marchers out of Washington.

In sight of the Capitol the infantry threw tear-gas bombs; the cavalry and tanks pushed back the veterans. The shacks on Anacostia Flats were destroyed, and the marchers scattered without a single casualty. Costa's picture of the clash between the police and the Bonus Army Marchers illustrates the adjustment pangs of the Depression.

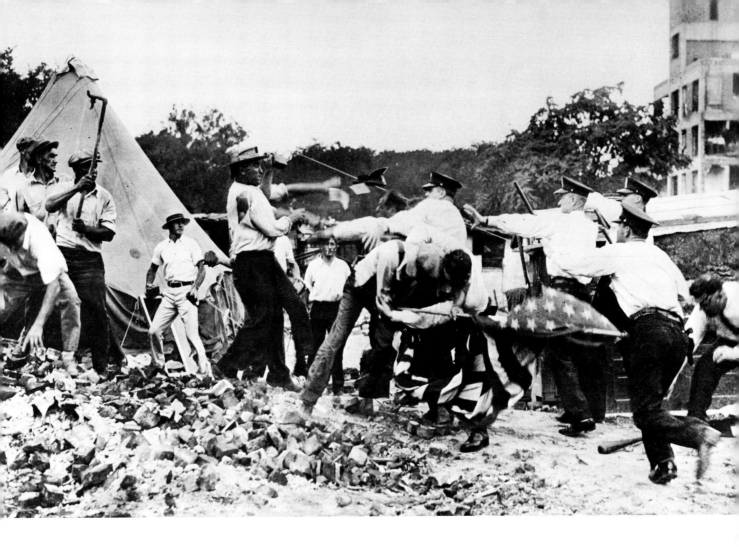

23. J. P. Morgan and the Midget

John Pierpont Morgan, Jr., had an intense dislike of publicity. An immensely wealthy man, he had become world famous as an international banker and handler of huge foreign loans. In 1933 he was called to Washington to testify before the United States Senate Committee on Banking and Currency as to the causes of the Depression. Little did he know that he was to be the focal point of a publicity stunt that day. The incident received widespread attention through the medium of press photography.

The hearing took place in the Caucus Room in the Senate Office Building, a very large and impressive room with an enormous "T"-shaped table and many overstuffed leather chairs. Photographers were permitted to make pictures only before and after the official proceedings.

On June 1, 1933, a group of cameramen returned early during noon recess. Among them were Bobbie Clark, I.N.P.; Al Nesensohn and Johnny Thompson, Acme; and Willie Hoff, N.Y. *Daily News*. Morgan and his staff of lawyers were already seated. The newsmen watched for something to happen that would make photographic copy. It did.

A man came to the door and asked if he and his companions might come in. He was from Ringling Brothers Circus, and was escorting two midgets through the building. The circus folks were in the habit of taking their people around to see senators, to get whatever publicity they could for the circus. Al Nesensohn nudged Bobbie Clark, "Keep your eyes open."

WILLIE HOFF

Clark later described, "The first person they introduced the midgets to was Thomas Lamount, Morgan's senior partner. Then the little man and woman passed down before the line of Morgan's lawyers, real high-priced guys, until they came to Mr. J. P. Morgan. I don't know if it was the guy from the circus [Dexter Fellows], or one of the lawyers, but somebody lifted the little woman [Lya Graf, 32] and sat her on Morgan's lap. He didn't seem too unhappy about it. It all happened in a fraction of a second. You had to shoot without focussing. You got one shot, and that's all there was to it." By then the senators had gathered, and the chairman rapped his gavel to begin the afternoon proceedings. The session was in order; news photography was over.

Western Union messengers picked up the exposed film. Afterwards Clark said, "The shot made one edition of the *Washington Times*, page one. Our Bureau Manager, Harry Van Tine, called New York I.N.P., and told them what we had. Walter Howie, who headed up I.N.P. at that time, got into the act and said not to use the picture until they 'checked.' Our picture was 'killed.' The other news photo services, however, did use it."

The publication of the pictures of multi-millionaire J. P. Morgan and the midget momentarily upset the dignity of the U.S. Senate hearings. The public smiled over the dilemma of the man who was known to detest publicity.

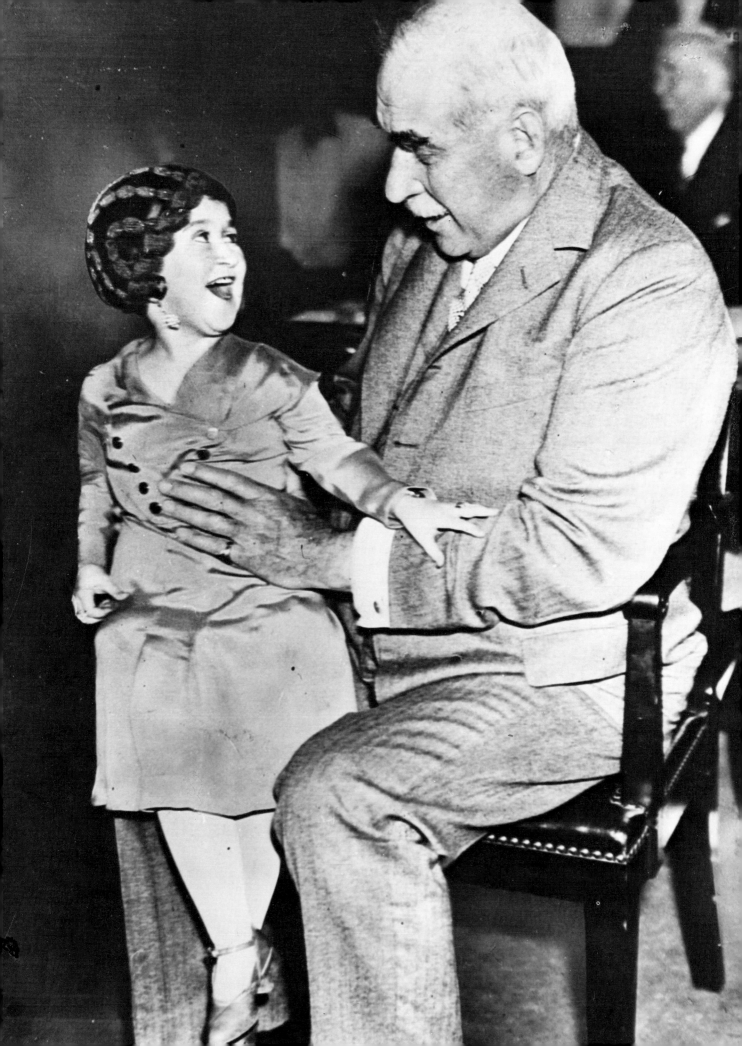

24. The Cuban Revolution of 1933

The dateline of the story was August 6, 1933. The place, Havana, Cuba. Strikes had tied up industry and commerce. The situation had assumed the character of a passive revolution. President Machado called a special session of the Cuban Congress to place the republic under military rule. In New York City, International News Photos manager Walter Howie had a hunch something was going to break. Within twenty-four hours he had INP photographer Sammy Schulman in Havana.

For five days the rival factions smouldered. On Saturday morning, August 12, Schulman and newsreelman Jimmy Pergola were walking along the Prado when they heard a burst of gunfire. They ran toward the action. They were about to record the "spark" that fired the Cuban Revolution of 1933—the overthrow of the Machado government. The beginning of the Batista regime.

They found a dignified-looking old fellow lying on the pavement, mortally wounded. Sammy recognized him as Colonel Antonio Jiminez, head of the Cuban Porra, or secret police. He was President Machado's strong arm, the most hated man on the island because of his brutality to those who criticized the President. "I cleared a little space in the crowd and made several pictures while he gasped his remaining breaths, at the same time asking what had happened.

"Jiminez had gone out for a stroll and had been followed by a number of youthful hecklers. To get rid of them, he whipped out his revolver and fired a few shots into the air. The kids scattered. As he fired again, a truckload of soldiers swung into the street. The truck stopped. A ragged soldier jumped out, backed Jiminez to a wall and shot him through the stomach. It blew him half apart. People came running and, when they recognized the dying man as the much-hated Jiminez, went wild with joy. Someone called for a cheer for the soldier, who stood close by watching me work. A couple of wild-looking men picked up the hero and the clamorous mob went down the street to the Prado. I followed. The crowd pulled a statue off its pedestal and boosted the soldier in its place. He loved it, and struck statuelike poses while I banged away at him. Then someone yelled, 'To the palace!' The soldiers jumped into their truck and led the mob. I ran along with them." The passive revolution, just as INP's Walter Howie had anticipated, had become an active one.

"After making a flock of other shots with my Speed Graphic, I got back to the Havana Post, where INS had its office. Bill Hutchinson, bureau manager, had made arrangements with Miami to fly a special plane over to pick up my films. Hutch had a tip a mob was headed for the Post Building to burn it. I quickly went to the seaplane base, waited for the plane to arrive, gave the pilot the exposed film, and told him to get out as fast as he could."

The photographic record of the Cuban Revolution of 1933 made by INP's Sammy Schulman was one of the great visual reporting jobs in the newspaper business.

SAM SCHULMAN

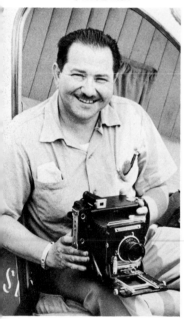

International News Photos

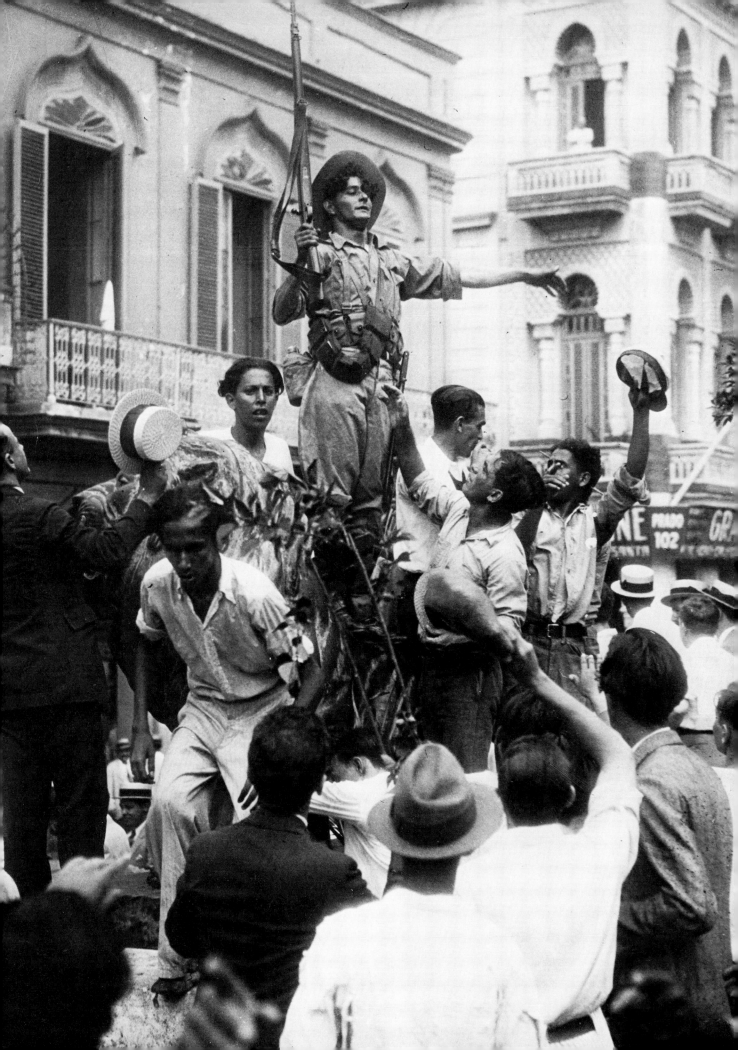

25. The Death of King Alexander

The date for the arrival in France of Yugoslavia's King Alexander was known well in advance. Yet like many things in the business of news photography, the decision to cover the story was made at the last minute. The Paris office of Fox-Movietone News sent newsreelmen Georges and Raymond Méjat on the overnight train to Marseilles. They arrived the morning of Oct. 9, 1934.

Georges had just enough time to set up the sound camera along the route King Alexander and French Foreign Minister Barthou would take. He checked out his hand movie camera and placed it nearby. Meanwhile Raymond covered the debarkation, and the first shots along the shore. He then went to the top floor of a near by building to make overall views. These "establishing shots" would make "cut-ins" for Georges' footage. Georges was shooting "sound" of the band playing the national anthem and the presentation of the guard of honor.

For some unknown reason the procession was delayed. Georges grabbed the hand camera and ran alongside the car carrying the King and Minister Barthou. He made several closeups. As the cortege began to move, Georges ran ahead. He was changing lens settings when the assassin broke through the crowd and jumped on the running board of the King's car. As the first pistol shot was heard, Georges had his camera in operation.

GEORGES MÉJAT

Lieutenant Colonel Piollet wheeled his horse about and struck the assassin Vlada Georggieff with a full-arm blow of his sabre. Dignitaries, and steel-helmeted soldiers of the Garde Mobile rushed to the auto as it came to a halt. Georggieff was flattened against the side of the car, bullets spewing from his gun, blood streaming from the great sabre gash visible from ear to chin. In the confusion Georges saw two women stagger from the impact of bullets. He swung his camera and filmed them as they fell to the ground, dead. He then rushed up to the King's car as the police dragged off the assassin. Slumped in his seat, King Alexander, now in a coma, lay dying. Barthou, also wounded, was carried off in a taxi to die later from loss of blood. Georges continued filming—"sweating out" if there was enough film left in the camera, and if the small battery which drove the mechanism would hold out.

The King, with his uniform torn open, blood drooling from his lips, was carried off. A gendarme picked up the sub-machine Mauser pistol Georggieff had used. As the policeman walked away Georges made a quick dramatic closeup of the man's hand holding the gun. It finished the story, and demonstrated experienced news sense in recognizing an important detail of story content. A matter of minutes had gone by since the first pistol shot had been fired. A matter of minutes were recorded by newsreelmen to be relived in the eternity of history.

After a shaky time with the officials over the exposed films, Georges boarded the train to Paris. Soon the long hours of waiting were over, processing completed, and in the projection room of Actualités Fox-Movietone the men saw the first showing of one of the all-time great and exclusive newsreel stories—the "death of a King."

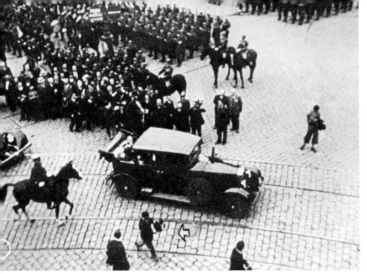

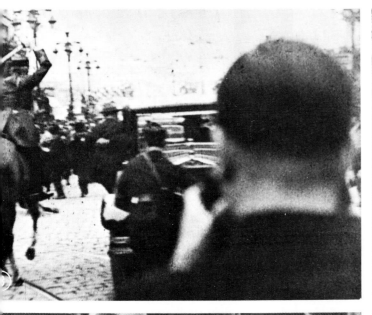 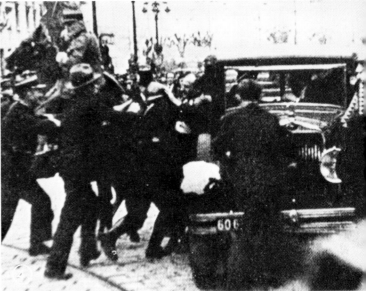

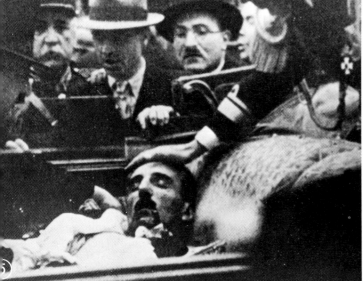

61

26. The Dionne Quintuplets

In the small farmhouse at Callander, Ontario, there was considerable commotion. The doctor worked feverishly bringing into the world five tiny babies whose total weight came to only thirteen pounds, six ounces. Dr. Allan Dafoe knew he'd seen a miracle; he also knew it would take another miracle to keep the little girls alive. With a borrowed incubator, and with hours of tender care, he achieved the second miracle. He saved the lives of the first quintuplets to survive to maturity.

The news spread to town, and then around the world. On May 28, 1934, quintuplets were born to Oliva and Elzire Dionne. The people of five continents anxiously awaited the details, and to see pictures.

Fred Davis, photographer for the *Toronto Star*, was sent to the Dionne home in Callander. He arrived there four days after the birth of Cécile, Yvonne, Annette, Émilie, and Marie. He was to stay on the story "exclusively" for almost six years. His captivating photographs charmed people everywhere. Among the many pictures he made, one called "Lapful," showing Dr. Dafoe holding the five children in his lap, received special recognition, winning the top award in the first *Editor & Publisher* photo contest.

Great numbers of gifts poured in from all corners of the world. The babies were famous. It was only natural that the wide publicity they received brought about endless offers from entrepreneurs, advertising firms, individuals, and the press. The Province of Ontario very quickly put through legislature making the children wards of the British King.

The *Toronto Star* obtained rights to make pictures of the Quintuplets. In September, 1934, twenty-five photos made by Fred Davis were offered by the *Star* to the American press via telegram. The picture rights to the photos were to be sold to the highest bidder twenty-four hours after the receipt of the telegram.

FRED DAVIS

In Cleveland, Ohio, General Manager Herb Walker of Newspaper Enterprise Association (NEA) quickly submitted a bid. "They didn't tell anyone what they had, just said they were good pictures. You had to buy them sight unseen. We made the highest bid and got the photos at that time. They carried through the rest of the year. Later by special arrangement with the Quintuplets' guardians we made a contract that covered all the still picture rights for both news and advertising."

Fred Davis continued the job he had started: recording the "human interest" activities of the "Quins," working directly for the NEA. The photos of the children at holidays, their first snow, their birthday celebrations, in the garden, at mealtime, all seasons of the year. The public was hungry for pictures of the five little girls.

The children lived in a special nursery until they were ten years old. They moved then to a 20-room mansion to live again with their parents and sisters and brothers. It was a far cry from the small farmhouse. The Quintuplets amassed a fortune from the endorsement of advertisers' products and from appearances in movies. A million-dollar reserve fund was set aside to be given to them when they came of age. In 1944, a parliamentary act returned them to the custody of their father.

It had been an important assignment for Fred Davis. A personal sidelight: Fred married the woman who was the Quintuplets' first nurse.

Newspaper Enterprise Association

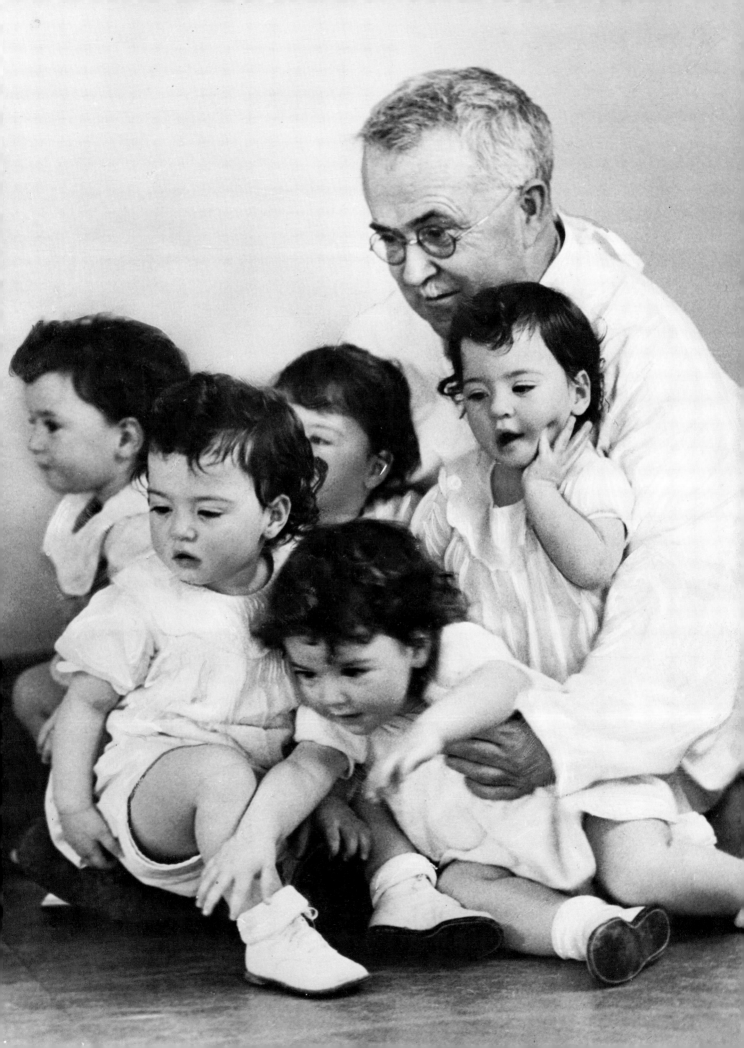

27. The Trial of Bruno Richard Hauptmann

The photographer, squeezed in tightly between reporters Damon Runyon and James Kilgallen, was about to record the climax of the most publicized kidnaping case of this generation. It was a moment carefully planned for by the photo chiefs of newspapers and newsphoto syndicates working out of the bakery shop near the old courthouse in Flemington, N.J. They had previously been advised by Judge Thomas W. Trenchard that no pictures were to be made while court was in session. Yet they had a press photographer's prime responsibility to get the "verdict photo."

The Lindbergh kidnaping case had been photographed as no other. From October 19, 1934, when Hauptmann arrived in Flemington, to the day of the verdict four months later, the town became a three-ring circus. Flemington shopkeepers laid in, and sold, extra stores of supplies. Housewives dusted out spare rooms, and rented them to newspaper people at exorbitant rates.

More than 100 photo personnel set up central headquarters in the bakery shop. The newsmen decided to pool their interests. From their group they selected two men to try for the picture. Sam Shere, INP, ran into trouble getting into location; Richard "Dick" Sarno, N.Y. *Mirror*, the man between the two reporters, was to make the historic photo. It was February 13, 1935, and Bruno Richard Hauptmann was about to be sentenced for the death of a little boy.

When advised he'd been assigned to represent the "pool," Sarno practised with a new 35mm Contax camera. He duplicated the lighting conditions he knew existed in the courtroom. His estimated exposure was one second.

DICK SARNO

Sarno later related, "I thought I might be stopped by state troopers. They'd been alerted to watch for cameras. I passed through with Runyon and Kilgallen, and went on the courtroom balcony where the reporters worked. I had wrapped my muffler around my camera to conceal it, and to keep shutter noise to a minimum. As Hauptmann stood up and faced the jury you could hear a pin drop. I tilted the camera, which I had braced on the balcony rail. The judge was directly in front and below me. If he looked up, I was sure he could see me."

The foreman of the jury stood and stated the verdict. Sarno recorded the instant. Hauptmann's attorney, Edward Reilly, quietly asked for a poll of the jury. Then Judge Trenchard delivered the sentence. "Bruno Richard Hauptmann, you have been convicted of murder in the first degree. The sentence is that you suffer death at a time and place and in a manner provided by the law."

The dignity of the courtroom changed to bedlam. In the confusion, Sarno slipped out with reporters racing for the nearest telephone. He ran to the old bakery shop where other photographers were waiting to learn what had happened. The film was developed and fixed. Shaking hands held up the 35mm strip with its single picture. The negative was good. Sarno had gotten the shot. Prints were made and given to all "pool" papers. It was a major newsphoto "beat." The N.Y. *Sun*, a conservative newspaper, ran Sarno's shot eight columns wide. One of the most dramatic moments in criminal history had been recorded for posterity.

SPORTING FINAL
★★★★★
RACING CHARTS
NRA

SPORTING FINAL
★★★★★
7th EDITION

The Sun

Copyright, 1935, by The Sun Printing and Publishing Association.

NEW YORK, THURSDAY, FEBRUARY 14, 1935.

VOL. CII—NO. 139—DAILY.

PRICE THREE CENTS.

HAUPTMANN SOBS AND DENIES HIS GUILT

BRUNO RICHARD HAUPTMANN LISTENING IN COURT TO THE VERDICT: 'GUILTY OF MURDER IN THE FIRST DEGREE'

The arrow (at left) pointing to the defendant, Bruno R. Hauptmann, who stands between a deputy sheriff and a State trooper. The jury is standing at the right. The judge is seated on the bench. The chief clerk asks the jury: "Have you reached a verdict?" The reply is "We have." In answer to another question by the clerk the foreman of the jury says, "Bruno Richard Hauptmann guilty of murder in the first degree." The clerk (holding book) is about to poll each juror. Eight men and four women then confirm the finding of the jury, each repeating the verdict. Mrs. Verna Snyder, one of the jurors, is crying hard. Mrs. Bruno Richard Hauptmann has tried not to cry out and break down and succeeds. A few moments later Justice Trenchard imposed sentence.

65

28. The Burning of the "Morro Castle"

The Ward Line's luxury cruise ship, the *Morro Castle*, was battling high winds and heavy seas near the end of her Havana–New York run. She was eight miles off the New Jersey coast. On the bridge, Chief Officer William Warms was in charge. He'd taken command a few hours earlier, when the ship's Captain Robert Wilmott had suddenly and mysteriously died. At 2:50 A.M. a fire was reported in the A deck reading room. In the confusion, the crew was ineffectively combating the blaze. High winds quickly fanned the fire into a holocaust. By the time the SOS was sent the ship was beyond hope. Scores of passengers burned to death in their cabins, others died trying to reach lifeboats, the greatest number were drowned. More than 134 people lost their lives that Saturday morning, September 8, 1934.

Despite attempts to tow her to a safer location, the *Morro Castle* continued to drift toward shore. By 7:30 P.M., she came to rest on the beach at the foot of Sixth Avenue in the summer resort town of Asbury Park, N.J.

Carl Nesensohn, N.Y. *Times* Wide World photographer, arrived with other news cameramen in late afternoon. They made photos of the victims and the burning hulk. Early the next morning, Carl Nesensohn decided to go aboard the smouldering *Morro Castle*.

In a hired boat he reached the side of the ship. Hand over hand he started up a dangling rope. Part way, he heard a command: "Get down or be shot down!" A Coast Guard patrol boat was "standing by." Nesensohn promptly dropped back into his rented boat and made for shore. He stormed into Coast Guard headquarters, shouting about the government threatening to shoot a newspaperman; how would it look in the newspaper? The official gave Carl permission to use a breeches buoy which had just been anchored to the doomed vessel.

CARL NESENSOHN

Carl, camera in hand, pockets stuffed with holders, swung out over the water in the dizzy ride from the pier to the stern of the smouldering ship. He jumped out of the harness onto the deck. The steel deck plates were hot. Flames, noxious gases, and smoke escaped from jagged holes. Underfoot, he felt minor explosions in the depths of the vessel. He kept to the windward side for safety. For two and a half hours he worked his way around the charred dead, the narrow passageways with their hot, searing walls.

He returned to shore, his clothing torn, his shoes almost burned through, his face covered with soot. His were the first photos of the burned-out interior of the *Morro Castle*.

A little later, N.Y. *Daily News* photographer Larry Froeber attempted the same thing. When the shore crew did not see him moving about, another *News* photographer, Stanley Brown, went aboard and found Froeber lying on the deck overcome by poisonous fumes. Both men got back safely.

These men risked their lives to bring back factual records. Photographic coverage of the disaster was excellent. Eventually, what remained of the once proud *Morro Castle* was towed away and cut up for junk.

Associated Press

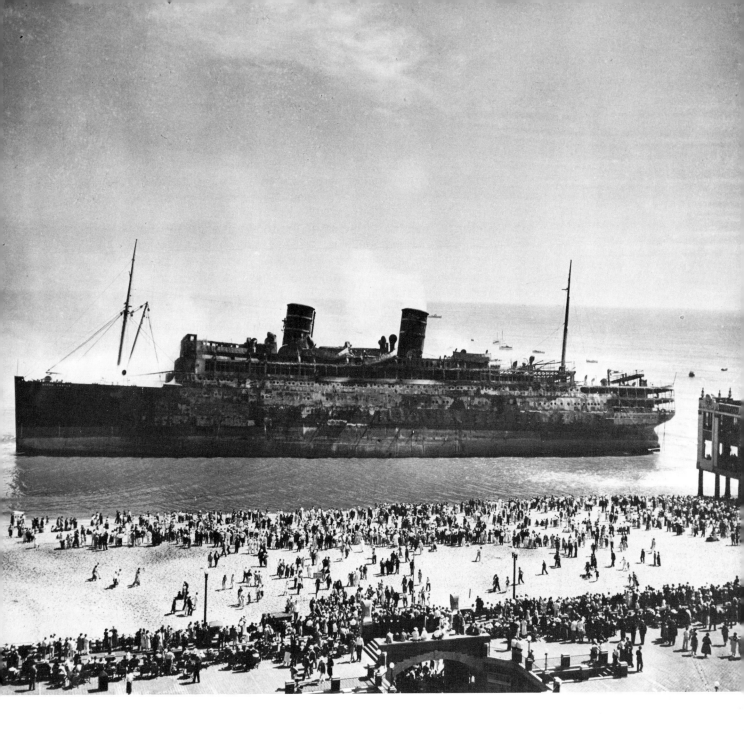

29. Oklahoma Dust Storm

During the early 1930's a great section of the southwest became known as the Dust Bowl. Due to poor farming methods, an area of some fifty million acres lay at the mercy of drought and wind. Topsoil disappeared in great curtains of dust to be carried as far as the Atlantic Coast and out into the Gulf of Mexico. Farmhouses and barns were nearly buried under the great drifts of sand. Livestock perished for want of food and water. Many families migrated to other regions where they could farm again.

In Washington, D.C., the Department of Agriculture had set up, as one of its independent agencies, the Rural Resettlement Administration (later known as the Farm Security Administration). Heading up the Historical Division as "Specialist in Visual Information" was Columbia University's ex-instructor of economics Roy Stryker. Stryker hired a staff of photographers, among them Arthur Rothstein. The cameramen were assigned to document the various programs sponsored by the Rural Resettlement Administration. After a briefing on what information was needed, the photographers were given complete freedom to operate on a creative basis.

In the spring of 1936, Arthur Rothstein was sent to document the dust bowl tragedy. He covered more than a thousand miles of desolation, working under the most difficult conditions. Dust was everywhere, it covered his clothes, it blew into his eyes and his mouth; it eventually destroyed his Super Ikonta B camera.

ARTHUR ROTHSTEIN

Cimarron County, in the Oklahoma Panhandle, was the center of the worst wind-eroded area. The County Agent took Rothstein on a tour, pointing out the few farms that were still occupied. "The most interesting and dramatic thing to me," Rothstein said, "was to show not abandoned farms but the relation of the people to their environment: what effect it had on them, their reaction to it. I took a great many photographs. The picture of the man and his two small sons seemed to sum it all up."

As he did on most location assignments, Rothstein processed his rolls of 120 film in his hotel room, returning the negatives to the Rural Resettlement Administration in Washington. Here prints were made for the organization's records, and also placed in files for public use.

The Washington newspapers and the Associated Press took advantage of the remarkable file of pictures made available by Roy Stryker and the Rural Resettlement Administration. Among the pictures selected by AP's Max Hill to service "member newspapers" illustrating the severity of Dust Bowl conditions, was the one made by Arthur Rothstein.

The documentary photograph, used as a news picture, and for forty-five years as a feature photo in thousands of newspapers and magazines, eventually found its way into the Metropolitan Museum of Art as an example of "Photography in the Fine Arts."

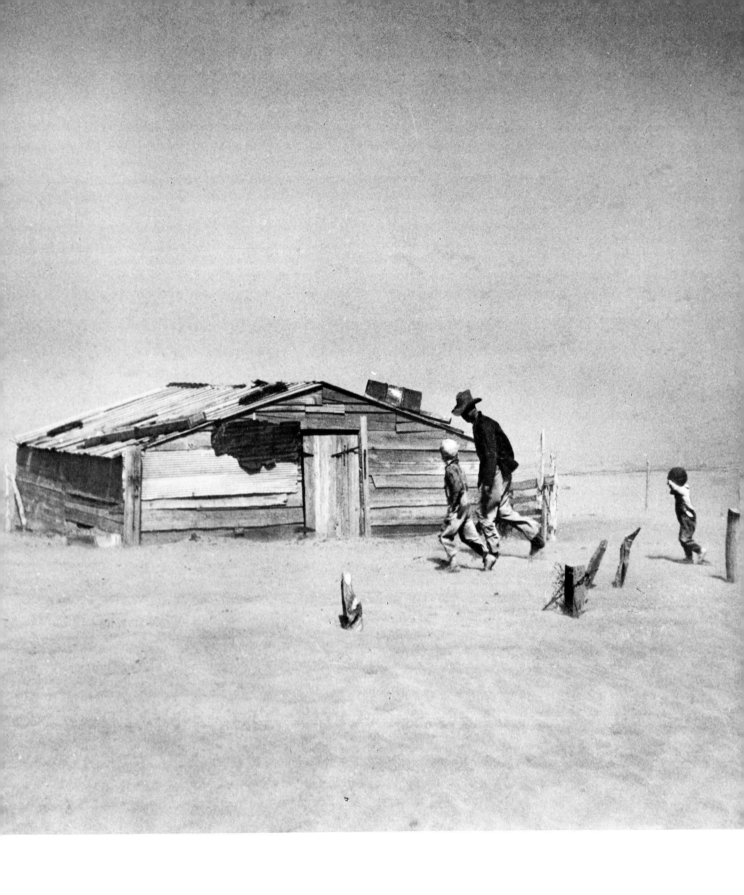

30. Death in the Making

The two struggling young photographers worked together closely in Paris. The woman, Gerda Taro, was the more practical of the two. It was she who arranged to sell the photographs they made to newspapers and news magazines. Her companion, Hungarian-born Robert Capa was, at twenty-three, a fatalist—gay, witty, lighthearted on the surface, but underneath intensely serious in his search for truth. The year was 1936. In nearby Spain, the seeds of unrest ruptured into violent, bloody civil war. The photographers left Paris to record the struggle of the Spanish Republic to hold off the forces of General Francisco Franco, who was supported by Hitler and Mussolini.

Robert Capa's pictures of the Spanish Civil War were honest, intimate reflections of the emotions of war. He documented the little joys and the great sadnesses; the despair of bereaved families, the desolation of children, the humiliation of surrender, the small pleasures people find in times of conflict, the joys of liberation. He stayed close to the fighting soldier. On one occasion he made what is considered to be one of the greatest combat photos of all times.

Capa had been with a group of Loyalist fighters outside Cordoba for several days. An attack was under way; bedraggled Loyalists rushed over open ground toward the Insurgent troops. The charge was repulsed and Capa found himself, with one of the Loyalist soldiers, in a trench isolated from the main force. There was nothing to do but wait. The impatient soldier was intent on returning to his comrades. When he thought it was safe, he clambered out of the trench. There was a rattle of machine-gun fire. A bullet thudded into the head of the Spaniard. At almost the same instant, Capa instinctively raised his Leica and made the picture. The dead man slid silently back into the trench. Hours later, when the protecting cover of night blanketed the battlefield, Bob Capa crept across the ground to Loyalist lines and safety. The photograph became a symbol of man and war.

Gerda Taro was in Spain with Capa during the months he covered the war. In her blue-denim coveralls the courageous twenty-five-year-old camerawoman was a familiar sight in the government trenches. Spanish Loyalist troops affectionately nicknamed her "La Pequeña Rubia," the little redhead. During one of her trips to the front lines she was crushed to death by a tank when it careened off the road into her as she stood on the running board of a correspondent's car. The untimely death of the girl who laughed at bullets and shells was a deep blow to Robert Capa.

In the United States, Capa's pictures of the war found their way into the N.Y. *Times* and *Life*. In Madrid, on December 19, 1937. Robert Capa wrote the dedication of a book containing his and Gerda Taro's war photographs. "To Gerda Taro, who spent one year at the Spanish Front, and who stayed on." The book was entitled, *Death in the Making*.

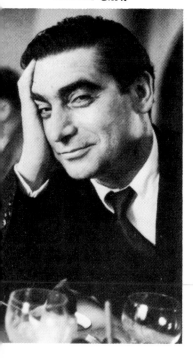

ROBERT CAPA

Magnum Photos

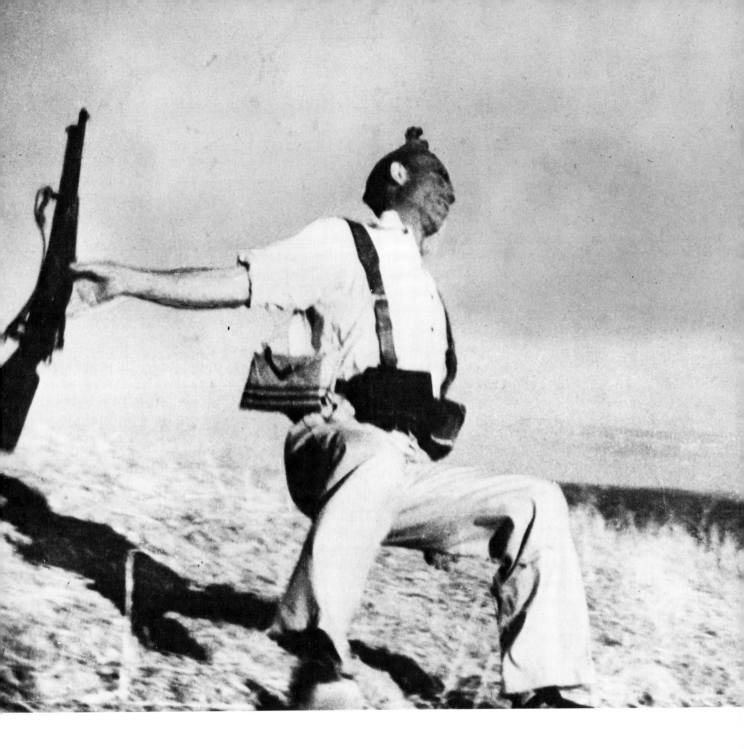

31. The "Hindenburg" Disaster

The assignment was routine. The boys were there to cover it—about twenty-two still and newsreel cameramen. The date, May 6, 1937. The place, Lakehurst, N.J. The story, the super-dirigible *Hindenburg* was arriving with commercial passengers on its thirty-seventh crossing of the Atlantic Ocean. The group of news photographers waited impatiently. Daylight was going fast. An electrical storm was approaching. Some of the men debated going home.

The *Hindenburg* finally appeared around 7:20 P.M. From the start, the ground crew had trouble trying to moor her. The ship was enormous, 803 feet in length, and 137 feet in diameter.

Bill Deekes, Pathe Newsreel, had trouble, too. He couldn't get the electric motor on his newsreel camera to work. He hastily substituted the handcrank. He framed the dirigible and started a slow pan shot. The story literally exploded in his lens. As he cranked, viewing the scene through the camera finder, he saw a finger of flame appear. He kept cranking. The *Hindenburg* exploded and began to fall to earth. Passengers and crew jumped from the gondola to save their lives.

Murray Becker's Associated Press training sent him into action with calm methodical precision. At the very instant of the explosion, he made the shot with his 4x5 Speed Graphic. He then slipped the slide in, removed the holder, turned it over, pushed it back into the camera, pulled out the slide, cocked the shutter, and made his next shot, all within five seconds. Changing holders, he made a third as the ship settled to the ground.

Sam Shere, International News Photos; Charles Hoff, N.Y. *Daily News*; Gus Pasquarella, *Philadelphia Bulletin*; and Bill Springfield, Acme-NEA—proved experienced news photographers react alike. Within the forty-seven seconds of destruction, each made just one shot—the peak of the explosion. All four are identical—the dirigible in the air, mid-section to stern a mass of flames.

Pat O'Malley, press representative of American Airlines, became the heroine of the news photographers that night. She had come to Lakehurst to transport *Hindenburg* passengers to Newark, N.J., and elsewhere. In the confusion of the disaster, realizing that the photographers could not leave the scene, she went from cameraman to cameraman, collecting film holders and information. Via the AA plane, she flew to Newark. She distributed the various precious films to waiting motorcycle messengers who had been alerted by phone from Lakehurst. They in turn rushed the exposed films to home offices in different cities.

Of the ninety-seven people aboard the German Zeppelin Transport Company's *Hindenburg*, thirty-six perished including the commander, Capt. Ernst Lehmann. The story appeared in newspapers and newsreels everywhere. Full color shots, the originals on 35mm Kodachrome, ran in the May 23, 1937, N.Y. *Sunday Mirror*—the only color photos of the disaster. They were made by the *Mirror's* Gerry Sheedy. Much praise and numerous awards were given the many cameramen. All had the satisfaction of knowing they had come through with pictures made under the most difficult and dangerous conditions. The news photographers had dramatically recorded the disaster which marked the end of commercial use of lighter-than-air craft.

MURRAY BECKER

Associated Press

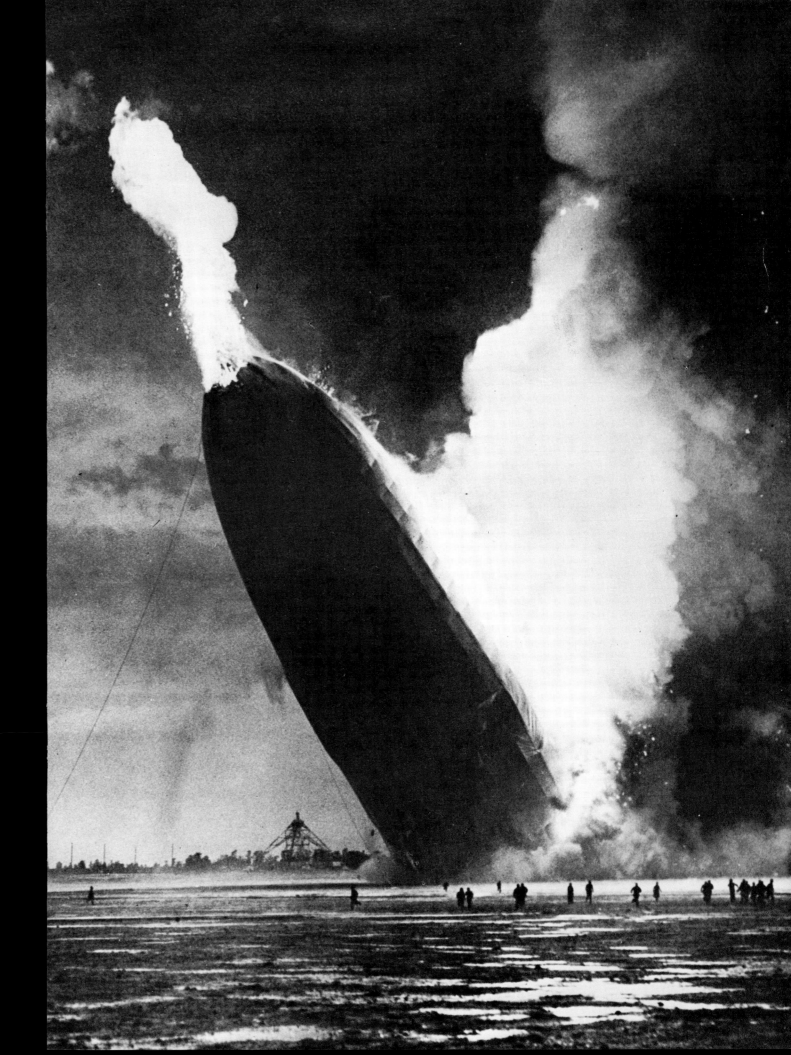

32. The Baby in the Shanghai Railroad Station

It was August 28, 1937. Retreating Chinese Nationalist troops had left behind them a blockade across the Whampoo River in Shanghai. At two P.M. that day, the Japanese Navy was scheduled to blow it up.

On the roof of the Butterfield Swires Building, which faced the Whampoo, were many correspondents and cameramen. They waited to record the bombing. By three o'clock the Japanese had not shown up. Word came through that the bombing had been postponed. The newsmen left. All but H.S. "Newsreel" Wong of Hearst Metrotone News; he decided to wait a little longer.

About four P.M. he heard the sound of planes. Three Japanese bombers came in low. They circled the temporary Japanese airfield and passed over Wong again. Seconds later, he felt the concussion of bombs exploding. Black smoke arose in the direction of the Chinese Arsenal, two miles away.

Wong grabbed his 35mm Eyemo camera and film. He raced his car toward the arsenal. As he approached it, he realized that the railroad station had been hit.

"It was a horrible sight. People were still trying to get up. Dead and injured lay strewn across the tracks and platform. Limbs lay all over the place. Only my work helped me forget what I was seeing. I stopped to reload my camera. I noticed that my shoes were soaked with blood.

H. S. "Newsreel" Wong

"I walked across the railway track, and made many long scenes with the burning overhead bridge in the background. Then I saw a man pick up a baby from the track, and carry him to the platform. He went back to get another badly injured child. The mother lay dead on the tracks. As I filmed this tragedy, I heard the sound of planes returning. Quickly, I shot my remaining few feet of film on the baby. I ran toward the child, intending to carry him to safety, but the father returned. The bombers passed overhead. No bombs were dropped.

"The next morning's papers said there had been more than 1800 people, mostly women and children, on the railway platform, waiting to be evacuated to the inland. The Japanese airmen had mistaken them for a troop movement." Fewer than 300 survived.

The film was sent by U.S. Navy ship from Shanghai to Manila, then to New York by Pan American Airlines. Two weeks later, the crying baby, sitting in the bombed South railway station in Shanghai, was seen in the Hearst newsreels and newspapers.

It was a story with international repercussions. The U.S. protested the Japanese bombing open cities, killing defenseless men, women, and children. Wong's life was threatened by the Japanese. He said, "To their embarrassment, the Japanese blamed me that the picture was a fake. They put a price on my head to prove they were right." He was under the protection of the British Authorities, and shortly after fled with his family to Hong Kong.

The October 14, 1937, issue of *Life* magazine estimated that 136,000,000 people had seen Wong's "Chinese Baby."

74

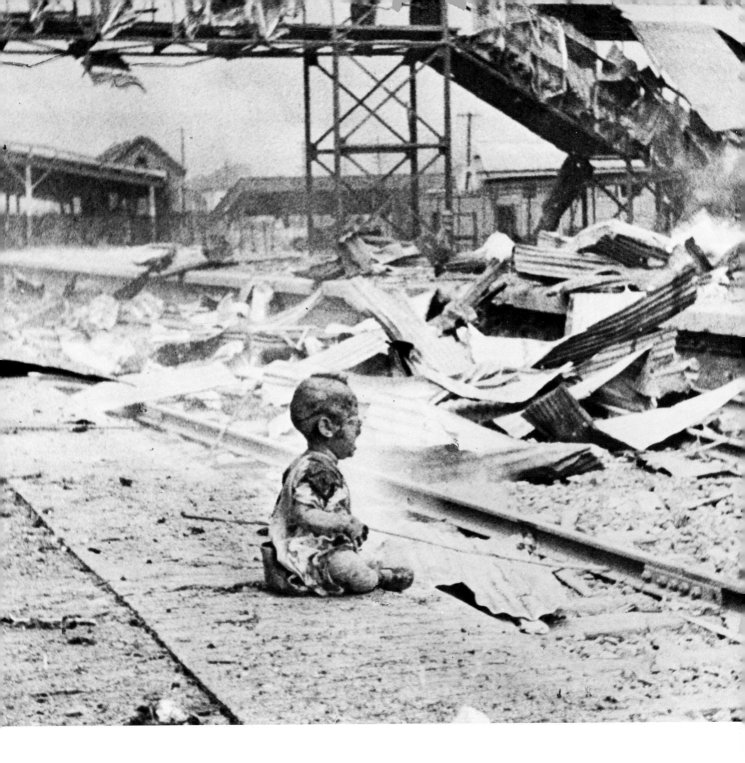

33. The Runaway Balloons

No matter what he did, the newsreel veteran could jump only twenty-five feet into the air. It wasn't enough. The feature assignment called for "house-hopping with weather balloons." The light was getting bad, the men were tired, bystanders were gathering, and the parachute harness had chafed the man into great desperation.

"The devil with it," said Al Mingalone, Paramount News. "This time let's put on a load for a decent jump and get it over with."

The man who had thought up the assignment, newsreelman Phil Coolidge, filled five additional balloons with hydrogen and attached them to Mingalone's harness.

Al jumped. They played out the mooring line. Mingalone kept rising rapidly. He shot footage with his Bell Howell 35mm Eyemo camera. It took only seconds for the rope, attached to a car bumper, to pull taut. It snapped. The feature became a spot news story. Mingalone, suspended from thirty-two weather balloons, was free of ground contact. He kept rising. He was being blown toward the Atlantic Ocean.

Below, on the golf course of Old Orchard Beach, Maine, the men knew the danger. They had to bring Al Mingalone down, and do it quickly. A bystander, Father James J. Mullen of St. Margaret's Church, joined Phil Coolidge and Jake, his father. From the gear on the ground he picked up a high-powered 22-calibre rifle, brought along for just such an emergency. The three jumped into Coolidge's car and chased after the disappearing balloonist. Mingalone kept rising, and then was lost from view in low-level rain clouds. The wind shifted, blowing him inland.

"I'd entered the lower bank of a quick rising fog, and couldn't see a thing. I tried to pull myself up the ten feet to the balloon lines. Part way, cramps grabbed me and I stopped. A sudden squall struck. I was jerked backward and dropped to the end of my harness. My camera fell free. Having lost twelve pounds of ballast I shot skyward again. My clothes were wet. The air was cold and raw. I must have been about 700 feet off the ground. After nearly an hour had gone by, I saw the car. I heard a ping. Then another. There was a hissing sound. I began to descend."

The men in the car had raced from Biddeford, along the Boston road, to Five Point Junction, before learning they were heading in the right direction. About five miles down Alfred Road, they spotted Mingalone. They stopped the car and Father Mullen got out and shot twice at the balloons. His bullets pierced three of them, and Al, balloons and all, came down on a farm in North Kennebunkport.

He had drifted thirteen miles from where the jump originated. His fallen camera, covered with mud, was found undamaged in a potato field. It was September 28, 1937. The film Al Mingalone made as the accident took place was awarded "Best Domestic Newsreel Scene of the Year" by the National Headliners Club.

AL MINGALONE

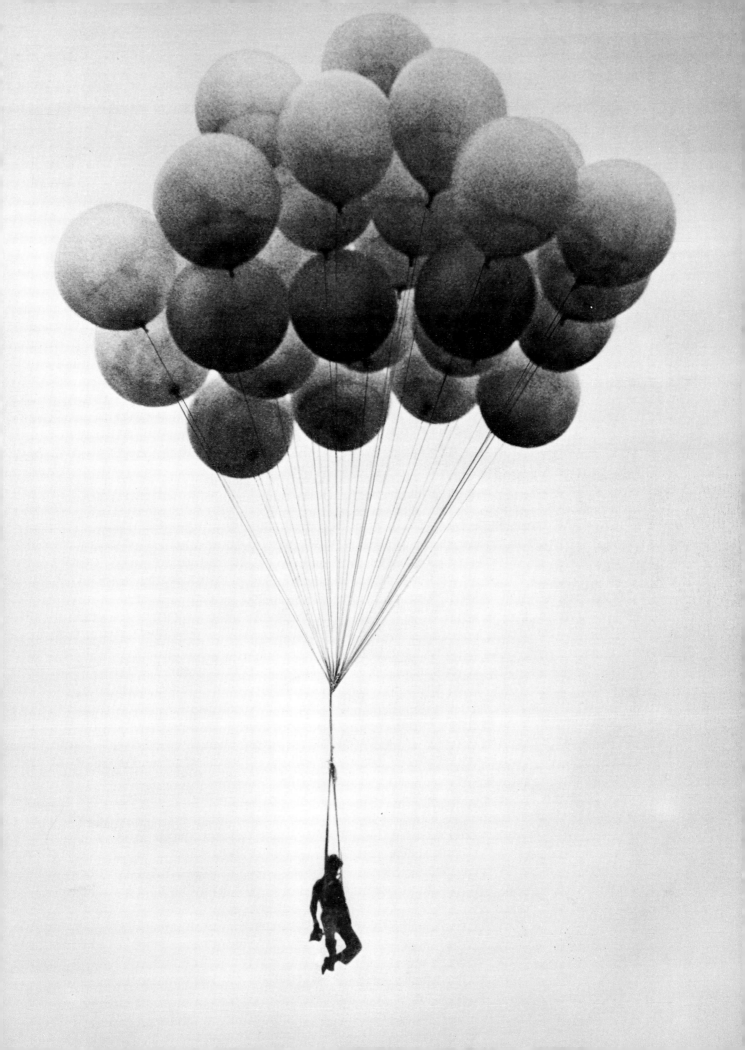

34. The Bombing of the U.S.S. "Panay"

The Japanese were bombing Nanking with regularity. Orders came from the American Embassy to evacuate the city. Early Sunday morning, December 12, 1937, Norman Alley, Universal Newsreel; Norman Soong, Times Wide World photographer; Eric Mayell, Fox Movietone News, and several reporters boarded the *U.S.S. Panay*, a flat-bottomed gunboat designed to navigate inland waters. The *Panay* steamed away, up the Yangtze, to supposed safety.

In the early afternoon, Norman Alley and Jim Marshall, *Collier's* staff writer in the Orient, went out on deck to enjoy the warm, clear weather. An instant later they heard the drone of planes. A squadron of bombers passed over at 7000 feet.

Alley said, "We heard a whistling noise followed by a terrific explosion as a bomb landed just off the port side. Another bomb exploded even nearer. The planes kept heading toward Nanking. Now a squadron of six smaller pursuit planes dove at us, releasing what appeared to be 100-pounders. The first one landed near the bridge, injuring Commander James Hughes. The bombs came in quick succession. Lieutenant Arthur Anders took command. Every man was at his emergency station. I stood there holding onto the rail. The ship was lurching. It was trembling and rocking. Anders was hit. I saw him go down, and blood spurt from his throat. A moment later he was calmly writing orders on the deck with a piece of chalk. God knows where the chalk came from. I ran back to the petty officer's quarters to get my camera."

Norman Alley filmed the diving planes, the bomb bursts, the wounded men firing the 1917 machine guns at the enemy. Anders ordered the wounded be taken ashore in the ship's outboard-motored sampan. At 2:02 P.M., twenty-five minutes from the start of the attack, the order came to abandon ship. The *Panay* was listing badly. There weren't enough lifeboats left undamaged to accommodate everyone. Some of the Navy men jumped over the side and swam for shore. Alley continued to film the grim drama with his 35 mm Eyemo camera. When the motor sampan returned, he left the *Panay*.

NORMAN ALLEY

Under cover of bamboo rushes along the shore, the men cared for the wounded. They watched as a Japanese landing-party went aboard the *Panay*. Fearful that they would next search out the survivors, Alley hid his camera and exposed film. In a few minutes the Japanese left the ship, and headed for the opposite shore. The *U.S.S. Panay* slipped beneath the surface of the yellow Yangtze River at 3:54 P.M. That night, a relief party arrived from Hohsein after a five-mile trek to aid the *Panay* men. American and British gunboats later carried them to safety.

From Shanghai, the important newsreel film reached Manila by way of a convoy of U.S. destroyers. It was feared the Japanese might seize an unprotected ship.

The official Japanese explanation of the incident claimed the attack was a mistake: visibility had been poor. Although President Roosevelt accepted the apology, Norman Alley's film showed that the day had been bright and clear, and the American flags had been prominently displayed.

Three Americans lost their lives in the bombing of the *Panay*. On another Sunday four years later, a similar Japanese attack would take the lives of hundreds of Americans at Pearl Harbor.

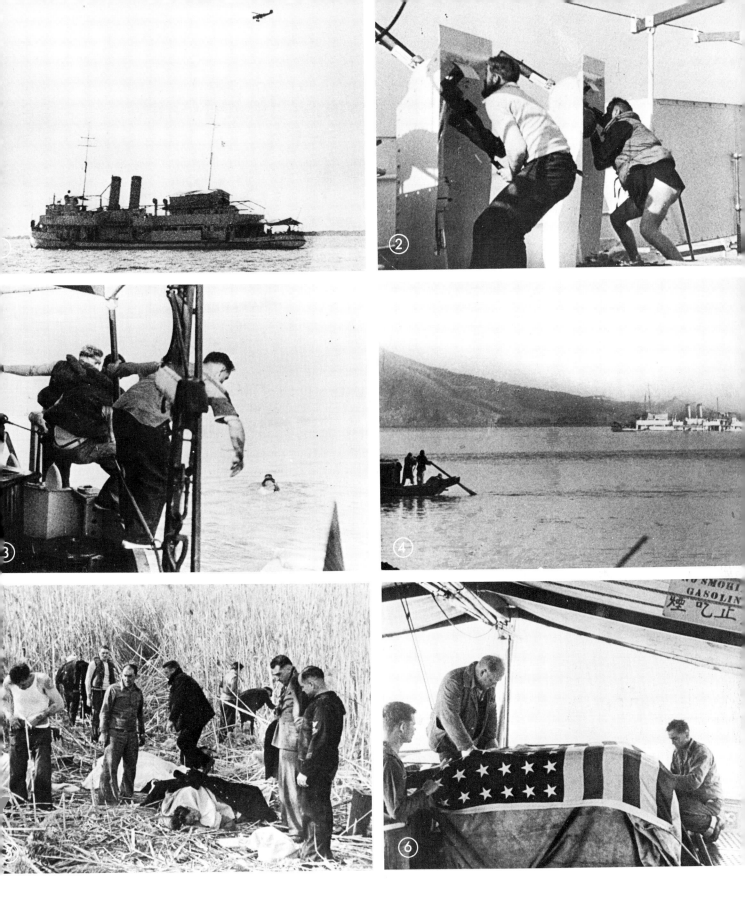

35. Norman Thomas "Egged Out"

The freelance news photographer, reading the *Newark Evening News*, spotted a story that looked as if it had picture possibilities. It read, "Norman Thomas, Socialist, is scheduled to appear in Military Park at 5:30 tomorrow to give the speech he had intended to give in Jersey City April 30 when he was 'deported' by police." He decided to cover it.

Late afternoon, June 4, 1938, Ralph Morgan went to Military Park in downtown Newark, New Jersey. Before long, more than 4,000 people, some hostile, others curious, were milling about. He noted the arrival of staff photographers from New York and New Jersey metropolitan newspapers. They clustered together and set up their equipment. He was familiar with this pattern of operation; he had worked for the N.Y. *Daily News* for a number of years.

As a freelance photographer, however, he was always faced with a special problem. He was constantly in direct competition with the staff photographers. His company, Morgan Newspictures, serviced the same newspapers and syndicates they represented. If he hoped to sell his pictures, they had to be different. He had learned to pick his location in advance, moving in only when the action began. Then it would be too late for the "boys" to move in next to him and make the same shots.

Norman Thomas stood up to deliver his speech. Ralph Morgan moved swiftly to his pre-selected shooting position. About thirteen feet from the platform was a park bench. On it, he placed his heavy duty camera carrying case. Standing on top of it, he could shoot over the heads of the people.

The angry crowd did not want the Socialist Party representative in their city. They shouted insults and threats. Banners read, "The Working People of Our City Are Contented—Reds Keep Out." Tension mounted. Groups of policemen stood ready for trouble. Thomas pleaded for fair play, and an opportunity to give his talk. He had uttered scarcely a dozen words when a parade of nearly 200 men, led by a 30-piece band, came from a side street, and pushed their way through the mob, toward the platform. It was the catalyst the crowd needed. Someone tossed an egg, and in an instant the air was filled with flying vegetables.

Morgan related, "I saw the barrage of things being tossed at Thomas, but decided to wait until I could catch a shot of something that could be seen in a picture. I had my 4x5 Speed Graphic camera trained on Thomas when it happened." Several eggs hit Norman Thomas simultaneously and Morgan made his flash shot. Detectives yanked Thomas from the platform and rushed him away to safety. Morgan fought his way through the crowd, and then drove to his office at Newark Airport. He processed the negatives, and made his prints. He sold the picture to many metropolitan newspapers, and to the newsphoto syndicates.

RALPH MORGAN

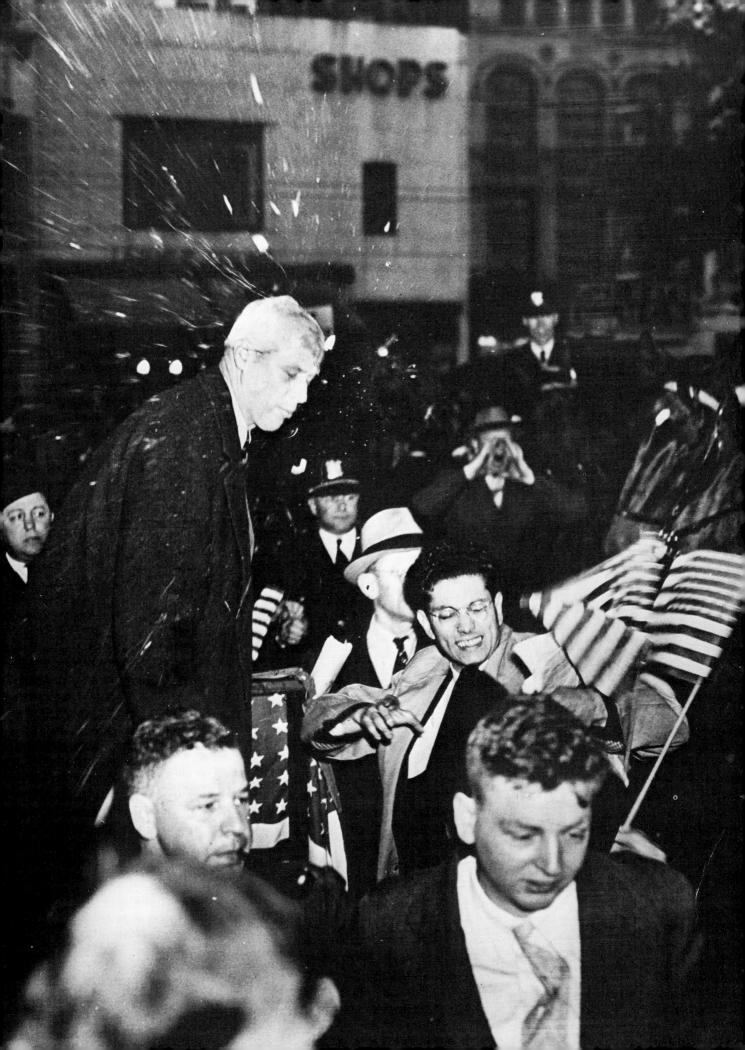

36. Raising the Sub "Squalus"

Two hundred forty feet below the surface of the sea lay a submarine. During a test dive, a faulty valve had flooded the aftercompartment, drowning twenty-six of the fifty-nine crewmen aboard. The sub had plunged to the bottom. The Navy, using a diving bell, had already rescued the thirty-three survivors. Now, four ships were engaged in salvage operations—the raising of the *U.S.S. Squalus*. It was July 13, 1939. The place, just off New Hampshire's Isle of Shoals.

On each of the ships were "still" and "newsreel" cameramen. They had been coming out each day, but this morning they had been told the *U.S.S. Squalus* would be raised from the ocean floor. Every man was on the alert, but the waiting was enough to try anyone's patience.

Aboard the *U.S.S. Sagamore*, watching the foaming water, was photographer James A. Jones of the *Boston Post*. Jones had begun his vigil at 6:30 A.M.

"I was watching the water practically all the time, and was afraid to go below to eat. Instead I lunched on deck. Having covered the sinking of the S-4 at Provincetown, the S-51 off Block Island, and the *Squalus* story from the beginning, I had some idea of what might conceivably happen. I figured that the bow of the sub, being lighter, since it was not flooded, might come up first. That's why I selected the *Sagamore*. The bow of the *Squalus* was closest to it. I set my 4x5 Graflex camera at infinity, and concentrated on the spot where the bow of the sub was designated by five buoys. The camera shutter was set at 1/680th and the 16-inch lens stopped down to f8.

"All morning and into the afternoon I stayed at my position, watching and waiting. Around three P.M. two pontoons came up at the stern, and I made a couple of shots. Half an hour later, a circle of green water appeared near the bow buoy about 200 feet away. Immediately I made that, but sensed that something was about to happen. Then one pontoon shot up, with the second seemingly coming up underneath it. That was the tipoff that something was wrong. Then, with a great rush of water, the *Squalus*' bow came hurtling out of the water. I got the picture at that instant."

The nose of the *U.S.S. Squalus* remained out of water not more than ten seconds. Jimmy Jones had patiently waited more than nine hours for the unexpected to happen. When it did he was ready. The sub suddenly appearing as it did was contrary to plans, for the ill-fated vessel was supposed to have raised slowly on the pontoons. Instead, she shot thirty feet into the air, then slipped below again. The towrope, connecting the sub to the *Sagamore*, was chopped free by a quickwitted sailor seconds after the picture was made. Had this not been done, naval experts agreed, the *Sagamore* might have been dragged under too. Jimmy Jones rushed back to Boston with his picture. The *U.S.S. Squalus*, with its dead, was later raised and towed to port.

JAMES JONES

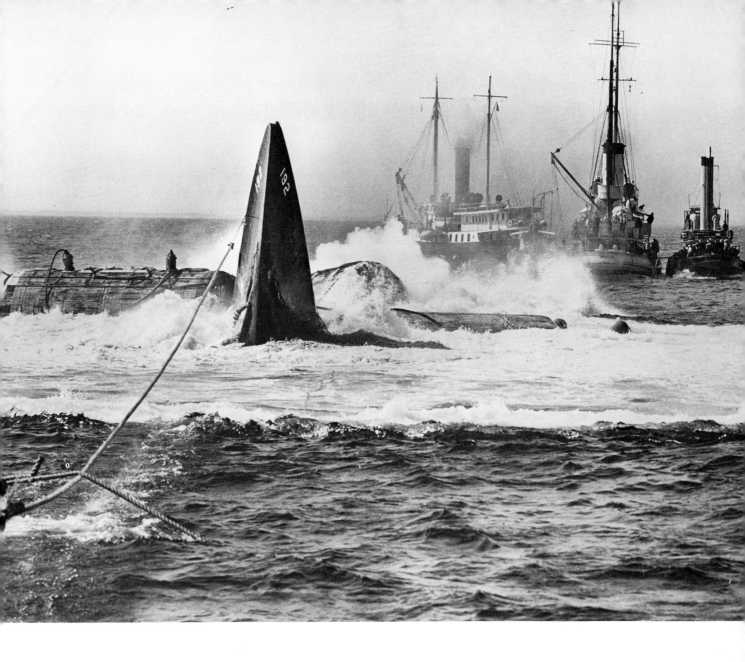

37. The Esposito Episode

Two men, Angelo and Joseph Esposito, walked into an elevator behind Alfred Klausman at 6 East 34th Street, New York. Klausman was returning from the Irving Trust Company with a $649 payroll. When he refused to give up the money, Angelo Esposito placed his revolver to Klausman's head and pulled the trigger. As the man died the brothers ordered elevator operator George Grebe to take them to the street floor. Fleeing, they shouted a warning for him to go to the top floor and keep quiet. Instead, he sounded the alarm. The Espositos ran across 34th Street while the policeman on duty fired warning shots.

In the New York office of European Picture Service, Max Peter Haas was talking to a client when he heard the shots. He opened a window and saw people running along Fifth Avenue. It was all he needed. He grabbed a 35mm Leica he'd used the night before. It still had 12 unexposed shots in it. He raced down the stairway to the street six floors below. It was 1:30 P.M. on January 14, 1941.

The fleeing Espositos ran through Altman's Department Store to 35th Street. Patrolman Edward Maher with three other officers took up the chase. Shots were exchanged, endangering the lives of the many people on the busy thoroughfare. Maher wounded Angelo Esposito in the leg. As the other brother tried to escape from the police, Maher went for Angelo. The patrolman pocketed his gun, and turned the wounded Esposito over. People gathered around, causing Maher to shout for them to get back.

Unexpectedly, Angelo Esposito drew a concealed gun and shot Maher three times. As he fell, taxicab driver Weisberger rushed to help and Esposito shot him in the throat. The crowd backed away, and Max Peter Haas arrived on the scene making pictures.

"I had no idea what was going on. There were three people holding guns. Another pistol laid on the ground. Three motionless figures lay in the street— killed or wounded. I expected any minute that someone, accidentally or deliberately, might start shooting at me."

The first picture Haas made was of Weisberger and Maher, with the crowd dragging Esposito away. In rapid succession he photographed the action that followed: the doorman from Altman's subduing the struggling murderer with a toehold; the older brother Joseph, as he was brought back to the scene by heavily-armed police; a patrolman helping the wounded cab-driver as the captured Joseph watched, spectators comforting the dying officer Maher. He made several other pictures, then rushed back to his office to develop the film. The N.Y. *Daily News,* Acme Newspictures, the *Journal-American,* and *Life* used Haas's photos.

In four minutes of quick-witted action, among throngs of people who witnessed the story, Max Peter Haas recorded one of the great photographic sequences in photojournalism.

MAX PETER HAAS

European Picture Service

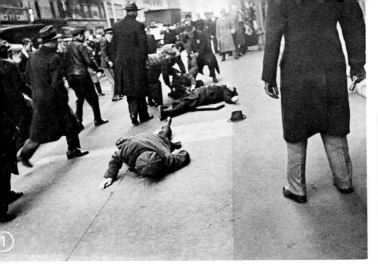

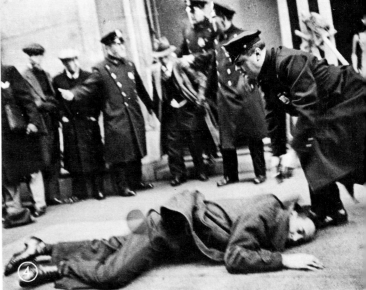

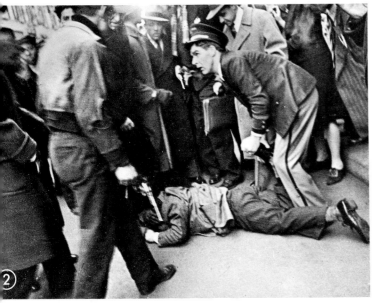

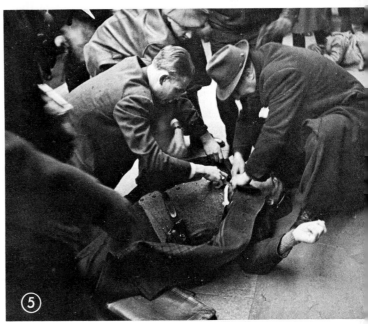

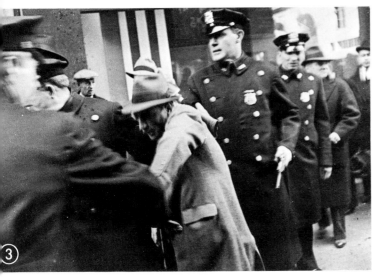

38. Sewell Avery Gets Tossed Out

This was the crucial day. For some time Montgomery Ward & Company, caught in a serious dispute between labor and management, had refused to either settle or negotiate their problems. The economy of the midwest was being affected; many people relied on Montgomery Ward for goods, supplies, farm implements, and other essentials. Normally, the clash would have been settled in time. But the United States was at war, and the government stepped in.

Sewell L. Avery, Chairman of the Board of Directors of the mail-order house, rose from his desk as U.S. officials and newspapermen entered his office. He was presented with a presidential order directing Wayne C. Taylor, Under-Secretary of State, to take over and operate the firm. Avery promptly declined to accept the order.

The next morning, April 27, 1944, Bob Tieken, "holding down the picture desk" at the Associated Press's Chicago Bureau, sent Harry Hall to relieve the AP photographer posted at the entrance to the Montgomery Ward plant. Another man had been assigned to cover the inside of the building. Hall waited. Avery arrived and went to his office. The U.S. Army was prepared to enforce the Department of Commerce's seizure of the plant. They did just that. Sewell Avery was lifted bodily and carried down on the elevator.

HARRY HALL

Harry Hall explained it as it happened to him. "I had my Speed Graphic ready, and was just waiting around, when all of a sudden the front door opened, and two soldiers came out carrying Sewell Avery. I made a long shot and then several others, following the three men down the street. They stopped in front of Avery's chauffeur-driven car, and let him down. He was smiling as he jumped into the auto, and I made some more photos." The car sped off to Avery's home on Lake Shore Drive. Several other news photographers had been present, among them William Pauer, *Chicago Times*; and Ed Geisse, *Chicago Tribune*. They made similar pictures.

Hall immediately ran over to the AP's motorcycle messenger and gave him his film holders. As soon as he could, he got to a telephone and called Bob Tieken at the office. "Whaddya know, the army just carried out Sewell Avery; Hank's on the way in with my pictures." By now it was "lunch-time" on the AP Wirefoto Network, a time then when national photos were not scheduled. Tieken knew he had a major news "beat," so he scheduled and transmitted the photo anyway. The AP was the first to "move" the picture. It caused a sensation in all the newspapers wherever it appeared.

The caption on the photo read, "Sewell Avery, Chairman of the Board of Directors of Montgomery Ward, was carried from the firm's office in Chicago, Ill., by two unidentified soldiers of the Army detail which seized the plant yesterday, April 26. The Attorney General Francis Biddle said Avery had refused to cooperate with government officials who had taken over the firm." The government had settled the dispute. Merchandise once again began to go out to fill vital wartime needs.

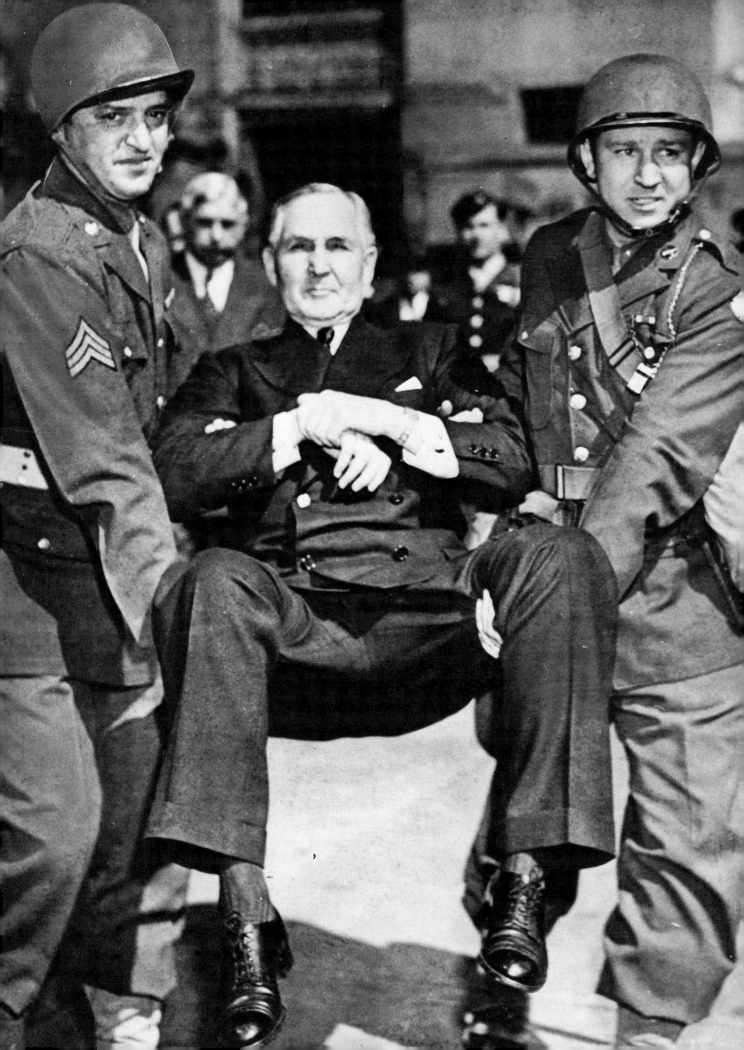

39. The Critic

"I was doing police Headquarters work for the newspaper *PM*, riding around all night in a police-radio-equipped car, the only civilian photographer in the city allowed to do so [during the war years]. As my work did not start till midnight, I decided to take a look at the 'opening night' at the Metropolitan Opera House. It's the big social event of the season. It was a very cold night. Inside the lobby of the Opera House were a flock of photographers, some in tuxedos. They were lined up in a semicircle, and when a socialite entered all the flashes went off. It was like a game of Follow the Leader. I was an outcast. The other photographers wouldn't give me the name of the socialites and told me to go back to my corpses. I went outside.

"It was during the war and there was a 'black-out' on. I heard a car pull up, my camera was focused at fifteen feet. I couldn't see much, but I could smell the smugness, so I aimed the camera and made the shot."

In the blinding light of the flashbulb he saw three women, two of them extravagantly dressed. He followed the socialites into the lobby, where the other photographers snapped their picture too. "I knew then I had photographed real society, so I asked the two women their names, and made them spell them out too. Reporters gathered around and asked if, in these critical times, it was appropriate to wear so much jewelry. The older woman first apologized for wearing last year's jewels, and added the reason she did was to help morale."

That picture changed the whole course of the photographer's life. His name is Arthur Fellig, better known as "Weegee." In those days he was a free-lance news photographer, and his specialty was violence. A non-conformist, he worked alone and liked it that way. There was an intimate quality to his pictures, whether they were stark and brutal or warmly humorous. He covered New York at night; he loved the city, and he loved his work. "It's exciting. It's dangerous. It's funny. It's tough. It's heartbreaking. It tears the guts right out of you. But I love it."

When Weegee had processed and printed his picture, he showed it to the editor of *PM*. He was amazed when the editor rejected it. He obtained permission to use the photo himself, and promptly sold it to *Life*, where it appeared Dec. 6, 1943. In his book of photos of New York, *The Naked City*, the picture attracted so much attention that Hollywood bought the book for the movie of the same name. Weegee became a celebrity.

He entered the field of advertising photography. He did magazine work for *Vogue, Holiday, Life, Look,* and *Fortune,* to name a few. For five years he commuted between Europe and America handling assignments. He had offices in Hollywood, New York, and London. He died at the height of his career.

"The Critic" is in the Permanent Print Collection at the Museum of Modern Art.

ARTHUR "WEEGEE" FELLIG

40. The Flag Raising on Iwo Jima

If ever Destiny singled out a photographer for immortality, she did so with Joe Rosenthal. Joe's "Flag Raising on Iwo Jima" became a symbol that boosted the fighting morale of the United States at a time when the tide of World War II had been against us, both in Europe and the Far East. It gave the nation renewed confidence. It almost was never made.

Iwo Jima was the site of the most viciously fought battle in the Pacific. From Feb. 19 through March 26, 1945, the toll of American lives was 6,821, while 19,217 others were wounded winning the seven-and-a-half square mile island. Joe Rosenthal, then an Associated Press photographer, landed on D-Day with the Marines. He spent a total of eleven days on Iwo Jima, making in all sixty-five photos. He shot only film-pack in his 4x5 Speed Graphic. His extra camera was a Rolleiflex. The equipment he carried weighed twenty-five pounds. Each day his exposed, identified film was flown back to Guam for processing and distribution.

It was on February 23 that Destiny showed her hand. It began early in the morning when Rosenthal, while transferring from the commandship to a LCVP, lost his footing and fell into the water between the ships. The ocean was rough, tossing the ships apart and then banging them together. Floating in the water, Joe watched as they closed in. He was about to have his life snuffed out. They stopped inches short of him as he was fished from the water. A few minutes before the accident, he had fortunately passed over his Graphic before attempting his transfer, otherwise it would have been lying on the bottom of the ocean.

Landing on the beach with Bill Hipple (*Newsweek*), they joined two Marine combat photographers, Private Bob Campbell and Sergeant Bill Genaust. These men carried guns, and covered the two correspondents on their dangerous climb up Mt. Suribachi. Part way, they ran into four Marines coming down. Staff Sergeant Louis Lowry (*Leatherneck Magazine*) told them he had made a series of photos of a Marine team going to the top, and raising the flag. Amidst the gunfire, it seemed foolish to duplicate Lowry's picture. Joe's group discussed the situation, and decided to go up anyway.

JOE ROSENTHAL

At the top, they found Marines taking down the smaller first flag, and preparing a larger 8' x 4' 8" flag to take its place. Rosenthal thought it best to make an overall shot, thirty-five feet away. Walking along, he set his shutter on 1/400th and the lens opening between f8 and f11. On the spot where he wanted to stand he found he was too low, so he threw together rocks and sandbags to stand on, for additional height. Genaust took his position close by, and shouted, "I'm not in your way, am I, Joe?" Rosenthal yelled, "No [at the same time catching movement from the corner of his eye]—and there it goes!" Joe swung his camera around and made the shot.

The historic photo was unposed, live action. Genaust's 16mm film, exposed at the same time, starts with the Marines in motion. Joe made two other photos of the men facing the camera. He wasn't sure his first picture would be used, because he couldn't see the faces of all the men.

He shipped his exposed films to news headquarters via Navy plane. It wasn't until nine days later, when he reached Guam, that Rosenthal learned that Murray Belfer, Picture Pool Coordinator, had selected the first photo for release.

Associated Press

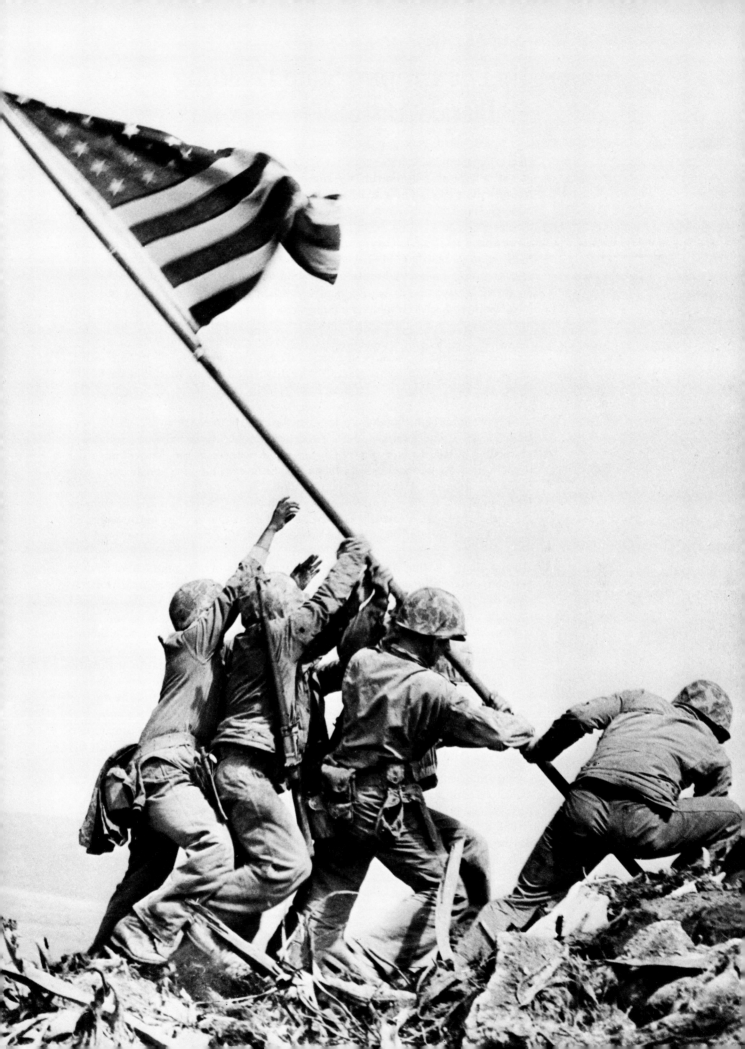

41. The Empire State Building Plane Crash

Heavy fog shrouded Manhattan's skyline early morning, July 28, 1945. Otherwise it was a typical midsummer Saturday; things were pretty quiet. Until 9:52. Abruptly, the stillness was shattered as steel clashed with stone and steel. There were agonized screams unheard on the streets below. They came from the seventy-ninth floor of the world's tallest edifice. The thing the skeptics said might happen, had happened. Twenty-four thousand pounds of airplane, flying at better than 300 mph, had crashed into the 102-story Empire State Building.

At the N.Y. *Times*, photographers Ernie Sisto and Bill Eckenberg were discussing the day's assignments when a copyboy rushed in with the news. The two men took their 4x5 Speed Graphic equipment and "hopped" the IRT subway to 34th Street. They pushed through hundreds of spectators, through police lines, past fire-fighting equipment. Black smoked spewed from a gaping hole more than 900 feet up. Eckenberg stayed below to make "street shots." Sisto ran inside. Those elevators still in operation had been commandeered by the fire department. Ernie was able to ride to the sixty-seventh floor, then began to climb to the seventy-ninth.

The plane, a U.S. Army B-25 bomber with three men aboard, was to have landed at La Guardia Field in New York. Because of poor visibility, the pilot was proceeding instead to Newark (N.J.) Airport. A witness to the accident reported that the twin-engine bomber was flying low on a course which roughly followed Fifth Avenue south. Too late the pilot saw the Empire State loom up before him. He attempted a tight left bank to clear the building. The plane plunged through the 34th Street side on two levels—the seventy-eight and seventy-ninth floors.

The impact was terrible. The major portion of the wreckage penetrated the seventy-eighth floor. One engine hurtled through partitions and fell down an elevator shaft, starting a fire in the basement. Parts of the motor and landing gear tore through the entire building, flew across 33rd Street, landed on a thirteen-story building, causing another fire. Worst hit were the offices of the National Catholic Welfare Conference on the seventy-ninth floor, whose people were working that morning. Eleven employees died, nine others were seriously burned as high octane gasoline exploded into flame.

Ernie Sisto surveyed the damage. If he could get out on the parapet just above, he'd get a picture that would tell the whole story. He took two news photographers aside and explained his plan. "All you've got to do is hold on to my legs while I get out far enough to shoot back and down the building." In return he'd "make a holder" for each of them. He put a wide angle lens on his camera and climbed up on the ledge. The odor of burnt wood and flesh drifted up. With the photographers holding his legs he inched out as far as he dared, lifted the camera out to arm's length. He made his shot. The men pulled him in. He repeated the dangerous stunt twice more. After recording the damage inside, he returned to the N.Y. Times Building.

The dramatic picture, carrying Ernie Sisto's credit line, appeared the following day on the front page of *The New York Times*. It had been made by a great newspaperman.

Ernie Sisto

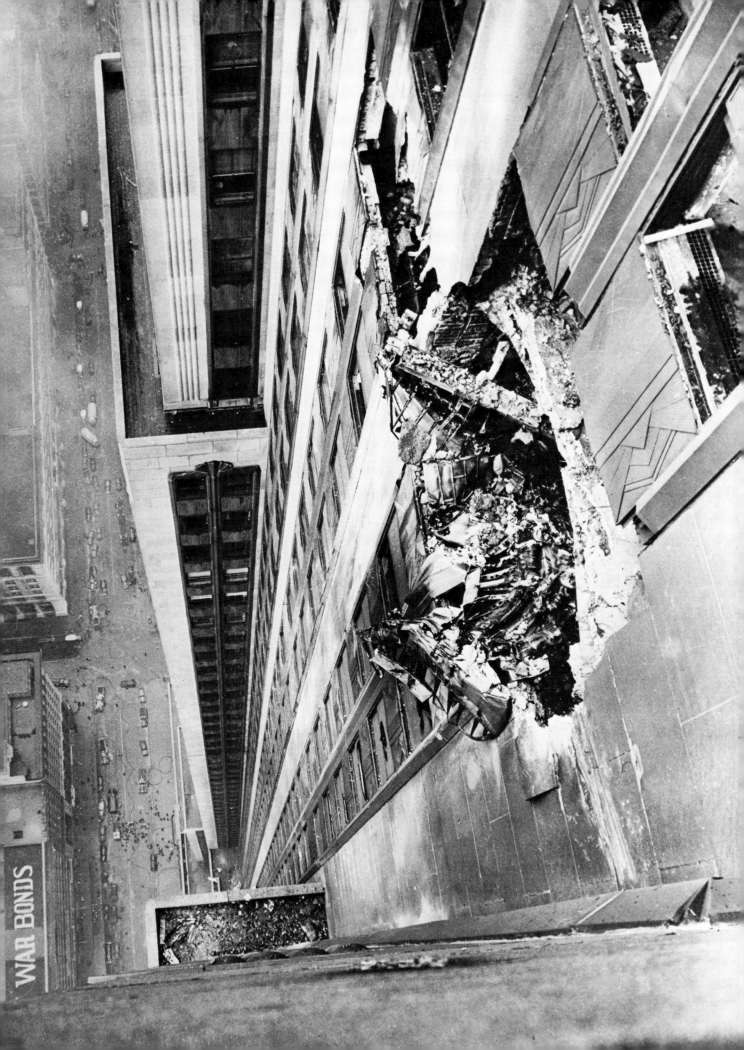

42. The Atomic Bomb, Hiroshima

Perhaps the most unforgettable of all military photographs ever released to newspapers by the armed services was that of the atomic bombing of Hiroshima. It was made by a 25-year-old U.S.A.A.F. sergeant from Brooklyn who always wore a "Dodgers" cap for good luck. He had never before used a professional camera.

The 509th Composite Group, based on Tinian Island, had been trained for many months for its top-secret mission. Three B-29's were scheduled to take off that early morning, August 6, 1945, to make and record the bomb drop. The *Enola Gay* piloted by Col. Paul W. Tibbets, Jr., would carry the bomb. The *Great Artiste*, flown by Major Charles W. Sweeney, carried scientists and instruments. The "91" piloted by Major George Marquardt carried motion picture and aerial cameras to record the extent of the destruction. Located in the belly of the two lead planes was a K-17 aerial camera. Its purpose was to make the actual "bomb strike" photo. The Photographic Officer of the 509th, Capt. Jerome J. Ossip, had counted on being on the mission. He planned using a K-20 camera which could be handled like any "press type" camera. His request to be aboard was turned down at the last minute. He went to the *Enola Gay's* tail gunner, Sgt. George R. Caron, told him what to do, gave him the K-20, loaded and set.

At 2:45 A.M. Col. Tibbets released the brakes of his silvery B-29 and it sped down the runway and into the air, carrying its 400-pound missile of destruction. Two hours from the Japanese coast the three ships climbed to 30,000 feet. Twelve miles from the primary target, Hiroshima, bombardier Major Tom Ferebee took over the *Enola Gay*, making ready for the "run." At 0815 he announced "Bomb's away." Col. Tibbets took back the controls and executed a violent turn away from the target area. The *Great Artiste* followed suit. In less than a minute the brilliant morning sunshine was slashed by a brighter blinding flash of light. Operation Silver Plate, "deliver the bomb," was completed.

The blast from the explosion covered the city area below. Sgt. Caron, his head forced against the plexiglass window in the tailgunner's tight cubicle, began making pictures with the K-20 camera. He exposed the entire roll as Col. Tibbets "leveled off" the B-29 to give the crew a look at the "thing."

As soon as the bombers returned to Tinian, Capt. Ossip had the K-17 film magazines removed, and picked up Caron's camera. While the lab men processed the large rolls of aerial film, Ossip "sweated out" the results. Also waiting were Generals Carl Spaatz, Curtis LeMay, and Nat Twining. Ossip inspected the wet K-17 negatives and saw nothing but sky and unimportant sections of ground; the fixed-position, automatically driven cameras had missed the "bomb strike" because of the "evasive action" turns of the planes. That left Caron's film. The roll was processed and showed picture after picture of the atomic bomb explosion. Ossip selected the best shot. On August 11 the picture was released by the military to appear in newspapers all over the world.

This was the first photograph of the devastation of a city by an atomic bomb. It is a picture that represents the instantaneous death of almost 80,000 people.

SGT. GEORGE CARON

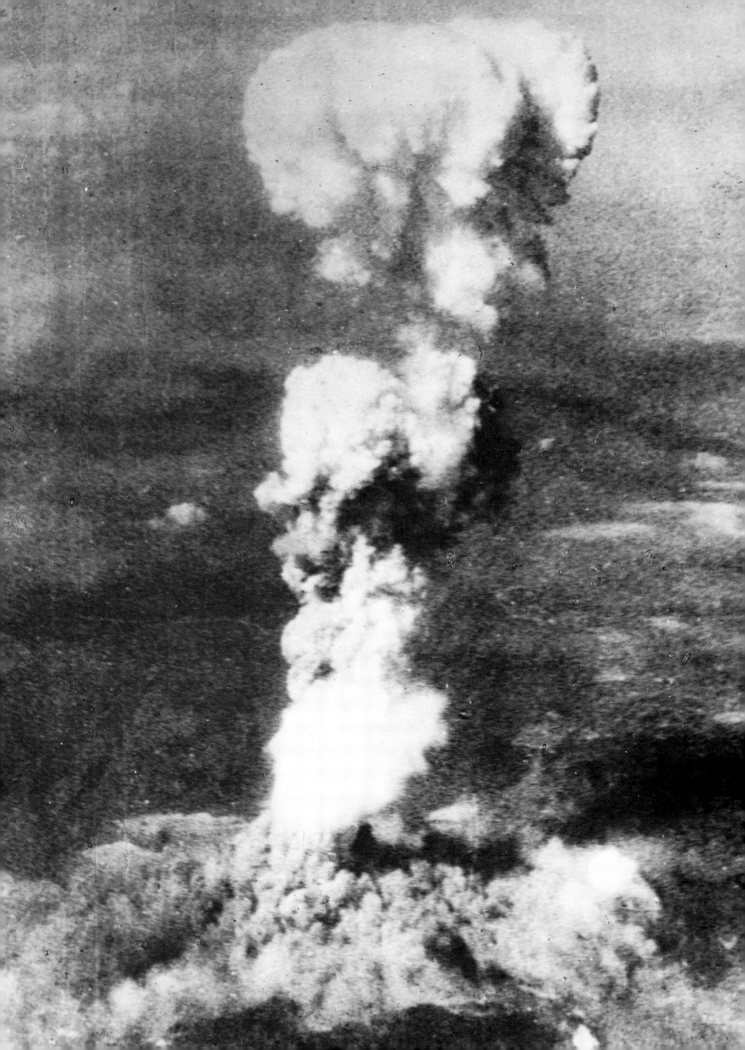

43. The Winecoff Hotel Fire

The *Atlanta Journal's* photographer, Jack Young, was suffering from a severe case of pleurisy. He'd worked as long as he could. Finally at 3:30 A.M., December 7, 1946, he committed himself to Grady Hospital. The doctor was strapping his chest when a nurse ran into the room. Frantically, she asked the doctor, "How can I get the Hospital doctors in? There's a big fire at the Winecoff Hotel, and the police say we'll need all the help we can get." Despite the doctor's objections, Young dressed, grabbed his camera, and raced for the burning hotel. He was the first news photographer on the scene.

Arnold Hardy, an engineering student at Georgia Tech, had come in late from a dance this Friday night. Hearing fire engine sirens, he phoned the fire department. "Winecoff Hotel" was the reply. Hardy was an amateur photographer with a month-old miniature 2¼x3¼ Speed Graphic camera. He grabbed a filmpack, and all the flashbulbs he had, five. The police stopped his cab two blocks from the fire. Jumping out, he ran the rest of the way. It was a little after four A.M. "Rounding the corner, I came upon it all at once. Fire was raging from the sixth to the ninth floor. From almost every window men, women, and children screamed for help. I offered help to the firemen, but they said no. I started making pictures.

"The trapped victims on the upper floors were descending ropes of blankets and bedsheets in desperate attempts to reach the fully extended fire ladders. Suddenly I heard someone behind me shriek. I looked up, raising my camera. A woman was plummeting downward. As she passed the third floor I fired, using my last flashbulb."

Ralph Johnson, Associated Press picture editor in Atlanta, was awakened by the phone. The Bureau's overnight editor told him what was happening, and that he had notified AP photographers Rudy Faircloth and Horace Cort. Johnson dressed and taxied into the city.

"Soon as I arrived, I switched on the Wirephoto network. Within minutes, Faircloth and Cort's exposed negatives started coming in, and utter chaos broke loose.

"We moved picture after picture over network wires. Shortly after noon, Arnold Hardy walked in, carrying damp negatives in a paper towel. Of three usable shots, one was a full front view of the burning hotel with a woman in midair, seconds from death. After dickering over the price, I gave Hardy our check for $300. We rushed out a print, scheduled it on the network, then transmitted it."

The Winecoff fire took 119 lives, injured twenty-one hotel guests and twenty-five firemen. Hundreds of excellent pictures were made of the tragic disaster. Arnold Hardy's photograph won a Pulitzer Prize.

ARNOLD HARDY

Associated Press

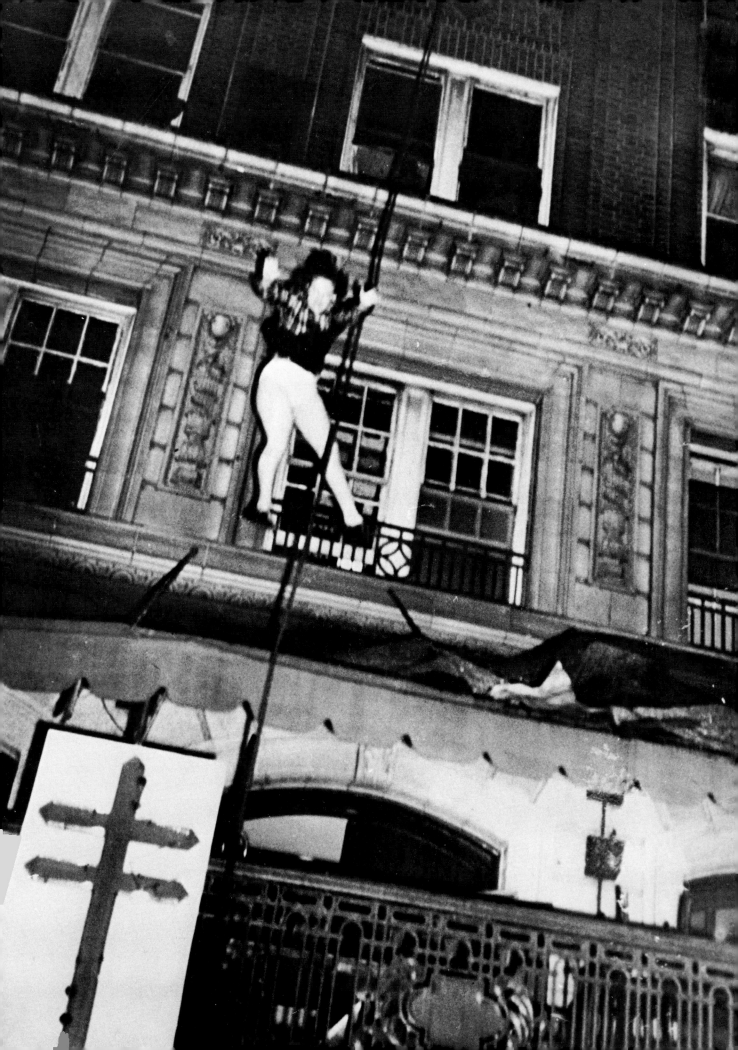

44. Texas City Disaster

Just how the fire began no one knows. The crew was loading ammonium nitrate fertilizer aboard the *SS Grandcamp* for shipment to France. It was a cool, pleasant morning in Texas City, Texas. Ship's Captain Charles de Guillebon ordered the hatches closed and live steam turned into the hold. At 8:33 A.M. the fire alarm was sounded and the crew ordered off the ship to the pier alongside. The fire attracted spectators, some 250 men, women, and children, to the wharf.

At 9:15 A.M. the *SS Grandcamp* exploded like an atomic bomb. The ship disintegrated, hurling missiles of steel and balls of flaming sisal twine in all directions. The force of the blast produced a ten-foot tidal wave, leaving the slip momentarily dry of water. Buildings on the principal business street, 5,000 feet away, collapsed. More than 570 people were killed, 3,000 injured, and damage amounted to $50,000,000.

The *Houston Post's* photographer, a girl of twenty-two, was eating breakfast at home when the phone rang. "Caroline?" Chief photog Bill Nottingham's message was brief: "A ship's blown up in Texas City. Get down there right away. I'm flying to make aerials. Thanks and goodbye."

CAROLINE VALENTA

Caroline Valenta dressed and minutes later, in her ancient 1929 Model A Ford, was racing the forty miles between Houston and Texas City.

Black billowing smoke shut out the bright Texas sunshine as she entered the wrecked Monsanto plant. The few rescue workers she met and questioned were from out of town and offered no information. She did not know the danger of the assignment. There could be other explosions, the chemical fumes in the air might be poisonous—these dangers did exist, and later took more lives—but now she was a newspaperman in the midst of a great story.

She walked a half mile into the center of the disaster area. Oil, tar, chemicals, downed cables, and human debris covered the ground. After several "safety shots," she still couldn't see the one photo that would tell the complete story. She walked back to an area where eight bodies lay beneath an overturned boxcar. In the background stood the twisted steel wreckage of a building, smoke almost blotting out the sky. This could be it, a foreground-background shot. She walked across the railroad tracks "setting" her 4x5 Speed Graphic. "I stopped down to f/22, changed the shutter to 1/50. I knew I needed the depth. I waited until a group of stretcherbearers, carrying bodies, walked into the scene. I made the picture."

Caroline returned to town. She had arrived at eleven A.M. It was now two P.M. and there was an edition to meet. She raced back to Houston. There she processed her films and helped make prints. The date, April 6, 1947. A date that brought Caroline Valenta into the history of news photography.

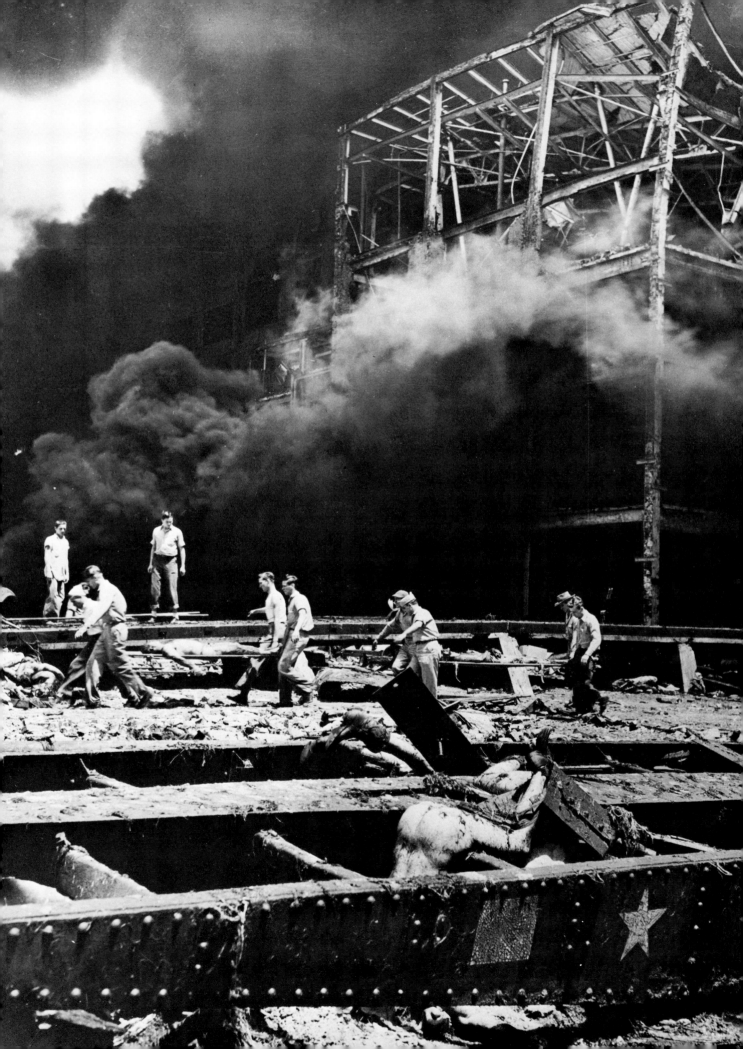

45. A Mother's Tragedy

Sunday, July 27, 1947, was a bright warm summer morning—ideal for a family outing. The father and mother with their two children, a boy of nine and a girl of six, had come to Hansen Dam Reservoir, California, for their picnic. Finding the shoreline crowded, they selected a site halfway around the reservoir from the designated beach and swimming area. The children wore their bathing suits in anticipation of wading in the shallow water. The father tested the depth and permitted the children to go out a few yards from shore.

The parents spread luncheon. When it was ready, they called the children. Tragedy had already struck, but the adults were unaware of it. Thinking the children were playing elsewhere in the vast playground, they did not immediately become alarmed. A search began for the boy and girl that continued the rest of the afternoon and into the night. While 200 volunteers combed the hills around the dam, the Van Nuys fire companies dragged the water with grapnels. All efforts were in vain.

Late that afternoon the local press learned of the missing children. They kept an all-night vigil with the parents huddled forlornly by a small fire on the shore. The next morning the overnight press crews were relieved by fresh teams from their respective papers. Among the Monday morning relief photographers was the *Los Angeles Times'* Paul Calvert. This is his story.

PAUL CALVERT

"The search had gone on so long, and now seemed almost hopeless. Some of the photographers had gone to a nearby truck for sandwiches. Others had left to eat in town. I had stayed with the Los Angeles City lifeguards who took over with skin diving gear. I was standing on the shore when one of them surfaced about a hundred feet out and shouted, 'I've got one of them.' I made a quick picture as the guard brought the rigid little body into view, then waited. The mother came running toward us. The lifeguard laid the body on the shore, turned, and with his arms spread, prevented the hysterical woman from throwing herself on the body of her child. Finally, she turned from the guard, and I made my picture as she walked away sobbing, 'We don't have any more babies! We don't have any more babies!'"

The pictures were exclusive. The rest of the photographers arrived shortly after Calvert finished shooting. By then the mother and father were completely shielded by friends, and the little bodies covered with blankets. The Chief Lifeguard told the press he had located the children in six to eight feet of water just beyond the "step-off."

Calvert's photo ran on page one of the *Los Angeles Times*. To soften the impact of the tragedy, a sheet was painted in, covering the child's body. Subsequently, however, the unretouched picture was serviced to "member papers" by the Associated Press. Conservative newspapermen question the ethics of publishing photographs in which personal tragedy is involved. Perhaps the answer lies with the reader who is shocked into avoiding similar tragic occurrences.

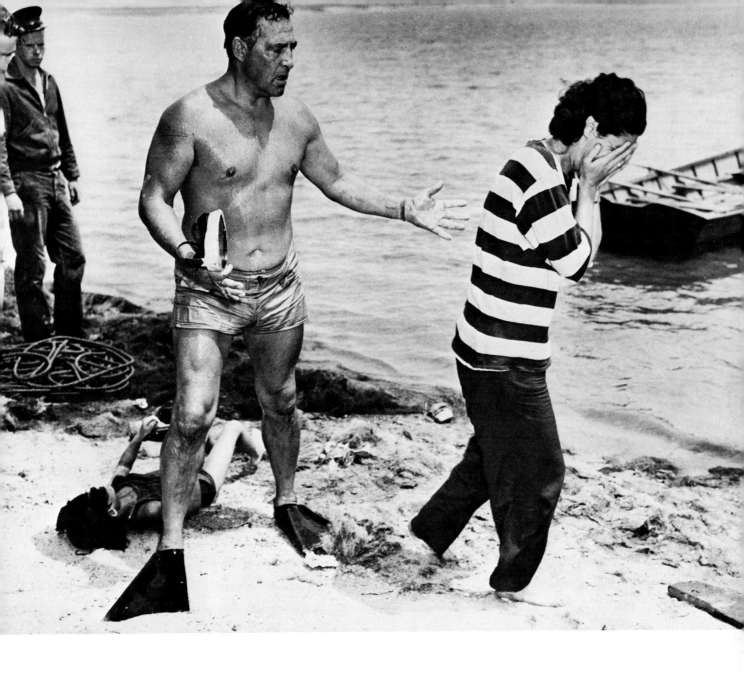

46. Babe Ruth Bows Out

It had been a very warm and exhausting day, and the photographer was glad it was over. The elevator let him off on the fifth floor of the N.Y. *Herald Tribune* building. He nodded to the receptionist and walked the long corridor toward the City Desk. There he saw a group of reporters and photographers huddled together with his wife, Lois Fein, and Picture Editor Richard Crandell. His wife had never been to the office before, so the first thought that flashed through his mind was that someone was sick at home. But, she was smiling and everyone gathered around him. "Nat," Crandell said, "we've got a surprise for you. You've just won the Pulitzer Prize for your Babe Ruth picture." Nat Fein almost dropped his camera. It took time for the idea to "sink in." Someone asked for the story behind the great picture and Nat gradually pieced together the things that had taken place almost a year before.

It had been a gloomy dismal day at Yankee Stadium this June 13, 1948. Babe Ruth was making his final appearance after fifteen years of playing baseball. Thousands of "fans" had jammed the stadium to say goodbye to Ruth. He was a very sick man. He died two months afterwards. The Babe came out of the dugout waving, and walked slowly to homeplate. The band began to play "Auld Lang Syne." It was a tremendous emotional experience. George Herman "Babe" Ruth stepped forward. No one could mistake that figure. His wide shoulders slightly stooped as he leaned on his baseball bat to steady himself. The crowd rose in tribute to the man who was the idol of millions and the symbol of good sportsmanship.

Twenty-five photographers were there covering the Babe Ruth Day ceremonies. Like the others Fein made pictures of the things that were happening, but he felt none told the story. The fact that Babe's uniform and his number 3 would never be used again had somehow to be included. So Fein left the other news photographers and walked around behind Ruth. Then he saw it—the composition that told the whole story in one picture. Fein remembered the "preaching" his photo editor had been giving him. Crandell had impressed his staff with "Whenever you can, make your pictures without flashbulbs. Natural light catches the mood of the occasion." Nat Fein thought of this because the light was very dull. Most of the other photographers had resorted to flashbulbs, as a precaution, to have enough light to get their picture. Fein opened the lens diaphragm to f5.6 and slowed the shutter on the Speed Graphic down to 1/25th. He made the picture without flash.

The assignment called for a photo of "Babe Ruth Retires." Nat felt he had his picture. He packed up his equipment and took the subway back to the *Herald Tribune*. Another photographer had been assigned to cover the ball game. At the office, Nat processed his negatives and prepared prints for Sports Editor Arthur Glass. He laid the prints on the desk, and immediately Glass pointed to the last photo Fein had made: "That's it."

In Baseball's Hall of Fame at Cooperstown, N.Y., among the historical exhibits are the things which once belonged to Babe Ruth. Next to where his uniform lays is the picture made by Nat Fein the day Babe Ruth Bowed Out of Baseball.

NAT FEIN

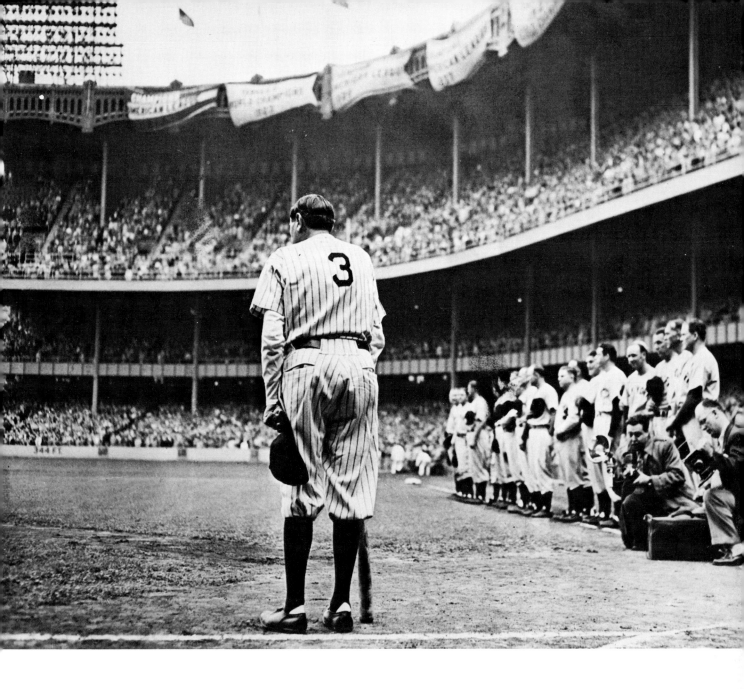

47. Dewey Defeats Truman?

There seemed no doubt about it. Harry S. Truman had little chance of being reelected to the office of President of the United States. The day before the election, the Gallup Poll gave Dewey 49.5% and Truman 44.5%; Elmer Roper's Poll gave Dewey 52.2% and Truman 37.1%. In New York City, the *Times*, the *Herald Tribune*, the *Sun*, and the *Journal*, as well as many newspapers across the country, predicted the Dewey-Warren ticket would win. *Life* magazine ran Thomas E. Dewey's picture on the front cover, with the caption, "The Next President of the United States." The Republicans were sure of it, even many Democrats believed it.

Harry Truman campaigned up to the very last minute. Now the presidential barnstorming tour, with its short speeches from the train's rear platform, was over. Nothing to do but wait for the outcome as the people went to the polls to vote. Many didn't even go. It seemed to veteran newsmen that the President had his doubts of victory, too. He had returned to Kansas City, Missouri, site of his early political career. With several close friends he disappeared from press contact, election night. The date was November 4, 1948.

As the evening wore on, commentator H. V. Kaltenborn told his coast-to-coast radio audience that President Truman didn't seem to be getting a majority of the popular vote (he never did), and despite early returns, would probably lose the election. Shortly after midnight it became apparent that the nation was witnessing one of the biggest political upsets in American history. Truman was going to win. At four A.M., he talked to the press and accepted victory.

The Presidential train left Kansas City, heading back toward Washington, D.C. First twenty minute stop-over was scheduled for St. Louis, Mo. The train came to a halt in the station. Several photographers assigned to cover the President's trip jumped off the train and ran back into the crowd to make an overall view. They were never certain that the President would appear, but always covered, just to be sure. It was standard practice to make the overall shot first, then move in for closeups. Should the train start to move out, they could easily jump aboard. Among the photographers who left the train were Acme's Frank Cancellare, Al Muto of International News Photos, and Byron Rollins of the Associated Press.

The President was thanking the crowd when someone handed him an early edition of the previous day's *Chicago Tribune*. Bold black headlines proclaimed, "Dewey Defeats Truman." The President laughed, and held up the paper to show the crowd. They roared. The train moved out of the station, carrying the victorious Harry Truman home to Washington.

All three news syndicate photographers made almost identical pictures. The photo received wide coverage, and remains a reminder to political analysts to be more cautious.

FRANK CANCELLARE

United Press International

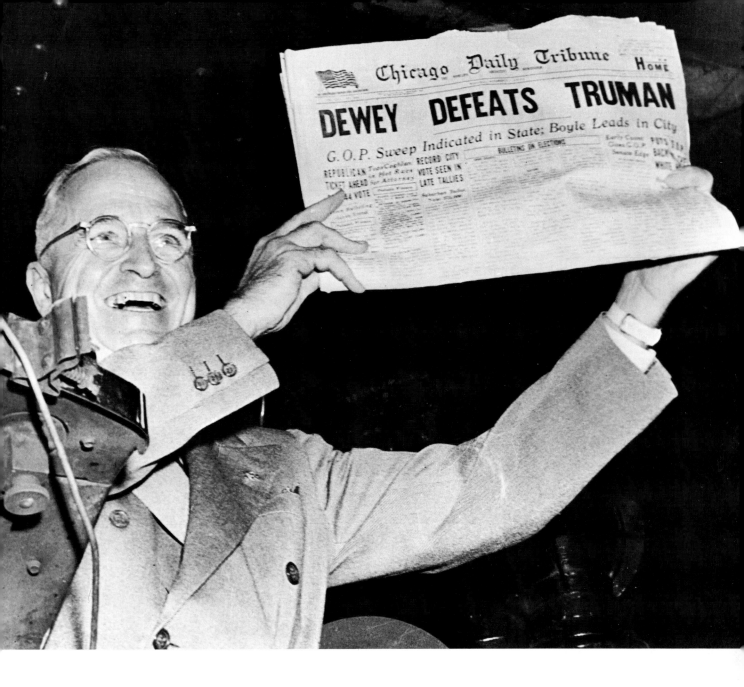

48. The Korean Bridge

The woman paused at the door of the hotel room, waiting for her husband to carry out the last of their luggage. They were leaving New York City for Miami, Florida, where Max Desfor was to work out of the Associated Press Bureau. The phone rang. It was Al Resch, General Newsphoto Editor, AP, New York. Was Desfor still willing to go through with the voluntary request he'd made recently, to go to AP's Tokyo Bureau? He was. Within two days, Max was on his way to the Orient. The Korean War was in progress.

By July 17, 1950, he was with the U.S. 24th Infantry Division in Korea. He'd been sent to Japan to coordinate photo work, but when he arrived he realized another photographer besides AP's Charlie Gorry was needed at the front.

In October, he received permission to join a special mission of the 187th Regimental Combat Team. Parachute troops were being sent to intercept a trainload of U.N. prisoners being transported deep into North Korean territory. In a matter of hours he received "jumping instructions," was fitted with special gear, packed his 4x5 Graphic and filmpacks, and slept briefly. In the early morning, the "flying boxcars" rumbled off the runway, carrying 1500 troops and Max Desfor. He made the jump successfully. The troops missed capturing the train, but succeeded in trapping several hundred Communist soldiers. Max recorded the story.

By December the North Korean Army had been reinforced by Communist Chinese. The U.N. forces were retreating. Max relates, "We had to get out; our troops could no longer hold the capital city of Pyong-yang. I hopped into a jeep with reporters Tom Lambert of the AP, and Homer Bigart, N.Y. *Times*. The only way to cross the Taedong River was with the military over a pontoon bridge. Reaching the far side, we went down river looking for stories.

MAX DESFOR

"I'll never forget the sight as long as I live. We came to a huge bridge which had been bombed and fallen into the icy river. Crossing over bits of jagged metal were hundreds of people, crawling like ants through the girders. They were half frozen, it being the dead of winter. Some had fallen into the freezing water, and were trying to reach safety. Others clung to the twisted metal in sheer exhaustion. I jumped out of the jeep and ran out on the slippery bed as far as I could go on our side of the bridge. It ended abruptly with a drop of fifty feet to the water's edge. I must have made four or five shots. All I could think of was the fortitude of these poor miserable souls as they fled from capture and Communist control.

"There was no need to stay longer so we drove the jeep to what was left of the airport. I gave my filmpacks to the pilot of the last Air Force plane, then helped the troops burn the remaining airport installations. I could have gone with the plane, but felt the story was in the retreat, so I went with the troops. I did manage to message Bill Achatz, our photo editor in AP Tokyo, to watch for my films."

Max Desfor's picture of the Korean Bridge was transmitted from Tokyo on December 5, 1950. In 1951 it was awarded the Pulitzer Prize.

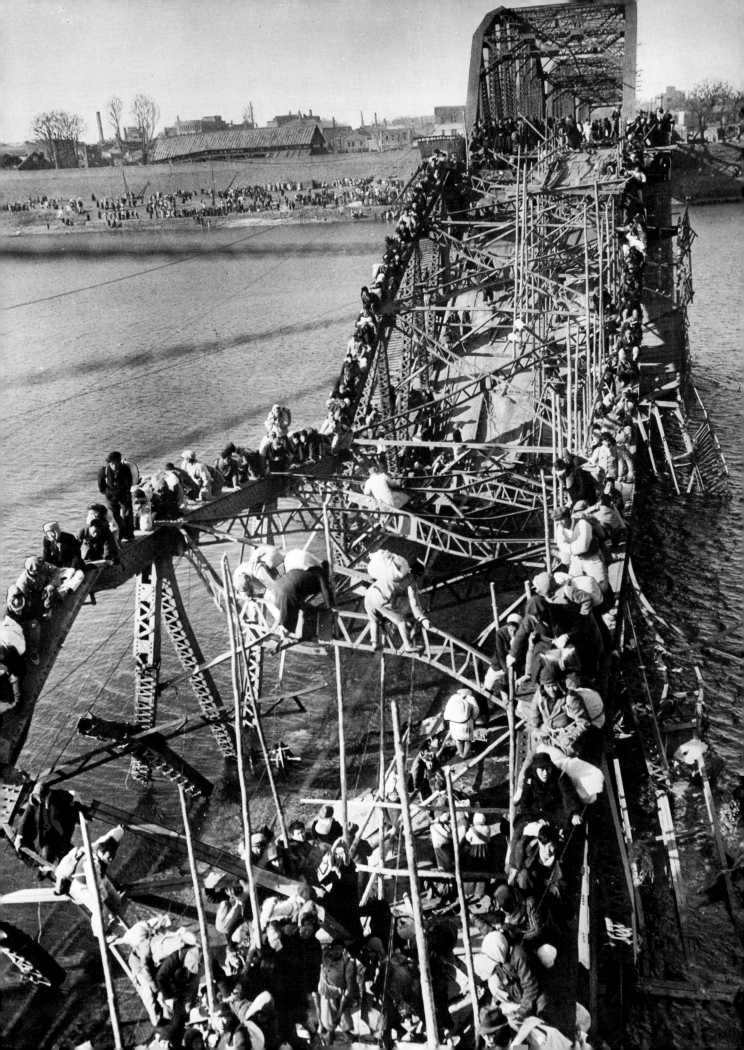

49. Einstein's Birthday Joke

A celebration was being held, on the night of March 14, 1951, at the Princeton Club. Friends and colleagues had gathered to pay homage to Albert Einstein on the occasion of his seventy-second birthday. The news photographers from the big city dailies were there to cover the event. Many speeches were made, and the Professor was presented with a plaque in token of the great affection held for him.

Einstein had become a life member of the Institute of Advanced Study at Princeton, New Jersey, in 1933. A gentle, witty, unassuming man of great patience and understanding, he was a favorite of the students. His informal attire on campus occasionally provoked some discussion. He wore his hair long, a funny leather jacket, no socks, no suspenders, no collar, no tie. To the great man, these details were simply unimportant. He enjoyed his classes, and the opportunity to do independent research work.

Albert Einstein had become famous in 1905 with the publication of his theory of relativity. In the ensuing years, his additional achievements in the field of theoretical physics were phenomenal. He has been called one of the eight immortals of history.

When his birthday celebration was over that night, Einstein was tired. He patiently posed for the photographers. A friend offered to drive him to his home at 112 Mercer Street, and they left the building together. As the Professor entered the auto, the news cameramen rushed up to make "just one more" picture.

ART SASSE

"There were a lot of photographers there," Art Sasse, INP, said, "so I let the other fellas go first. My chance came. I was only four feet away from the open door of the automobile. Einstein was looking the other way, talking to his friends. So I kind of loudly asked, 'Ya, Professor, shmile for your birthday picture, Ya?' Well, he turns around and lets me have it. I don't know why. Maybe he thought I wasn't quick enough. But when he turned around and stuck his tongue out at me, I made my shot. Half a dozen photographers were crowding me, and they saw what happened. One shouted, 'Hey Art, ask the Professor to do it again!'" The car whooshed away, leaving the newsmen standing forlornly at the curb.

The photographers crossed the street to the Princeton Railroad Station, and caught the next train to New York City. En route, they argued with Sasse, saying the picture shouldn't be used.

"Well, it wasn't up to me," Sasse felt, "it was up to the editors. Back at the office, I showed Caveo Sileo, assignment editor, the negative. He liked it, but the chief editor didn't. So they had a conference with the 'big chiefs upstairs.' The picture got okayed, and we used it on the network. Public and press reaction was tremendous."

Later, Professor Albert Einstein sent a letter to International News Photos, requesting nine prints for his personal use. Art Sasse said, "I think he liked it. He even autographed a print for me. I was just a lucky guy."

International News Photos

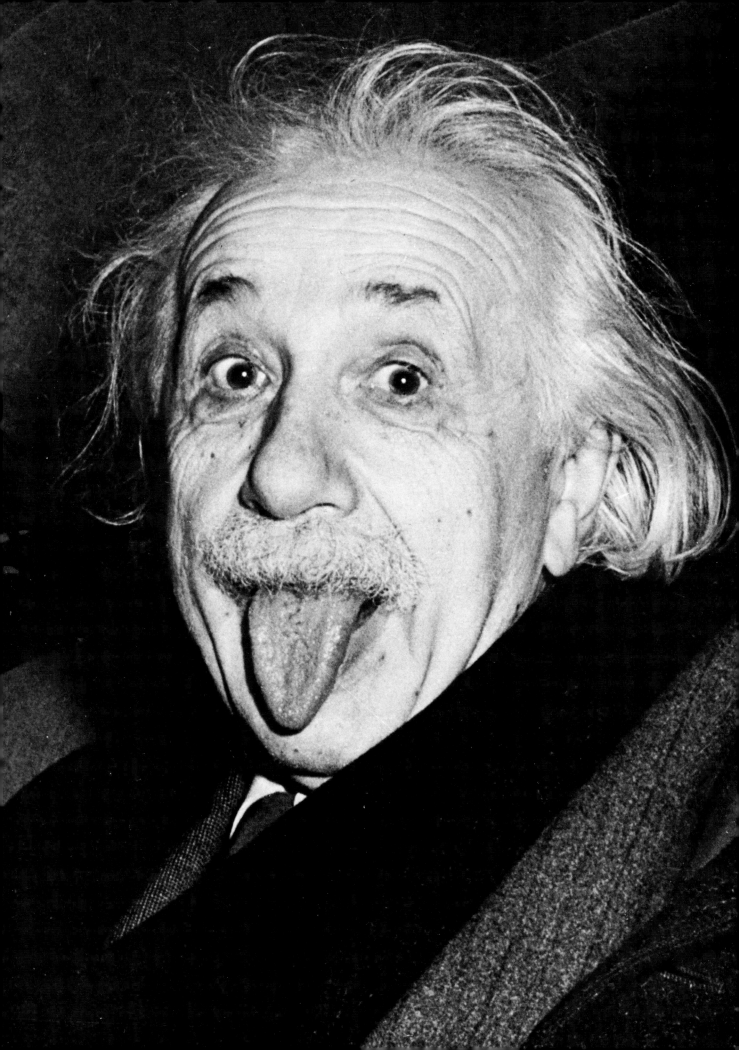

50. Louis-Marciano Fight, the End of an Era

The fighter, wearing a faded blue and red dressing-gown, walked down the aisle to the ring. All eyes were upon him. This night, October 26, 1951, Joe Louis was making his last comeback bid in Madison Square Garden. He was matched against the young heavyweight from Brockton, Massachusetts. Rocky Marciano was the talk of the "fight game." Louis knew if he could beat him, he would be the main challenger in line for a title fight.

No man in the history of prizefighting had accomplished what Louis had. It had begun in Chicago seventeen years before on June 1, 1934, when he had fought his first professional fight, knocking out Jack Kracken. Louis's manager, John Roxborough, gave him the entire $50 purse. Twenty-seven consecutive victories followed before Louis was stopped by Max Schmeling in 1936. Then in 1937, after seven wins, Joe Louis knocked out James Braddock to become world heavyweight champion.

Through 1949 the "Brown Bomber" knocked out twenty-one challengers, defending his "crown" twenty-five times. That year he retired, undefeated, from the fight game. He had held the title of "Champ" longer than any other man.

In July of 1950 newspapers carried the announcement that Joe Louis was coming out of retirement. He had challenged Ezzard Charles to a fight for the title he had given up. Louis had run into financial problems, primarily a debt of $150,000 owed the U.S. Government. Close friends had cautioned him, "no ex-champion had ever come back to regain his title." He lost that fight. His share of the "gate" went to the government for "back taxes." He kept fighting, but it wasn't the Joe Louis of old.

Andy Lopez, Acme Newspictures, who had covered most of Louis's fights, saw the old veteran climb into the ring. He checked out his 4x5 Graphic and electronic flash unit. Other news photographers crouched close to the brightly lighted canvas. Charlie Hoff and Hank Olen of the N.Y. News; International News Photos Herbie Scharfman; John Lindsay and Mattie Zimmerman of the Associated Press. They watched as Marciano and Louis came out of their corners at the sound of the gong. Acme's Lopez made his first picture as the fighters took their counter-action positions. A "runner" took his holder to the specially built Acme photolab in Madison Square Garden. The negative was developed, and a rush print made. Within minutes, the monitor on Acme's Telephoto Network was scheduling the first photo of the fight. Newspapers across the U.S. received the picture while the fight was still in progress.

Lopez kept making photos, but the "Brown Bomber's" age and flagging reflex action made him look bad. In the eighth round, Marciano let loose a left hook that dropped Louis to the canvas for a count of eight. Moments later, a final right sent Louis through the ropes, giving Marciano a technical knockout. It was the last punch Joe Louis ever took as a professional fighter. He was through in the fight business.

Joe Louis had been a great champion. Andy Lopez's photo had recorded the end of an era in prizefighting. His ability to capture the highlight of a news story has granted him much recognition. In 1960 it culminated in his receiving the Pulitzer Award for his photo-reporting of the Cuban Revolution.

ANDY LOPEZ

United Press International

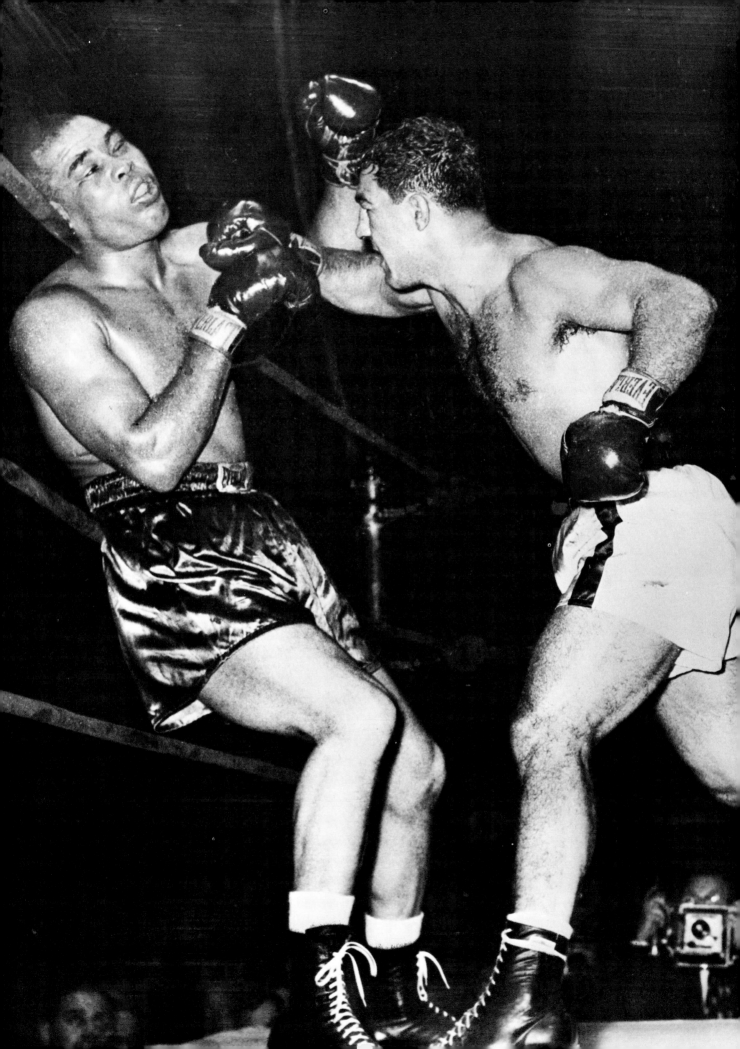

51. Operation "Father Christmas"

Six miles south of the Changjin Reservoir in Northeast Korea, a convoy of U.S. Marines was attempting to reach an isolated regiment, December 1, 1950. Associated Press photographer Frank Noel was with them. They didn't make it. Frank "Pappy" Noel, one-time Pulitzer Prize winner, was among those captured by the Chinese Reds. The laughing man with the PFC stripe pasted on his battered Speed Graphic camera went out of circulation. Stan Swinton, AP reporter who often teamed with Noel, said: "Don't write off Pappy Noel . . . He has seen a lot of war and any number of tight spots. I am betting that 'Pappy' will come back—probably with exclusive pictures!"

A year later, four men sat in the AP Tokyo Bureau, dreaming up a Christmas package for POW Noel. "How about cigarettes?" "Some canned food, like chicken?" "It's cold in those prison camps, how about a bottle of whiskey?" "As long as we're dreaming, how about a camera?" joked Max Desfor, Photo Editor. Bob Eunson, Bureau Chief, Bob Schutz, staff photographer, and Bob Tuckman, reporter, digested the electrifying idea. Why not?

At the Panmunjom truce parley site a few days later, Tuckman and Schutz worked on the idea with Communist correspondents Wilfred Burchett, Paris *Ce Soir*; Allen Winnington,, London *Daily Worker*; Chu Chi-ping, *Tu Kung Pao*, Peiping. Within a short time Burchett informed Bob Schutz that the Red Authorities had approved the plan. Schutz packed up his camera outfit, enclosed a letter to Noel, and passed it over the dividing fence to Chu Chi-ping.

Arrangements were secretly made in order not to alert either officials or competing newsmen. The AP dubbed the project OPERATION FATHER CHRISTMAS (for "Pappy" Noel). On Jan. 2, 1952, Bob Eunson and Max Desfor cabled AP headquarters in N.Y. "Sent Father Christmas package including Speed Graphic. Under plan. Pappy will make pictures present location for Associated only. Send Tokyo via various couriers whose reliability already proven. Realize this gamble but looks hopeful from here." AP N.Y. replied: "Resch [General News Photo Editor Al Resch] joins appreciation for fatherly report and best wishes for its success."

Three weeks of tense waiting went by before AP Tokyo "messaged" N.Y. on Jan. 24: "Christmas package in hand being carried by Schutz due Tokyo late tonight." Next hurdle to clear was G.H.Q. censorship (the Reds had censored the film before it got to Schutz). In a few hours, seven pictures made by Frank Noel behind the bamboo curtain were being transmitted by radiophoto to the United States. The AP had scored a "beat." Frank Noel was back on "active status" although a prisoner of war in Korea. A "first" had been written into photojournalism history.

The nation's newspapers headlined the story. "Exclusive—'Pappy' Noel Comes Through." "First Photos from Korean POW Camp." "Captured AP Lensman Scores Exclusive from Behind Iron Curtain." There were full page picture spreads, eight-column strips, panel displays.

Noel's pictures brought hope to the POW's, and to their folks in the U.S. During his internment he made several hundred pictures. On August 9, 1953, after thirty-two months of imprisonment, Frank Noel was freed. A unique episode had ended.

FRANK NOEL

52. Helen Keller Sees the President

The two women walked hesitantly into the office of the President of the United States. The one woman guided the other. The President welcomed them. As he spoke, an unusual thing was happening. Each word Mr. Eisenhower said was carefully listened to by one lady. She stood close to her friend, her hand resting lightly in the other's hand. The fingers of Polly Thomson danced swiftly across the palm of her life-long companion. Helen Keller's face broke out in a smile of gratitude as the President's words were interpreted to her.

The life story of this great woman is known to almost everyone from school child to adult. At the age of two, a serious illness had destroyed her sight and hearing. When she was seven, her father employed Miss Anne Sullivan, of the Perkins Institute for the Blind in Boston, Mass., to be both teacher and companion to the little girl. Anne Sullivan made contact with the child's mind through the sense of touch. She worked out an alphabet by which she spelled out words on Helen's hand. Gradually she was able to connect words with objects. Once Helen understood, she progressed rapidly. A special typewriter was made for her. By the time she was sixteen, she spoke well enough to go to college. Anne Sullivan remained with her, interpreting all lectures and classroom discussions. Helen Keller graduated with honors from Radcliffe in 1904.

CHARLES CORTE

After college, she devoted her life to promoting better care for the sightless. When Anne Sullivan died in 1936, Polly Thomson, who had been Miss Keller's secretary, took Miss Sullivan's place. During World War II, Helen Keller directed her efforts to working with war-blinded soldiers. She is an outstanding example of a person who not only conquered physical handicaps of her own, but also contributed to helping her fellow man. These were the things the President spoke of as the two women stood before him.

A few minutes earlier, in the White House press room, Mr. Eisenhower's press secretary, Jim Hagerty, had told the news syndicate photographers and the newsreel cameramen of Helen Keller's pending visit. Charles Corte, United Press photographer, later said, "Most of us wondered what was going to happen, knowing of Miss Keller's physical handicaps. We knew our time in Ike's office would be limited. When we entered the office, the three people were standing together, chatting. We all made one shot while the President spoke. I waited for a gesture or emotion before making a second shot. Evidently Miss Keller had expressed a desire to 'see' the President's famed smile. For a fleeting moment she touched his face, and I made the picture. We left the President's office.

"When the print was made, our Washington Bureau Chief, George Gaylin, 'cropped out' Miss Polly Thomson, leaving just her hand touching Helen Keller's. This was explained in the captions that accompanied the photo." The picture appeared on the front page of many newspapers, dated November 3, 1953. It shared a great moment in the life of a great lady.

United Press International

53. The Miracle Mile at Vancouver, B.C.

In a crowd, neither man would have been singled out as an athlete. Yet, in May, 1954, Dr. Roger Gilbert Bannister of England cracked the four-minute barrier at 3:59.4 at Oxford, England. The following month, at Turku, Finland, Australia's John Michael Landy set a new world's record of 3:58.0. It was inevitable that the two giants of the track would be pitted against each other.

Seven weeks later 32,000 fans filled the newly constructed two-million-dollar Empire Stadium at Vancouver, B.C. The climax of the British Empire and Commonwealth Games, a miniature Olympics, was the most widely heralded and universally contemplated footrace match of all times. It was Bannister versus Landy. The stage was set, the crowd tense.

Scores of news photographers were on hand to record the "Duel of the Four-Minute Men." Among them was *Sports Illustrated's* Mark Kauffman, a veteran news photographer who had worked many years as a staff photographer for *Life*. With *Sports Illustrated* reporter Paul O'Neil, Kauffman set about selecting the position from which he would photograph the race. After some discussion, Kauffman made his decision. Bannister would probably make his bid for the race against pacemaker Landy in the middle of the backstretch on the final lap. Accordingly, the photographer stationed himself beside the track about a hundred yards from the finish.

The starting gun popped. Eight men were off to a fast start. At home, millions of people watched the tense spectacle on TV. New Zealand's Murray Halberg took the lead with his teammate William David Baillie at his heels. Landy let them go and settled into fourth position. He stayed there for less than a lap. When he moved into the lead, his strategy was simple: to run the first seven furlongs at so blazing a pace that Bannister would be robbed of his famous last-minute kick. They ran Landy first and Bannister second at the end of the stretch. The battle had begun.

MARK KAUFFMAN

At the half Landy was still in the lead, Bannister was gaining ground. The rest of the field were far behind. The spectators were wild with excitement. Two hundred yards from the finish line, Landy made his bid for victory. Bannister refused to be shaken; he stretched his plunging stride. He came abreast of Landy, then pulled away to a four-yard lead with ninety yards to go. Mark Kauffman's 35mm camera nailed the split second that Bannister shot into the lead. His planning had paid off. His picture, looking as though Bannister was tearing right into his camera, has since become a symbol of the greatest footrace in history.

Bannister broke the finish tape, victorious. A second later he fell utterly exhausted, arms flapping, legs folding, into the arms of the English team manager. Bannister's time, 3:58.8; Landy's 3:59.6. The "Mile of the Century" was over; both men had finished under four minutes.

Kauffman's picture appeared in the lead story of Volume 1, Number 1 of the new magazine, *Sports Illustrated*, August 16, 1954.

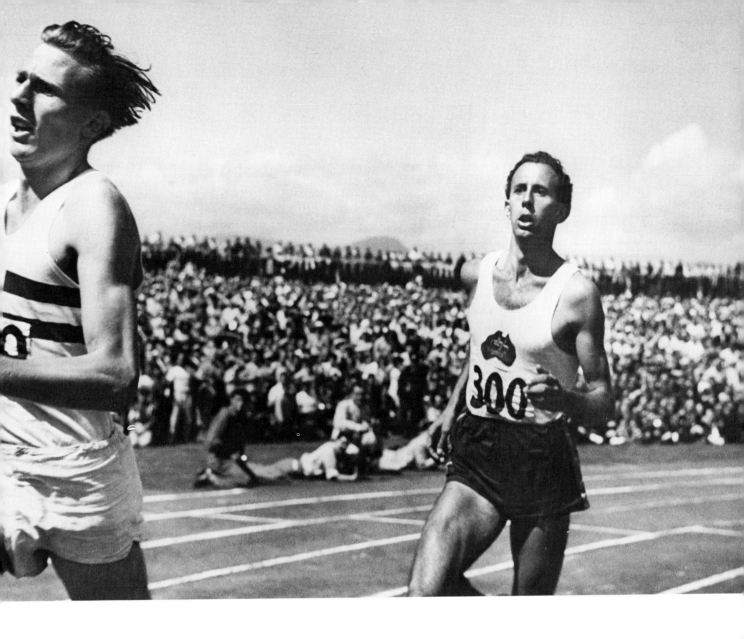

54. The Future

"How many of you fellows expect to come back alive?" asked a woman reporter. Seven men raised their hands in a single motion. Ralph Morse, long-time *Life* staffer, made a "grab shot" with his 35mm Contax.

There were 250 reporters and photographers present in the National Aeronautics and Space Administration auditorium in Washington, D.C., that day in April, 1959, when a special news conference announced the selection of the seven Astronauts. Morse was the only photographer to catch the picture which seemed to exemplify the spirit of the seven men, one of whom would eventually be shot into space.

The Mercury Astronaut program went into high gear. *Life* assigned Ralph Morse to document the lives of the Astronauts, their families, their training, the equipment involved in that training. It is one of the great stories of this generation.

It is not surprising that Morse was selected to do the job. He had covered most of the "shoots" from Cape Canaveral in the late 1950's, including the launching of Explorer I. But perhaps the most important factor was a story he'd done five years before.

In 1954, Morse had spent eleven weeks with the Strategic Air Command. He covered all phases of the program, both on the ground and in the air. In the process, he used a variety of photographic equipment valued at more than $10,000. It requires more than equipment, however, to turn out the kind of work Ralph does; it takes imagination, perseverance, ingenuity.

The zebra-faced man, looking like a creature from another world, was photographed on this assignment. Actually, the picture was made to illustrate a device which measured the contours of men's heads, used in the development of a better type of flight helmet. Ralph explained, "It was a horseshoe Strobe-Flash light. They passed this light from the rear of his head forward, and all the way across. The light was weak, so I set up the Rolleiflex on a tripod, darkened the room, and opened the shutter on a 'time exposure.' I passed the light over the man's face, at half-inch intervals, several times to build up the exposure on the negative." When the test was developed, it was badly underexposed. "We kept shooting and developing until we got one that had enough exposure. It finally took six flashes in each spot to register the light."

On the same assignment Morse flew the grueling 16-hour B-47 Globetrotter mission, the first civilian so permitted by the SAC. To record the reactions of the three crewmen, he mounted a small automatic camera in front of each one. On the flight, he triggered them by remote control from where he sat, wedged on a catwalk under the pilot.

"The flight," he recalls, "was lonely. The body of the plane was so cold that my small camera could have frozen stiff from contact with it, but some of the plane's equipment around me was too hot to touch."

Ralph Morse's pictures appeared as a thirteen-page photographic essay, "Airmen Gird for the New Jet Age," in the December 6, 1954, issue of *Life*. On the cover was the zebra-man. The caption read, prophetically, "Measurement for Future Flight."

As Ralph Morse continued to document the Mercury Astronaut Program for *Life*, man went into space and finally landed on the moon. Future historians studying this period will learn from news photography the story of our times.

RALPH MORSE

55. Bob Barksdale's Record High Jump

In the files at the N.Y. *Daily News* there is an envelope marked Charles Hoff. It contains news clippings about the man, and a record of the photographic awards he has received since 1938. Sixty-seven prizes are listed. The majority of them are in the field of sports. . . . Charlie Hoff is one of the top sports photographers in the U.S. today.

Of the many pictures he has taken, one brought more honors than any of the others. It was made on February 13, 1956. The photo shows Bob Barksdale of Morgan State University as he shattered a 22-year-old record for the high jump. The picture is outstanding because of action recorded by Hoff and the unusual lighting effect on the subject.

The position of the three electronic flash units had been worked out well in advance of this, the eighty-eighth N.Y. Athletic Club Meet at Madison Square Garden. At the Garden, house electricians who hang the N.Y. *News'* electronic flash lamps refer to this positioning as the "Levine Method." They credit Phil Levine, Studio Manager of the *News*, who for many years has taken the interest to work out special lighting arrangements with the *News* photographers.

At the Garden that Saturday night, Charlie Hoff recalled Levine's suggestion. "You might be able to get someone silhouetted in that light." The week before he had tried for it, but couldn't get the jumper in the right position. Tonight, if a jumper came in from the left side, he'd get the chance he was waiting for. Charlie was busy; besides the high jump, he had to cover the mile run, the two-mile run, the 100-yard dash, and other events.

He remembered "aiming" the electronic flash units. Two were hung from the top balcony in the Garden, and a sidelight unit was wired on to the mezzanine. All were connected by cable to the shutter of his 4x5 Speed Graphic. With this system, Hoff could walk around and fire his shots as needed.

CHARLES HOFF

The high jump event got underway. Hoff spotted Barksdale making the jump from the left side. Immediately he moved into a position twenty feet from the jumper's standards. He laid on the floor, looked through the camera finder. His main light source pointed directly into his lens from the top balcony—one hundred twenty-five feet away. He would have to catch the jumper at the precise moment he went over the bar, his body blocking out that light. The bar was set at a record-breaking 6′9″. As Barksdale swung over it, Hoff triggered the Graphic. He knew he had his shot. Finishing up at the Garden, he went back to the office and left his film there for processing.

Hoff's picture of Barksdale's record high jump ran the full rear page of the *Daily News*. It was serviced by the Associated Press. Charlie Hoff received letters of congratulation from all over the country.

In 1957 he received 1st Award in Sports Pictures for the Barksdale shot in the coveted National Press Photographers Association—Encyclopaedia Britannica Picture Contest of the Year.

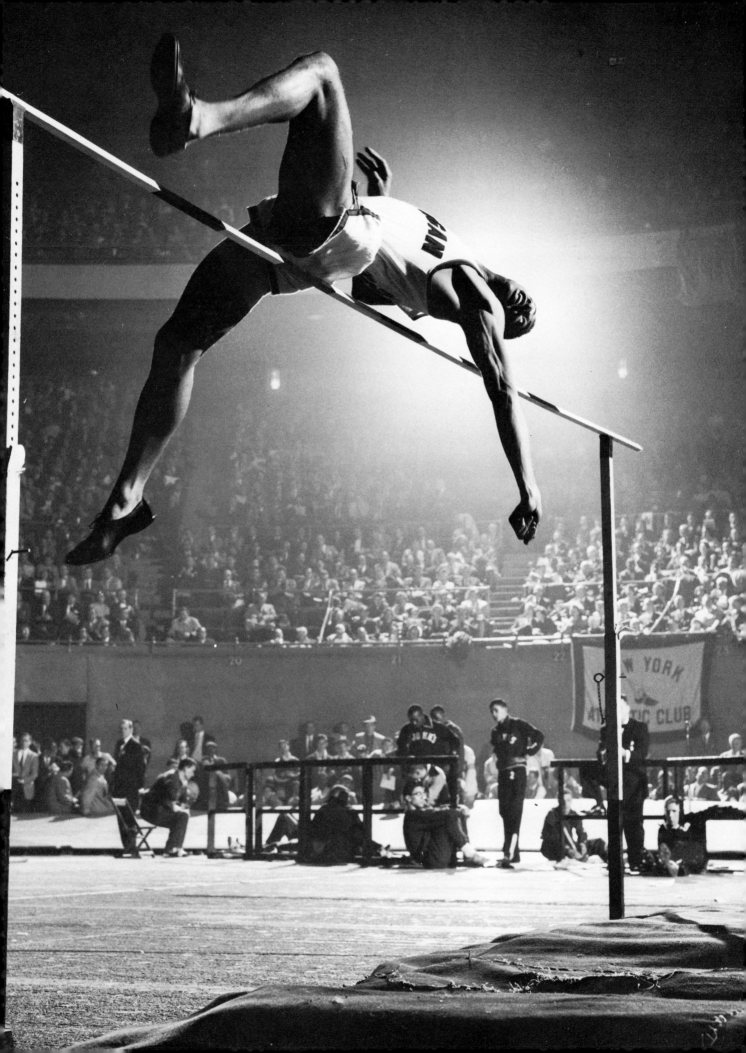

56. Global Assignment

In the darkroom on the second floor of the *Christian Science Monitor* in Boston, Mass., chief photographer Gordon Converse was busily engaged making prints for the day's newspaper. There was a knock on the door. The copyboy handed him a message. It stated simply that he was to photograph twenty of the world's great leaders in their respective cities. This casually delivered assignment was one of the greatest reporting undertakings ever devised by a newspaper.

The *Monitor* explained to its readers, "William Stringer, Chief of the Washington Bureau, and Gordon Converse, award-winning Chief Photographer, will fly around the world for views and interviews with the world's most famous political figures. On their list are such men as Eisenhower, Nasser, De Gaulle——."

Managing Editor Saville R. Davis later explained, "We wanted to listen to what others had to say about the important contributions which their people could make in the world today. This was a trip to give these world leaders our respectful attention and to let them speak."

On November 6, 1958, the photographer and the reporter left Washington, D.C., for the Far East. In Tokyo they interviewed Premier Nobusuke. Stringer had three basic questions to ask during each interview. As the conversation became more animated, Converse would open up an attache case he carried. It held two 35mm Leica cameras. "As Bill began to talk, I'd take out the Leica with a normal 50mm lens, and gradually begin to make pictures. I was never stopped."

In Taipei, they talked with Generalissimo Chiang Kai-shek. In Burma, the editor of the newspaper helped them obtain an interview with Prime Minister U Nu. In India, as they listened to Prime Minister Nehru, pet monkeys chattered just outside the window on the balcony. The interview with President Sukarno of Indonesia was held at the airport. After the President left, an over-zealous security officer confiscated Converse's films. The officer thought the airport, a forbidden subject, might have been photographed. Only through the efforts of a highly respected and persuasive U.S. official were the films rescued the following day. In Israel, they saw Prime Minister Ben-Gurion; later in Egypt another newspaper editor helped them obtain an interview with Prime Minister Nasser.

Arriving in Moscow, they waited seven days at the Metropole Hotel for word of a promised interview with Premier Khrushchev. It didn't come about. They flew on to Germany where they chatted with Chancellor Adenauer. From England, where they saw Prime Minister MacMillan, they flew to Ghana to interview Prime Minister Nkrumah.

Converse and Stringer returned to the United States on February 22, 1959. Their assignment had taken them 40,000 miles by air over a period of three and one-half months.

The *Christian Science Monitor* ran a series of twenty-three "Summit Interviews" written by William Stringer, with photos by Gordon Converse. These were followed in seventeen subsequent weekly editions by full pages of "human interest" pictures made by Converse between interviews. This later series was titled "Around the World in Pictures."

Gordon Converse received the National Conference of Christians and Jews Brotherhood Award in 1960. It read in part, "His photographs were an emphatic contribution in promoting friendship and brotherly love between the peoples of the world."

GORDON CONVERSE

Top left: Jawaharlal Nehru. *Top right:* Gamal Nasser. *Bottom left:* Chiang Kai-shek. *Bottom right:* Konrad Adenauer.

57. Death at the Indianapolis Speedway

The young architect had a yen for news photography of a very special kind—automobile races. Each year Eugene Pulliam, Jr., Managing Editor of the *Indianapolis News*, hired four additional non-professional news photographers to insure greater coverage of the famous Indianapolis 500-mile automobile race. For five years J. Parke Randall had been a member of this "permanent one-day staff"—a job he thoroughly enjoyed. He didn't know, when he left home early Memorial Day, May 30, 1960, that by nightfall his pictures would be seen coast-to-coast.

He arrived at the Indianapolis Speedway at 9:30 A.M., walked the mile or so to the northeast corner of the track to which he had been assigned. It was the third and fastest turn.

Upwards of 175,000 spectators had turned out to see the race. As usual, many framework stands had been erected by private speculators for use of fans who had not bought grandstand seats. One in particular, some thirty-five feet behind Randall's location, was a 30-foot tall aluminum and wood structure, not unlike an oversized housepainter's scaffold. It was "guyed" to a two-ton flatbed truck. More than one hundred twenty-five fans had paid $5 or $10 for the privilege of viewing the race from this vantage point.

Randall checked his Leica 3F, fitting on the 90 mm lens, and tested the Leicavit trigger. At 11:00, thousands of balloons were released, signalling the start of the parade lap. Thirty-three cars jockeyed into position. Then the pace lap began. The spectators roared with excitement. As the cars rounded the third turn, Randall made his shot. The crowd behind him was in a frenzy. Above the sound, Randall suddenly realized he heard terrified screams. Glancing over his left shoulder, he saw the 30-foot scaffold toppling off its base into the crowd below.

J. PARKE RANDALL

He swung around, and made a series of pictures as the structure crashed downward. The racing cars could be heard approaching again. Randall, reacting as an experienced cameraman, recorded them as they passed. Between laps he continued to photograph the tangled mass of struggling humanity. He maintained his position. "My first obligation was the assignment the newspaper had given me. I stayed where I was to cover the race." That afternoon he saw Jim Rathmann win with a recordbreaking average speed of 138.757 mph.

Seventy persons were injured in the fall. Ironically, one of the two men who died was the man who had "leased" the platform.

Telephone contact between the *Indianapolis News* reporters was cut off by the crashing scaffold. It was more than an hour after the accident that a reporter picked up Randall's films and rushed them to the paper via motorcycle driver.

Driving back to the *News* office after the race with veteran photograph Larry George, Randall heard Bob Lavelle, chief photographer, inquiring by radio where J. Parke Randall was. He identified himself. Lavelle explained that the series of photos had "hit." The Associated Press had serviced the pictures nationwide. Messages of congratulations were pouring in.

Across the country, the news of the winner of the Indianapolis Speedway's 44th Annual Race, normally headline material, was relegated to inside pages. Page One carried J. Parke Randall's remarkable sequence.

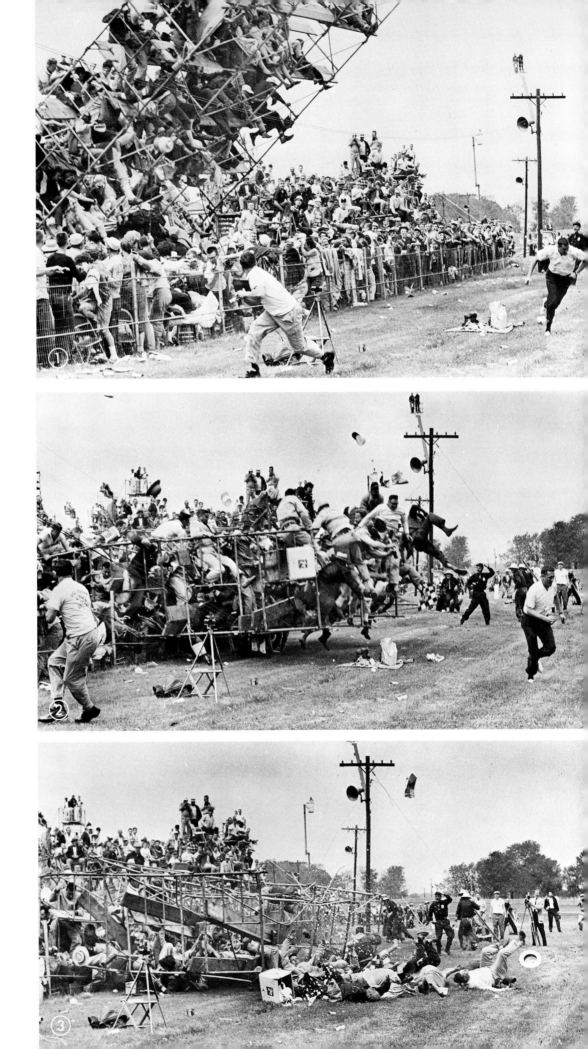

58. The Assassination of Asanuma

Yasushi Nagao was one of thirty-six cameramen working for *Mainichi*, a daily newspaper in Tokyo with a circulation of three million. For eight years he had performed his job faithfully, but without special recognition. October 12, 1960, would be different. He arrived at *Mainichi* promptly at ten A.M. There were the usual routine things to do until Picture Editor Hisatake Abo assigned Nagao to cover a political debate at Hibiya Hall. He slipped a twelve-exposure filmpack into his 4x5 Speed Graphic camera and was driven to his assignment, arriving just after two P.M.

More than 3,000 people had gathered to hear the debate on the forthcoming elections between Inejiro Asanuma, Chairman of Japan's Socialist Party, and Hayato Ikeda, the Liberal-Democratic Prime Minister. Feelings were running high between factions of both parties. The crowd was noisy and unruly.

In the giant hall, Yasushi Nagao worked his way through the crowds to the speaker's platform where fifteen other photographers had gathered. To the rear of the room twelve newsreel and television cameramen were working. Using an electronic flashgun, Nagao shot five general views, three pictures of Asanuma, and three of the introductory speaker. He thus had only one unexposed negative in the filmpack.

Asanuma began his address. A group of rightist hecklers started to jeer and toss wads of paper. As policemen ran to stop the demonstration, the other news photographers followed them. Nagao stayed where he was, along with a cameraman from *Kyodo Press* and one from the *Tokyo Shimbun*.

A slender figure emerged from the jostling crowd. Otoya Yamaguchi, seventeen-year-old son of a Self-Defense Force Colonel, part-time student and fanatic ultra-rightist, charged up the steps of the speaker's platform and ran out onto the stage toward Asanuma. Nagao quickly changed focus of his camera by "feel" from ten to fifteen feet. "I thought," he later said, "Yamaguchi was carrying a brown stick to strike Asanuma." The "stick," proved to be a foot-long sword.

Asanuma, in fearful astonishment, recognized the weapon. He closed his eyes as the blade pierced his body. The *Kyodo Press* and *Tokyo Shimbun* photographers made the shot (one picture was out of focus and in the other most of the action was hidden by the podium). Nagao instinctively waited for a clearer view. The momentum of the running assassin crashing into the victim whirled the men clear of the podium. Asanuma sagged as Yamaguchi withdrew the blade. Eluding would-be rescuers, Yamaguchi again aimed the sword at the wounded Asanuma. Yasushi Nagao recorded that moment on his last unexposed negative.

At *Mainichi* the staffers were watching Public Television Company's NHK-TV coverage of the Japanese World Series. The program was interrupted by a news flash about the assassination. Three photographers grabbed their cameras and raced in a car to Hibiya Hall. There they met Nagao who immediately gave his exposed filmpack to the driver to rush it back to *Mainichi*. Nagao phoned the newspaper to let them know he "had the picture," then hurried to the hospital where Asanuma had been taken, only to find he had died en route.

The Tokyo bureau of the United Press International was located on the eighth floor of the Mainichi Building. UPI, having exclusive rights to all *Mainichi* news pictures, immediately radiophotoed the assassination photo to the United States. In New York City, Harold Blumenfeld, Executive Newspictures Editor for UPI, entered it in various news photography competitions. It captured every top award in the United States, including the coveted Pulitzer Prize of 1961.

Yasushi Nagao

126

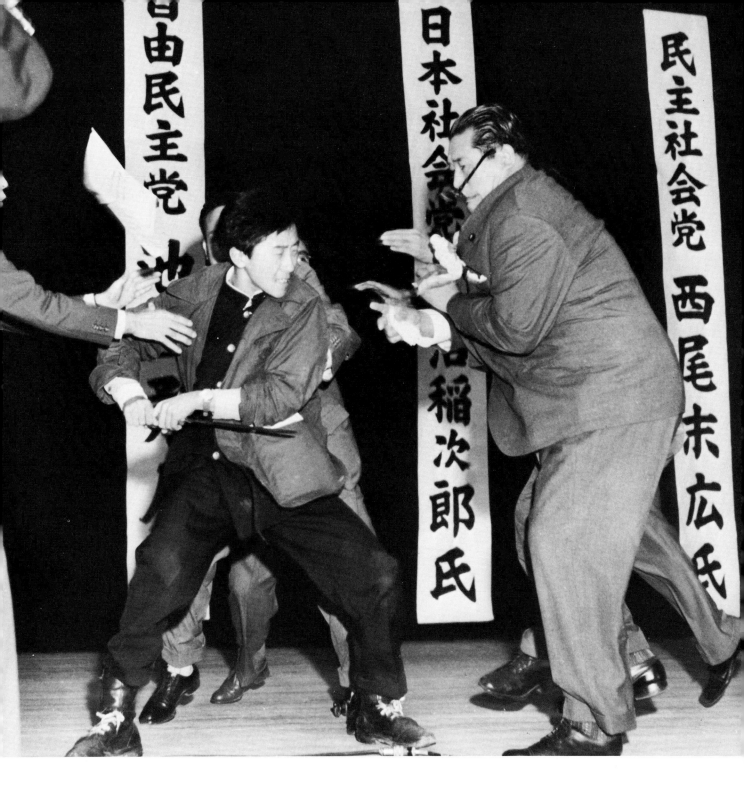

59. The Official Portrait of President John F. Kennedy

The presidents of the United States have commissioned artists to create their official portraits from the country's infancy. Most have been executed in oils, but John F. Kennedy was among the few presidents in recent years to opt for a photographic portrait. An omnivorous reader, he was greatly impressed with the photojournalism techniques used in *Life* magazine and decided that Alfred Eisenstaedt should be the man to take his official portrait.

Three weeks after President Kennedy's inauguration in 1961, Eisenstaedt was sent to Washington by *Life* to do a photographic essay on the men around Kennedy. He had photographed Arthur Goldberg, Dean Rusk, and Robert McNamara when Presidential Press Secretary Pierre Salinger came to Eisenstaedt to tell him that the President had requested that Eisenstaedt take his official portrait.

At the appointed time he reported to the Oval Office in the White House, carrying several cases of photographic equipment. As he waited for Kennedy he started planning how he would make the picture. He would use indoor tungsten 35mm film with several photoflood lamps to offset the mixed tungsten and fluorescent room lights. "My great worry," Eisenstaedt later said, "was the strong daylight pouring into the room from three huge windows just behind the President's desk. I knew it would ruin the color balance in my pictures." He tried drawing together the draperies, but they would not stay closed. As he pondered the problem he was told that the President had been forced to cancel his appointment. He was asked to come back the following day, February 23, 1961, at noon.

ALFRED EISENSTAEDT

Early that morning Eisenstaedt bought several packages of large safety pins to keep the draperies in the President's office closed. Arriving again at the Oval Office Eisenstaedt was greeted by an apologetic President Kennedy. Only three people were present during the session: the President, the photographer, and a reporter for *Life*. Eisenstaedt began to set up his lighting equipment and the President helped him arrange some of the gear. When Eisenstaedt explained he would have to close the drapes to shut out the strong daylight, the President helped him pin the material together.

"My first roll of 35mm color film I shot of the President standing. I then asked if I could make another roll of him sitting behind his desk. 'Go right ahead, do whatever you feel is necessary,' the young President replied. I kept talking to him to record the right expressions. Once, while I was changing lightstand positions, the President walked over to a side table and glanced down to read several newspapers. I quickly took another 35mm camera and made several candid shots.

"When we were finished I thanked the President and showed him my autograph album. In it are hundreds of signatures of famous people I have photographed. I asked if he would sign it for me. He carefully examined the book and asked questions about an unpublished poem the poet Robert Frost had written when he signed my album. He then wrote, 'For Alfred Eisenstaedt, who has caught us all at the edge of the New Frontier. What will the passage of the next four years show on his revealing plate? John Fitzgerald Kennedy.'" The President would never know. He was assassinated on November 22, 1963.

First appearing in *Life*, Alfred Eisenstaedt's famous Official Portrait of President John F. Kennedy has been reproduced in publications throughout the world.

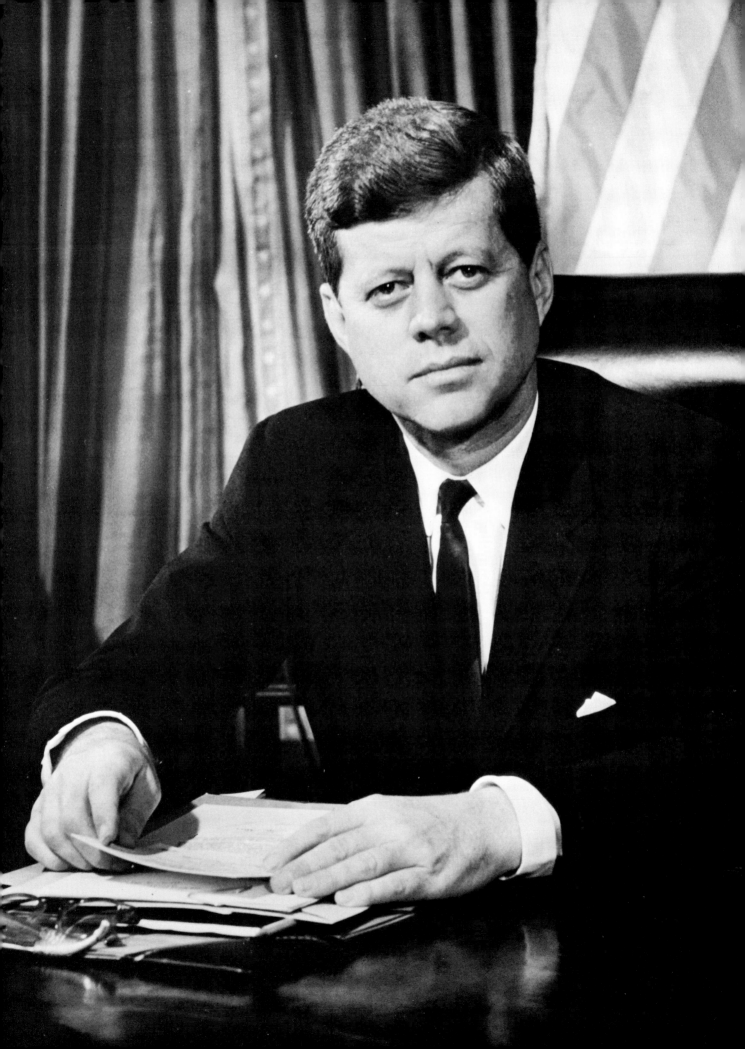

60. "I Have A Dream..."
Martin Luther King, Jr.

Dr. Martin Luther King, Jr., the American civil rights leader, felt his eight-minute speech had to be better. Silently throughout the night he reworked his words. He thought of using a theme he'd tried earlier in Detroit, about a dream, but decided against it. In the morning he showed what he had written to his wife, Coretta, and together they made the final revisions. Shortly before noon they drove to the Lincoln Memorial. It was August 28, 1963, the day of the Civil Rights March on Washington, D.C.

Among the hundreds of press members covering the event was a handpicked staff representing both *Jet* and *Ebony* magazines. Simeon Booker, Washington Bureau Chief, coordinated the staff assignments.

G. Marshall Wilson started the day at six A.M. He carried four 35mm cameras hung around his neck, an equipment case of accessories, and enough film for twenty-four hours. His photographic gear weighed thirty-eight pounds. His assignment was to roam the area making human-interest shots. By noon he had worked his way to the speaker's platform in front of the Lincoln Memorial. He climbed a nearby elevated cameramen's stand. From the top he saw the thousands who had come, an inspiring sight, and had a great idea. Rushing down to where the speakers were gathered he searched for Dr. King. He explained his idea. Knowing the value of a good news picture, Dr. King consented to accompany Wilson to the top of the cameramen's platform. There Wilson photographed Dr. King as he waved to the tremendous audience below. The stand was small, so Wilson used a 24mm wide-angle lens on his 35mm camera. When the photography was over Dr. King returned to wait with the other speakers.

As the sunny, hot afternoon wore on, the crowd grew restless. Finally, at 3:30 P.M., Dr. King began his prepared talk, "Five score years ago, a great American, in whose symbolic shadow we stand, signed the Emancipation Proclamation. . . . But one hundred years later, we must face the tragic fact that the Negro is still not free."

Then, although Dr. King had not planned to use the phrase about a dream, he went into what has become one of the most memorable speeches of all time. "I say to you today, my friends, that in spite of the difficulties and frustrations of the moment I still have a dream. It is a dream deeply rooted in the American dream."

In cadence thousands of voices repeated "I have a dream," causing the great leader to pause for quiet. "I have a dream. . . . I have a dream that my four little children will one day live in a nation where they will not be judged by the color of their skin but by the content of their character." As Dr. King continued he began each thought with "I have a dream." In conclusion he lowered his voice. "When we let freedom ring, when we let it ring from every village and every hamlet, from every state and every city, we will be able to speed up that day when all of God's children, black men and white men, Jews and Gentiles, Protestants and Catholics, will be able to join hands and sing in the words of the old Negro spiritual, 'Free at last! Free at last! thank God Almighty, we are free at last!'" There was almost total silence as Dr. King gathered up his notes and moved back to his seat. Then the crowd went wild. Marshall's photograph has become the symbolic picture of a great man, a historic day, and a tremendous human event.

G. MARSHALL WILSON

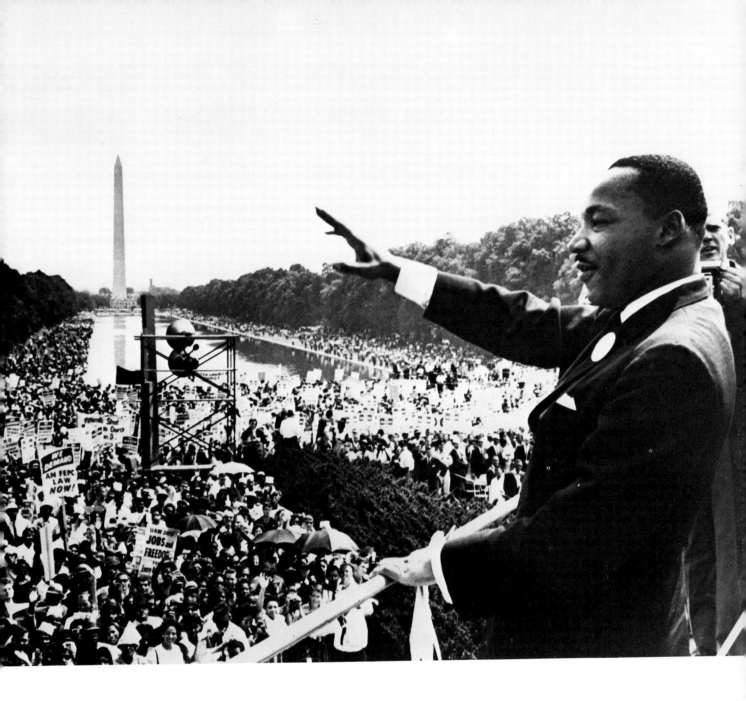

61. The Sacrificial Protest of Quang Duc

South Vietnam's two major religions were in violent conflict. President Ngo Dinh Diem's militant Roman Catholic regime had finally brought the Buddhists, eighty percent of the country's population, to the end of their nonviolent protests. Previously the Buddhist monks and nuns, chanting prayers, had formed almost endless processions, going from pagoda to pagoda. When their religious flags were displayed, Diem had them torn down. On May 8, 1963, in Hue, eight people were left dead when Diem's police attempted to break up a demonstration.

The foreign press, wondering what action the Buddhists would take, became deeply involved chasing down rumors and false leads. Already under heavy pressure covering the Vietnam War, the correspondents were now burdened with new frustrations. One evening, Malcolm Browne of the Associated Press received a phone call from Thich Duc Nghiep, who served as a kind of information officer for the Xa Loi pagoda, the principal pagoda of Saigon. Nghiep told Browne he was calling all the correspondents in Saigon to inform them of a special memorial service set at the Tu Nghiem pagoda for eight the following morning, June 11. He stressed again and again that Browne should be there.

Six blocks east of the Xa Loi pagoda, Malcolm Browne and Ha Van Tran of the AP found the small Tu Nghiem pagoda. The narrow alleyways around it were already packed with monks and nuns in ceremonial robes. Several laywomen, Buddhists in the white dress of mourning, cried as they served tea. Browne saw only two other correspondents present—Simon Michau of Agence France Presse, and Nguyen Ngoc Rao, working for United Press International. It was evident to Browne that only he and his AP colleague had brought cameras.

Within an hour the chanting and ceremonies ended. The vast group, led by a gray automobile, began to move up the street toward the Cambodian diplomatic mission. The car halted where Phan Dinh Phung and Le Van Duyet streets met. The long line of monks and nuns, over 350 people, formed a huge circle. Two monks got out of the vehicle, opened the hood, and removed a white five-gallon jerry can full of pink gasoline. Three other Buddhist monks left the car, walking to the center of the intersection.

MALCOLM BROWNE

"I realized at that moment exactly what was happening and began to take pictures a few seconds apart," Malcolm Browne later remarked. "The two monks placed a brown cushion on the pavement and helped the third monk [Thich Quang Duc] to sit. The other two monks carrying the gasoline poured most of it over his head. They then stepped back and joined the circle of people.

"Standing about twenty feet away I clearly saw him strike a match in his lap, and with a slight movement, touch his robes. The actual lighting [Browne kept checking his wristwatch] happened at 9:22 A.M. His expression slightly grimaced when the flames engulfed him, but he never cried out or said anything. By 9:35 A.M. Quang Duc had fallen over backwards, and after a few convulsive kicks, was clearly dead and charred although he was still burning." By 10:45 A.M. the film was en route to Tokyo.

The picture of the burning monk appeared on the front pages of the world's newspapers, horrifying the readers. The international public could now judge, evaluate, and take action on the fight for religious freedom in Saigon.

Associated Press

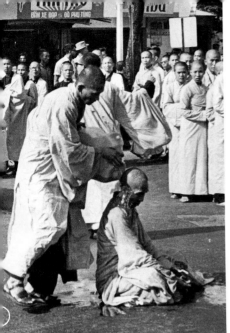

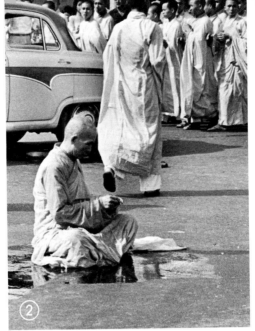

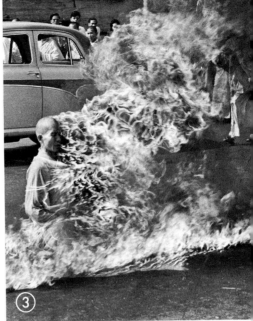

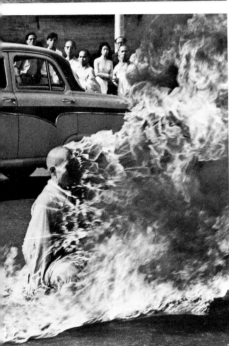

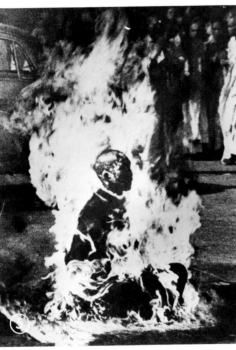

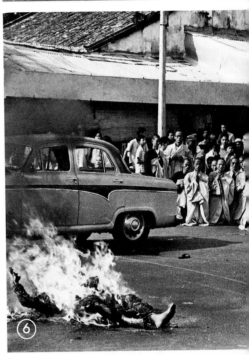

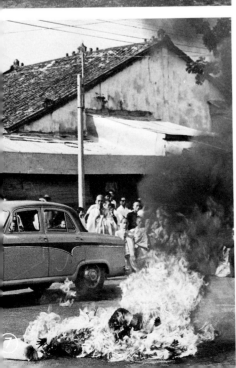

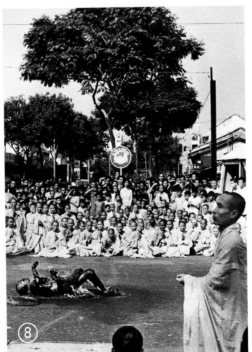

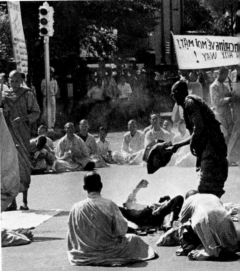

62. The Shooting of Lee Harvey Oswald

Sunday morning, just before noon, November 24, 1963, the nation was in a state of deep shock. On November 22 the President of the United States, John Fitzgerald Kennedy, had been assassinated in Dallas, Texas. Today he would be buried in Arlington National Cemetery. In Dallas, Texas, a crowd of over two hundred angry people had gathered outside the County Jail to get a look and express their feelings at Lee Harvey Oswald, the alleged assassin, who was about to be transferred there from the City Jail.

Early that morning *Dallas Times-Herald* photographer Bob Jackson had been given two assignments. At 9:15 he was to photograph the Oswald transfer, and at 10:30 he was to cover a press conference held by Mrs. John Connally, wife of the wounded governor, at Parkland Hospital. Jackson arrived before nine at the City Jail. When reporter Bob Fenley showed up, both men went to the basement to wait for the prisoner's exit. As the time neared to cover his second assignment, Jackson asked Fenley to report the delay to their newspaper. The city desk told them to stay on the Oswald story.

Around eleven it was said that Oswald had just gotten on the elevator and would be coming off in the basement in a few minutes. In the small lower-level corridor area more than fifty men scrambled for positions along the ramp in front of the door where Oswald would soon appear. NBC-TV, with its tripod-mounted camera, would be going "live." Bob Jackson had already taken his spot in the crowd on the right.

ROBERT JACKSON

The door opened and Captain Fritz emerged, followed by Oswald. Handcuffed, he was guided on his right side by Detective Leavelle, who held his right arm, and by Officer Graves, who held his left. They began moving into the crowd. Bob Jackson was sighting his 35mm camera when a heavyset short man pushed his way toward Oswald. Someone yelled, "Jack, you son of a bitch!" Moving by instinct, Jackson tripped his camera's shutter a split second after the gunshot was heard. Oswald gave out a loud moan. He doubled over as the officers dragged him back to the doorway from which he had just emerged. Others jumped the short man with the snub-nosed revolver, disarming him. Jackson tried for another picture but his electronic flashgun, not having had enough time to recycle, failed. When the confusion subsided it was learned that the man who shot Lee Harvey Oswald was Jack Ruby, a fifty-two-year-old local nightclub owner.

Having to wait almost two hours at the City Jail before he was relieved, Bob Jackson worried if he had recorded the actual shooting. Had he triggered his camera too soon? He raced back to the *Dallas Times-Herald* to find that a similar picture of the shooting, made by competitor news photographer Jack Beers for the *Dallas Morning News*, had already been sent over the nation's "wired-photo" network. It had been taken an instant too early. Although it showed Jack Ruby pointing his gun at Oswald, the prisoner and two police officers had not seen Ruby and were looking straight ahead, unconcerned. Jackson hurriedly developed his 35mm film, made one "wet 11x14 print," and dropped it on the city desk. Jackson had recorded the terrifying instant Oswald was shot. The fright of the event was shown in the faces of the men in the scene. Robert Jackson was awarded the 1964 Pulitzer Prize for his memorable news picture of the historic moment.

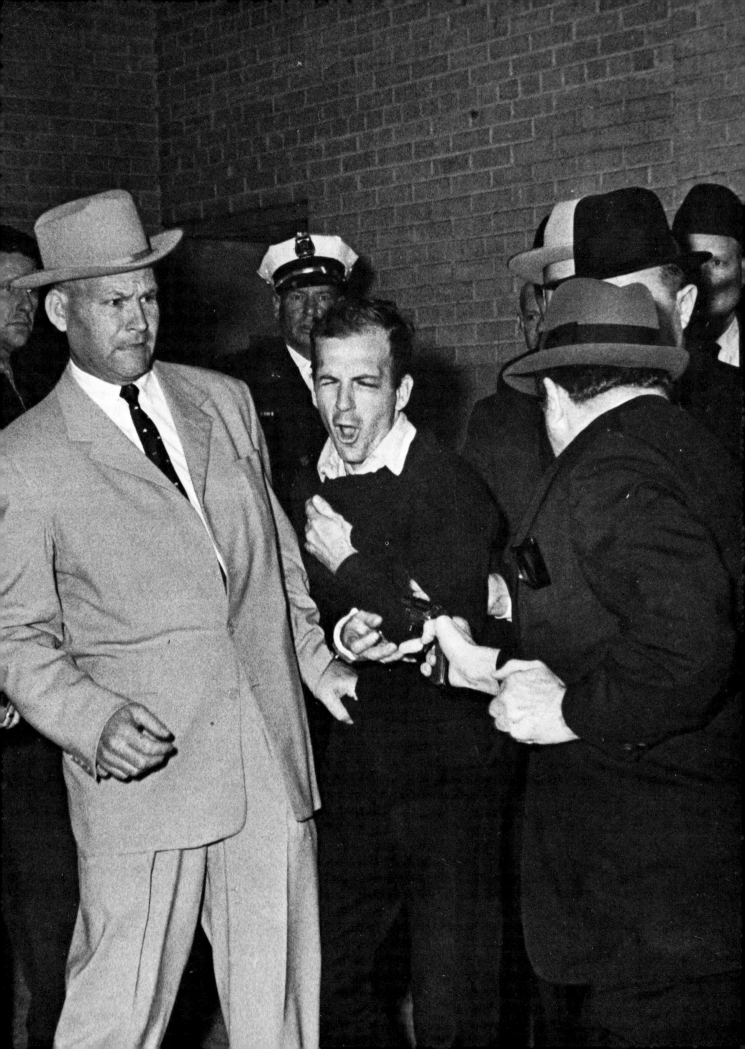

63. Execution in the Streets of Saigon

Saigon, February 1, 1968. The Tet Offensive was sweeping through South Vietnam. The Viet Cong commandos had already penetrated the city and were even fighting within the U.S. Embassy compound. Brutal street fighting between the Communist infiltrators and the South Vietnamese police became a daily routine. The Associated Press's war correspondent photographer, Eddie Adams, in his third tour of duty, began his day.

The staffs of AP and NBC-TV had found that if they covered war assignments together they had a better chance of returning alive. On this morning, Vo Su, an NBC cameraman, rushed over to the AP office to tell Eddie Adams a battle was taking place at the An Quang pagoda near the Cholon section of Saigon.

The two cameramen, accompanied by Howard Tuckner of NBC, drove their car into the Cholon area. Hearing shooting, they parked the auto and made their way through the debris on foot. At the pagoda, as the South Vietnamese police and airborne troops broke through the main gates to capture the infiltrators, the two cameramen photographed the dead and wounded.

As Eddie Adams relates the facts, "Half a block away I noticed a policeman and an airborne trooper bring a suspect out of a building. He was a small barefooted man in civilian clothes with his hands tied behind his back. As they walked toward me, I ran up just to be close by in case something happened. I felt it was just another ordinary street arrest since they were heading for a nearby jeep. My friend Vo Su kept filming as we saw another policeman on my left start walking toward the prisoner. He was drawing his pistol from its holster. I thought he was going to threaten the V.C. so I framed my 35mm rangefinder camera, making the picture as I heard a gunshot." The bullet tore through the prisoner's temple. He fell over backwards. Eddie Adams kept making photos until the blood gushing from the dying man's head made the scene unbearable. As soon as the confusion ended, Tuckner questioned the executioner. The newsmen learned he was Colonel Nguyen Ngoc Loan, Chief of the South Vietnamese National Police.

Returning to the AP office, Eddie Adams turned in his exposed film to be processed and transmitted to the world's press. He did not stay to see what the photos looked like, having seen enough brutal killings.

Within two days telegrams began pouring into the AP's Saigon Bureau, demonstrating how Adams' execution picture had influenced the world's thinking. In the United States the photo was ammunition for antiwar factions. The North Vietnamese Communist press published the picture, claiming it proved the war was a civil war and that the United States had no right to be involved.

Colonel Nguyen Loan's military career was greatly altered because of the picture. Although he was promoted to Brigadier General, his police responsibilities were taken away. His life was constantly threatened. He now worked surrounded by protecting staff officers until he was badly wounded inside Saigon. Eddie Adams visited him in the hospital and during his recuperation they became good friends.

Eddie Adams's "Execution in the Streets of Saigon" was awarded the 1969 Pulitzer Prize along with the first-place honors in almost every news-picture contest through the world.

EDDIE ADAMS

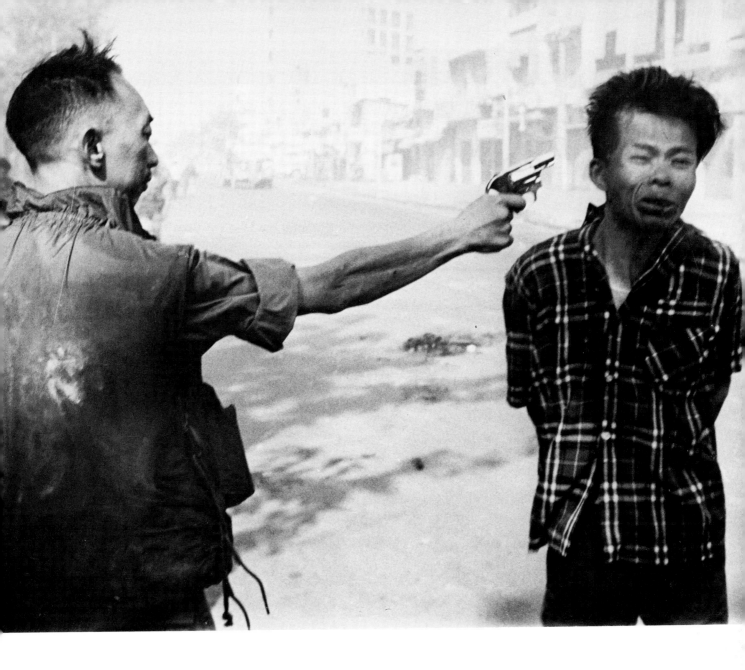

64. The Death of Presidential Candidate Robert Kennedy

Robert Francis Kennedy was one of the most promising young political leaders in recent American history. He had successfully run his brother's presidential campaign in 1960. The following year President Kennedy appointed the thirty-six-year-old Bobbie Kennedy Attorney General of the United States. He was known as a relentless fighter for the poor, the downtrodden, and the alienated inhabitants of the black slums. In 1968, as Senator from New York, he announced his intention to run for the presidential nomination of the Democratic Party. So it was that Robert Kennedy was in the Ambassador Hotel, Los Angeles, on June 4, 1968, the day of the California primary election.

Boris Yaro, photographer-reporter for the *Los Angeles Times* working the 1:30 P.M. to ten P.M. shift, had gone home two hours early because of illness. Yaro greatly admired Kennedy and was certain that he would make it all the way to the White House. He felt better around 10:30 P.M. and drove to the Ambassador Hotel, where Kennedy was certain to give a victory speech around midnight.

Parking his car, he decided to make his pictures under the existing light. Knowing he would be working in crowded conditions, he slipped a 28mm wide-angle lens on his 35mm reflex camera. He dropped two unexposed rolls of film in his pocket. Entering the hotel he found the Embassy Ballroom jammed, making easy passage to the speaker's platform impossible. Talking to several people in the Press Room, Yaro learned the Senator would be entering the ballroom through a kitchen hallway and immediately rushed there, but missed Robert Kennedy by a few seconds. He tried the ballroom again, pushing his way to within thirty-five feet of the Senator, hearing him ending his victory speech. But Yaro still didn't have the close-up photo, so he decided to take a chance that Robert Kennedy would exit the same way he came in. He raced back to the kitchen hallway to wait. Other people had also gathered in the hallway, including Sirhan Bishara Sirhan, a Jordanian Arab who disliked Kennedy's support of Israel. Photographer Yaro paid the group no attention. It was now 12:16 A.M., June 5th.

BORIS YARO

Boris Yaro later remembered, "When the Senator started back through the hallway, I scrambled over to his right to try to keep him in frame and as I went. Then he gave me a break, stopping to shake hands with someone. I was trying to focus in the dark when I heard a loud bang! bang!

"I watched in absolute horror. I thought, 'Oh my God, it's happening again! To another Kennedy!' The fear that held me broke only after the shots stopped and someone shouted, 'Get him!' Two men grabbed the suspect's arms.

"I turned towards the Senator. He was slipping to the floor. I aimed my camera, starting to focus when someone grabbed my suit coat arm. I looked into the dim light, seeing a woman with a camera around her neck. She's screaming at me, 'Don't take pictures! Don't take pictures! I'm a photographer and I'm not taking pictures!'" For a brief instant Boris Yaro was dumbfounded. Then he told her to let go of him. The woman hung on, repeating her words. "I said, 'Goddammit, lady, this is history!'" He took his photographs.

At the *Los Angeles Times*, Yaro's film was processed and printed by Bill Murphy while Yaro told his story to a rewrite man. Afterwards Boris Yaro, still in shock, went into a darkroom and wept over the tragedy he had recorded for history.

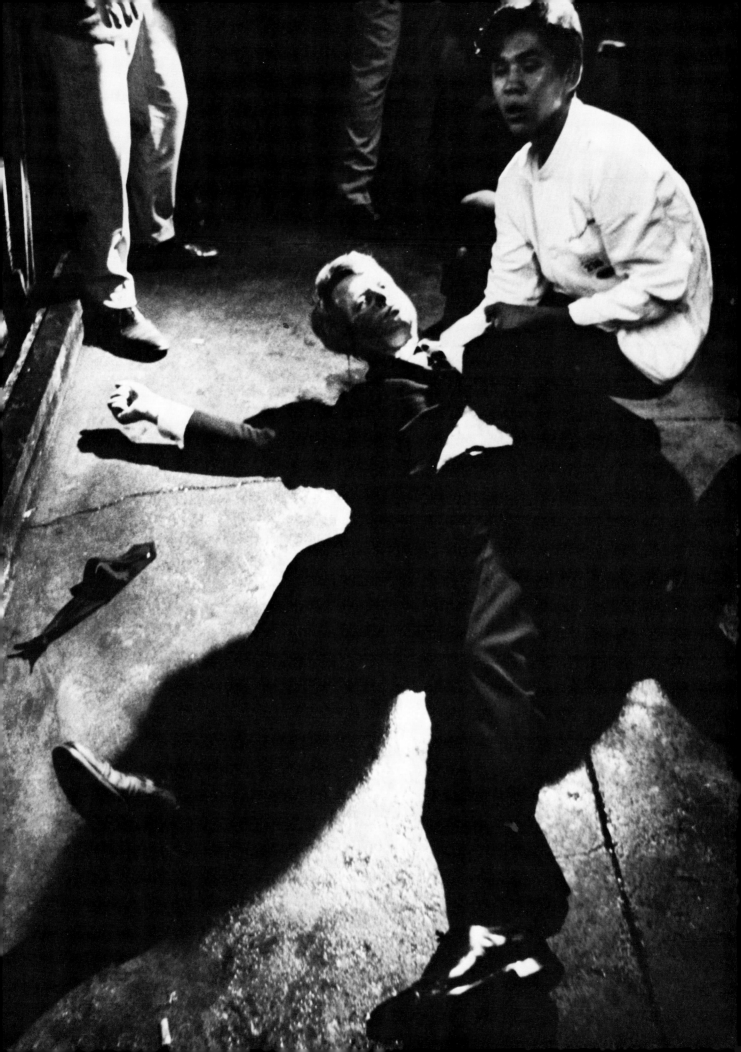

65. The First Men on the Moon

They were trained to do a photojournalistic recording job—to photograph what they saw and did in addition to performing their other duties. Their pictures would allow the public to see what had never been seen before, and offer scientific researchers priceless material. They were to fly to the moon, land on it, and return to Earth. They were American astronauts Mr. Neil Armstrong, Col. Edwin "Buzz" Aldrin, and Lt. Col. Michael Collins.

At 9:32 A.M., July 16, 1969, the huge Apollo 11 spacecraft slowly lifted from the launch pad at Cape Kennedy and by July 20 the command ship *Columbia* was circling the moon. Collins, the command ship's pilot, remained with the *Columbia* while Armstrong and Aldrin, aboard the lunar module *Eagle*, separated and headed for the surface of the moon.

The *Eagle* was programmed to land within a 600-foot crater strewn with boulders the size of automobiles. The landing computer, overloaded, refused to work additional landing equations so Mission Commander Armstrong had to take over the manual controls as Aldrin called off altitude readings.

"Houston? Tranquility Base here. The *Eagle* has landed," Armstrong dramatically reported at 4:17:42 P.M., E.D.T. The entire operation had been televised back to Earth, some 238,000 miles away. The men at Houston Space Center and the millions of viewers around the world thunderously cheered. Inside the *Eagle* the two astronauts made ready for their venture outside the craft. At 10:56:20 P.M. Neil Armstrong opened the module's hatch and slowly climbed down a ladder. Television viewers on earth watched the shadowy figure. When his left boot cautiously touched the moon's surface, they heard Armstrong's voice. "That's one small step for a man, one giant leap for mankind." News photographers on earth were busy photographing the images on their TV sets. Soon the presses were rolling, spewing out newspapers headlining the story, illustrated with news pictures.

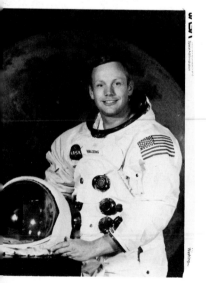

NEIL ARMSTRONG

Nineteen minutes later, Aldrin joined his partner. Armstrong already had his specially modified motor-driven Hasselblad 70mm camera operating and recorded Aldrin's descent. As Aldrin put together a device to record the bombardment of subatomic particles constituting the "solar wind," Armstrong made photos. Among the other recording projects they photographed the undisturbed ground with a special Kodak stereo camera. Another remote television camera was set up on a tripod beyond the *Eagle*. Their work on the moon finished, the astronauts climbed back into the lunar module. They had walked the surface of the moon for about two and a half hours.

At 1:54 P.M., July 21, the *Eagle*, using its descent stage as a launch pad, blasted off to redock with the *Columbia*, which still circled above the moon. After Armstrong and Aldrin transferred into the command ship, greeting the patient Michael Collins, they jettisoned the *Eagle*. On the way back to Earth they took inventory; aboard they had forty-eight pounds of lunar rock and surface material, nine magazines of exposed 70mm, and thirteen magazines of 16mm film.

The spacecraft splashed down into the Pacific Ocean, July 24, 825 nautical miles from Honolulu and within thirteen nautical miles of the recovery ship, U.S.S. *Hornet*. An hour later astronauts Armstrong, Aldrin, and Collins were safely aboard, mission completed.

N.A.S.A.

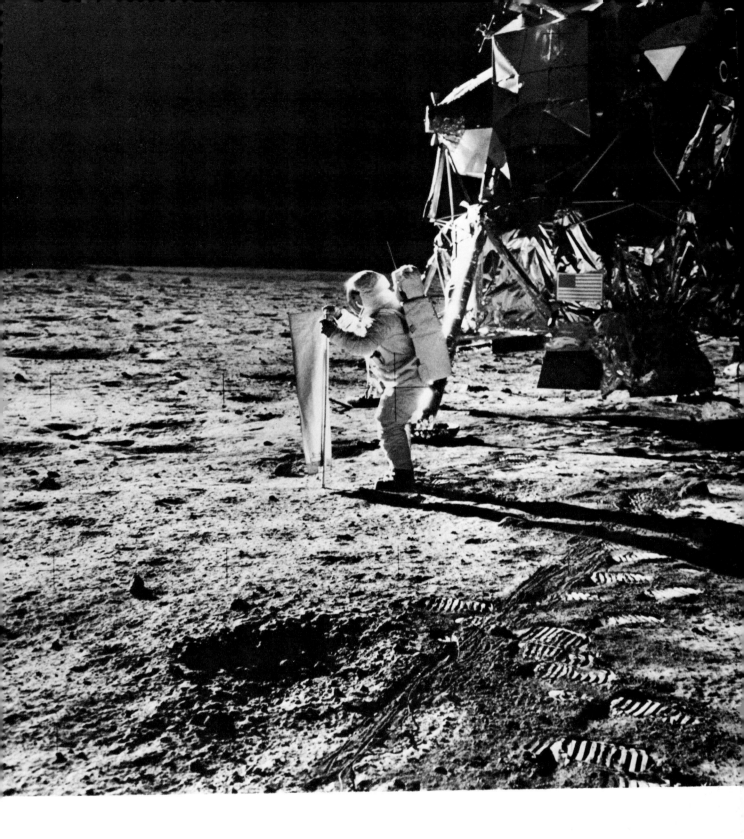

66. President Richard Nixon's Visit to China

Pilot Col. Ralph Albentazzie braked the *Spirit of '76* at the airport in Peking. The door of the plane opened and a hatless man accompanied by his smiling wife came down to shake hands. Chou En-lai welcomed Richard M. Nixon, the first President of the United States to visit China. It was February 21, 1972.

Arrangements for the visit had been made months in advance. Of the eighty-seven credentials issued by the White House only eight were allotted for still press photography. Vigorously fought for, they went to news photographers Dirck Halstead and Frank Cancellare of the United Press International, Bob Daugherty and Horst Faas of the Associated Press, John Dominis of Time-Life, Inc., Wally McNamee of *Newsweek* magazine, and to lab technicians William Lyon of UPI and William Achatz of AP. Nine credentials were given to television newsfilm cameramen. Planning their photographic needs for the complete stay in China was complex.

Dirck Halstead, reviewing his experiences, explained, "I don't think there ever was another picture story in my life of which I was so aware of the historical significance. We arrived aboard the press Pan Am jet the day before. By seven A.M. I was at Peking Airport setting up my equipment on the designated cameramen's platform. I was four and a half hours early for the scheduled arrival. I wanted to be sure I could make every possible good picture in black-and-white and color of the first historic moment. I set up six 35mm cameras—two on tripods with 600mm lenses, two with 300mm lenses, and two with shorter focal-length lenses. Using a zoning technique I focused each pair at different points where the subjects might be." The picture of the President reviewing the honor guard proved to be the first transmitted over the UPI network.

"During the eight days President Nixon was in China, I believe I never got more than two hours of sleep in a bed each night. Each night I would return to the hotel darkroom to help Bill Lyon with the processing and color duplication work, or the transmission of photos. We worked through the night and it was always around dawn when I got to bed."

William Lyon assigned himself the job of lab technician. He was much more than that. A former UPI Atlanta bureau chief and the leading color expert in the field, he had recently been made Vice President and General Manager of news-pictures. His thirty-one years with UPI had made him a good news cameraman, an excellent picture editor and writer, a highly knowledgeable electronics and picture transmission expert, a newsman who could do every phase of news picture service work as well as being an efficient bureau manager. He had to use all of his skills when he arrived in Peking. He found the Chinese had not provided dark-rooms for the news pictures services. He immediately acquired an extra hotel room and improvised a highly efficient photolab in the little time he had. Lyon stayed in the room around the clock for most of the eight days the President was in China. He processed and printed almost all the 350 rolls of black-and-white film, developed the 250 rolls of color film, 2000 duplicate transparencies, and transmitted 200 black-and-white photos along with twenty-five three-color separation prints over the UPI network.

It was only when Chairman Mao Tse-tung invited President Nixon to his home in Peking that none of the news photographers were allowed. Instead Chairman Mao's personal cameraman recorded the two world leaders together and later released pictures of the event.

DIRCK HALSTEAD

United Press International

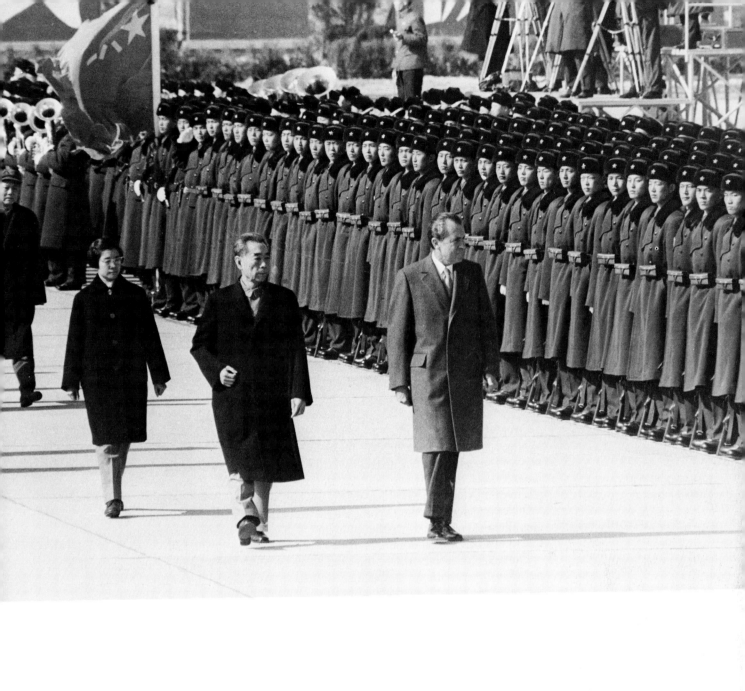

67. The Shooting of Governor George Wallace

George Corley Wallace's reputation as a vehement supporter of states rights and his opposition to school integration was well known and had gotten him the governorship of Alabama in 1963 and in 1971. Although he lost the presidential election of 1968 to Richard Nixon as a candidate of the American Independent Party, he had managed to poll ten million votes. Now, in 1972, he was again a presidential candidate. This time he was running for the Democratic nomination.

On May 15 Governor Wallace flew to campaign in Maryland, going first to Wheaton for a morning meeting. After lunch he headed for a rally at a shopping center in Laurel. Among the press covering the routine appearance was Laurens Pierce, CBS-TV newsreel cameraman.

Before Wallace arrived, Pierce set up his 16mm newsreel camera, making cut-away shots of the assembling crowd. Through the camera finder he spotted a man he had filmed before at other Wallace meetings. He wore sunglasses and a red-white-and-blue shirt with Wallace campaign buttons. The cameraman's curiosity caused him to walk over and ask, "Have I seen you at other Wallace rallies?" The man appeared embarrassed, answering, "Oh no, not me!" and quickly disappeared into the crowd.

Over 1000 people gathered to hear the controversial Governor's speech. As Wallace finished, Pierce quickly replaced his exposed 400-foot-film magazine and removed his camera from its tripod, fitting it onto a shoulder mount for hand-held mobility. As the audience applauded, Wallace stepped off the small speaker's platform to shake hands. Five shots, fired in one and a half seconds, tore into Wallace and several others. None of the bullets hit Pierce. As Wallace fell those around him grappled with the gunman. "I had a tremendous urge to just stop, but I felt I had to keep filming."

LAURENS PIERCE

Pierce raced over to where the police were putting the gunman into a car and recorded the action. An ambulance pulled up. Wallace and Dothard, Wallace's wounded security chief, were placed inside. "At this point I realized we were close to broadcast time. I knew I had to get my film immediately to our Washington office. I had a rough time getting to a phone. . . . When I finally got through to CBS Washington I found the office as frantic as we were in Laurel. They finally decided I would have to bring the film in although I had no means of transportation. . . . I kept asking individuals to take me to Washington, offering any sum of money, but everyone wanted to stay at the scene. Finally a wonderful elderly woman offered to help by taking me to a Singer Sewing Machine store. She talked the manager into letting one of his men drive me in a company truck."

Pierce rushed his 16mm film to CBS's processing lab. As he waited for the results someone showed him a still photo of the man who had shot Governor Wallace—twenty-one-year-old Arthur Bremer, who was none other than the man Pierce had tried to talk to earlier in the day!

Although the Alabama Governor's fighting spirit helped him recover from his serious wounds, his legs were paralyzed. He lost the nomination.

For his exclusive historic newsreel film story, Laurens Pierce was awarded the Television Academy's coveted Emmy Award for 1972–73 for outstanding achievement in cinematography news and documentary programming.

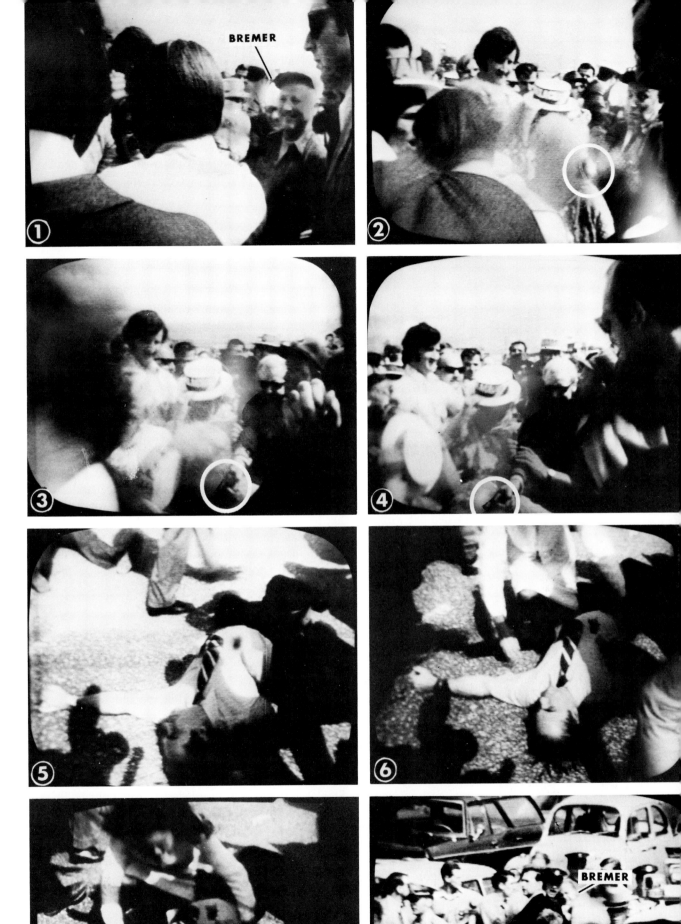

68. The Boston Fire Escape Tragedy

July 22, 1975 was one of those hot, sticky summer days. The minute hand on the clock had just passed four P.M. as photographer Stanley Forman turned in pictures of an earlier fire assignment and went to the city desk of the *Boston Herald American* to see if there were any other assignments to be covered before he finished the day. Staffers were monitoring a radio alert on an apartment-house fire. Forman raced for his car.

Driving through the South End section of Boston, Forman spotted a fire engine leaving the Harrison Avenue firehouse. He followed it. Several blocks ahead he saw heavy black smoke billowing up as he monitored a radio call from a fire chief ordering a ladder truck to the rear of the burning building. He parked his car as close as he could get to the fire and started running. While he ran he checked his two 35mm cameras, making certain each was set for the proper shutter speed and lens opening. He had a 135mm telephoto lens on the motor-driven camera, and a 35mm wide angle lens on the other. He headed down an alley toward the rear of the building.

The interior of the building was filled with smoke and fire. Using a ladder raised in the front of the five-story building, fireman Robert O'Neill had reached the roof to break a vent hole in the skylight. Hearing screams he raced to the rear where, looking over the edge, he saw a woman and child on the upper fire escape. The woman appeared hysterical so he lowered himself onto the fire escape to calm her. He showed her a fire truck below as it raised its aerial ladder to reach them. The three moved up to the corner of the outside guardrail as O'Neill reached out with his other hand to guide in the ladder.

STANLEY FORMAN

Below, news photographer Stan Forman climbed on top of the ladder truck to gain height. He later recalled, "I got a wide-angle shot of them on the fire escape and then switched over to my motor-driven 35mm camera with the telephoto lens. I made shots as they waited to be rescued. . . . Suddenly someone screamed, or maybe it was the shriek of the metal as the fire escape gave way. I was seeing everything through my camera finder and I was shooting."

The bracing on the heavier side of the fire escape had collapsed, spilling out nineteen-year-old Diana Bryant, and three-year-old Tiara Jones. Fireman O'Neill managed to grasp the ladder and hung onto it, dangling until he could pull himself to safety. But the two girls fell five stories into a little backyard behind a wooden fence. Bryant hit ground first. Jones landed on top of her, probably saving the child's life. The older girl died several hours later.

Stan Forman's series of news pictures were shocking. The *Boston Herald American* ran the key photo a full page, five columns wide, on the front page. Following up, on page three was another full page of pictures. Stanley Forman was awarded the 1976 Pulitzer Prize for his work. The following year another news picture made by Stanley Forman was awarded the 1977 Pulitzer Prize—the first time that a news photographer had received two Pulitzer Prizes in succession.

Within twenty-four hours of the publication of Stanley Forman's pictures, action was taken in Boston to improve the inspection of all fire escapes. The impact of the shocking pictures carried the trend nationwide. Forman's memorable news photos contributed to the betterment of the public.

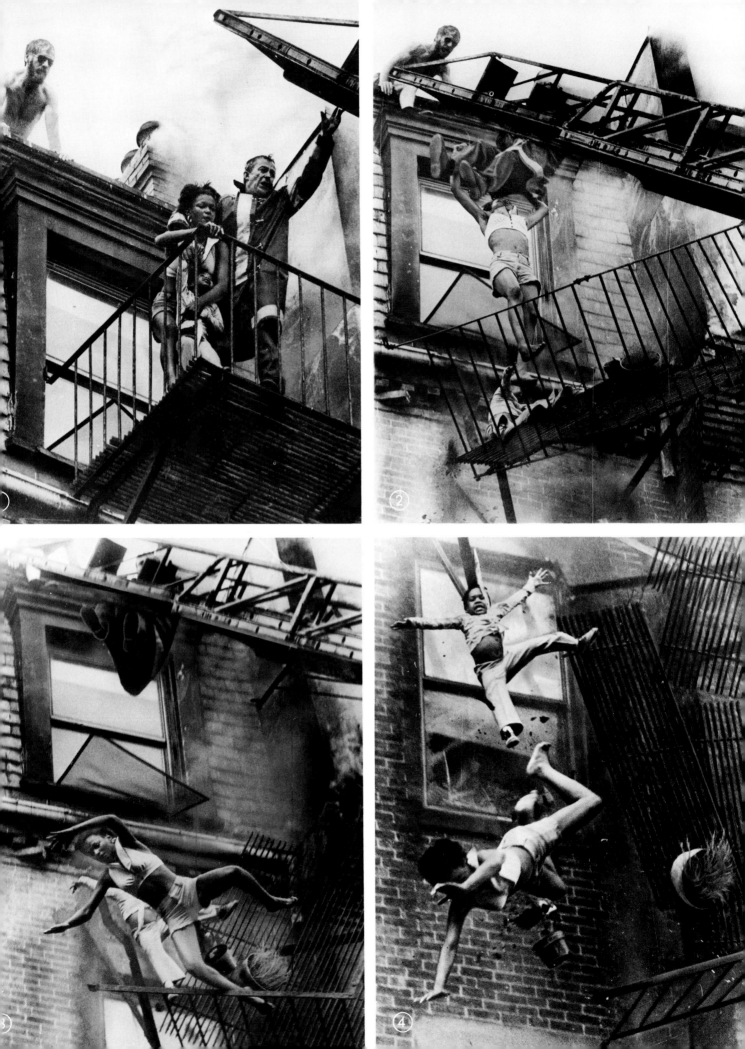

69. Olga Korbut Steps Down for Nadia Comaneci

The finest athletes and more than one hundred of the best news photographers from around the world crowded into Montreal to take part in the Olympic Summer Games, July 17–August 1, 1976. The athletes were there to perform, to be judged, and then to be honored. The cameramen were there to record sports history as it happened. Frequently one person, having given a performance that captures the public's fancy, is always remembered as the star of a year's Olympic Games. At the 1972 Olympics seventeen-year-old Olga Korbut of Russia was the star. Four years later, the public again directed its attention to her performance.

By the end of the first week there was no doubt about it. The public had a superstar to worship and admire. But it was not Olga Korbut, then twenty-one. It was Nadia Comaneci of Romania. Looking like a small child—she was only four-teen—Nadia stole the show by being the first gymnast in Olympic history to earn a perfect score of ten points from each of the seven judges. She captured seven tens in the uneven parallel bars and the balance beam competitions. Olga Korbut barely ranked third on her own team. The public sensed the competitive emotional stresses. Only one of the news photographers present recorded the feeling. He was Eddie Adams, representing the Associated Press.

In The Forum, late in the evening of the final competition, the news photographers were cramped together in two sections of the floor, one group at each end of the court. Other groups of cameramen were stationed on elevated platforms just beyond the center-court sidelines. As Nadia moved toward the far end of the gymnasium the photographers in Adam's group left to take the better floor positions closer to her. Eddie Adams, finding himself alone, decided to shoot across the gym with an 800mm telephoto lens. The extra-long-focal-length lens on his tripod-mounted single-lens reflex camera gave him a different view of the action. Although he had a motor-driven camera, he selected each shot rather than "machine-gunning" the subject. When the awards ceremonies began he was in the same position, using the same technique.

EDDIE ADAMS

Nadia Comaneci mounted the platform to receive her gold medal. Olga Korbut stood on the floor just below and in front of the raised stand. She was waiting her turn to receive the silver medal for second place which she had won for a 9.9 performance on the balance beam. Eddie Adams watched through the single-lens reflex camera's finder as the gold medal was hung around the neck of Nadia Comaneci. The audience applauded thunderously. Eddie rapidly made two shots as Olga turned her head away to look at the crowd. Then she looked back and up at Comaneci with an appraising smile. The long 800mm telephoto lens magnified the two figures almost outside the finder frame. "I could see the tears in her eyes. I knew of the fierce competition between the girls. I could sense Olga's emotions seeing Nadia in the position she once had held. I knew that instant told the whole story. I made the picture," Adams later explained.

It was now Olga Korbut's turn to receive her medal. The fans in The Forum were quiet as she went up the steps. They seemed to realize the injustice they had done her by switching their allegiance to the younger, more agile Nadia Comaneci. The audience began to applaud. The noise grew louder until it seemed the cheers would never stop. The small Russian girl bowed her head in acceptance. It was by far the most touching moment in the entire competition.

Associated Press

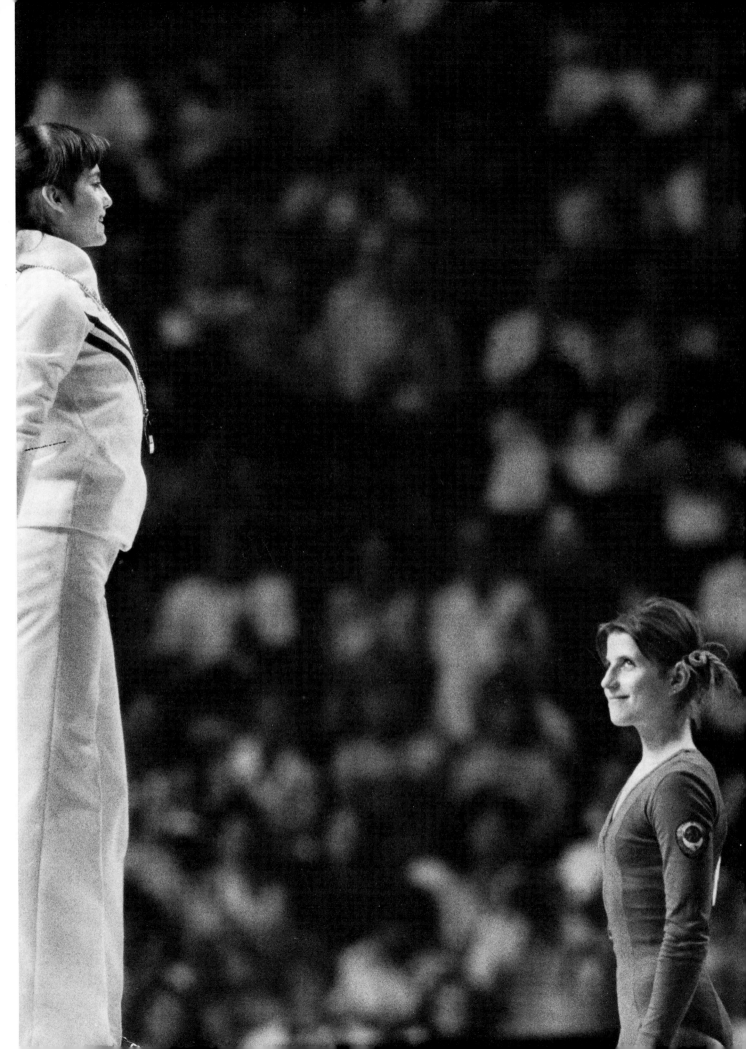

70. The Miracle of Jimmy Carter

Many said, "If he really makes it, it'll be a miracle." The public could not conceive that the little-known former governor of Georgia could become the Democratic Party's 1976 presidential candidate. But had the public studied Carter's career they would have found that he had all the essentials to be the new kind of presidential candidate needed in the post-Watergate era.

Carter knew he had to capture the Democratic delegates before the National Convention. He did it by running in nearly all the nation's presidential primaries, winning eighteen. Then he headed for the final runoff. On July 14, the Democratic National Convention would elect the Party's presidential candidate at Madison Square Garden in New York City.

Over 20,000 people—delegates, alternates, newsmen, technicians, visitors, police, and others jammed the huge indoor arena. Hundreds of cameramen worked around the clock recording the activities. Typical was *Time* magazine, which had called in its top news personnel from around the country to work on the story of the week. John Durniak, *Time*'s dynamic Picture Editor, had carefully planned the complex coverage. By the time Dirck Halstead, Washington Bureau photographer, arrived, he had finished handing out picture assignments.

In a staffed operation each photographer strives to make the most outstanding picture so it will be used in the prime display spot of his publication, the front page. Having covered political conventions since 1960, Halstead decided to work for one picture only. It would be made near the end of the convention when the presidential and vice-presidential nominees stood together on the podium.

On the first day of the convention, while other photographers were busy making pictures, Halstead canvassed the arena, searching for the best shooting position for his planned photo. The main problem was the thirty-foot height of the podium. Each position he tested was either too low, too close, at too great an angle or too far away. Eventually he had to settle for a position on a cameramen's platform forty-five degrees to the left and about 500 feet in front of the podium, high among the press observers' seats. Even with his 800mm telephoto lens, the longest he had, the image sizes were too small. When he discussed his problems with Durniak, he was told that *Time* had just received a new super-telephoto, an f5.6, 1000mm catadioptric lens no one else was using. It took two men to carry the tripod-mounted lens, with the 35mm camera (small by comparison) attached, up the steps to Halstead's shooting position. The lens gave him the full 35mm-frame image size he needed and he spent the next two days making test shots of the action on the podium. Having to use the extremely slow shutter speed of 1/60th to properly expose his color film with the existing light, he found there was a new problem—vibrations. Anyone moving ever so slightly on the cameramen's platform would transmit vibrations to the lens sufficient to blur the pictures. Halstead had to ask the other photographers to remain as motionless as possible when the time came to take the picture he planned. They all agreed.

Jimmy Carter won the Democratic nomination on the first ballot and selected Walter Mondale as his vice-presidential running mate. As the convention ended, the man the public once gave little chance to win the Presidency of the United States had become a well-known national figure. Dirck Halstead's planned picture appeared on the front cover of *Time*, July 26, 1976.

DIRCK HALSTEAD

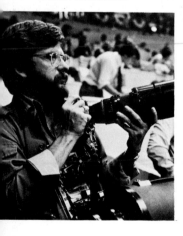

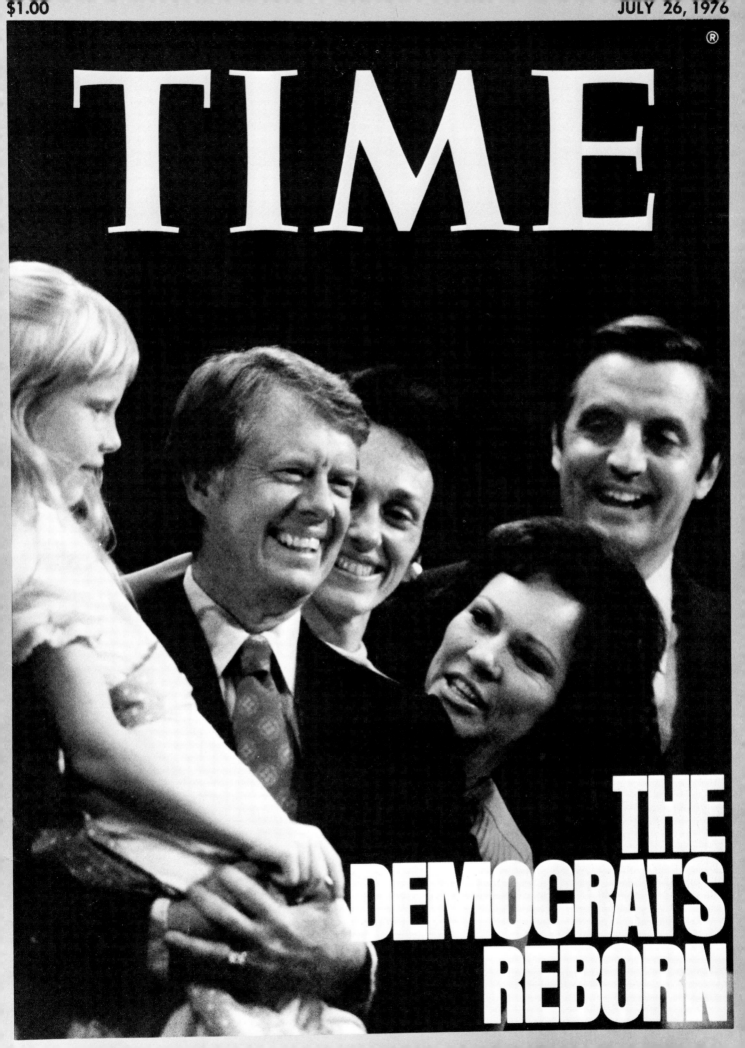

Credits

This revised edition of *Great Moments in News Photography*, published by Dover Publications, Inc., updates the first edition published in 1960 by Thomas Nelson & Sons. The first edition featured fifty-seven memorable stories in the history of photojournalism, spanning the years 1855 through 1960.

The author would like to acknowledge the following professional people according to the positions they held in 1960. The author expresses his sincere appreciation for their contributions of knowledge, guidance and time given in the preparation of this book. Today, most of these people have retired, have moved to other jobs, or are no longer with us.

1960 EDITION

Joseph Costa, Chief Photographer, King Features Syndicate; Editor, *The National Press Photographer*; Chairman of the Board, National Press Photographers Association, N.Y., N.Y.

Harold Blumenfeld, Executive Newspictures Editor, United Press International, N.Y., N.Y.

Vincent S. Jones, Executive Editor, The Gannett Newspapers, Rochester, N.Y.

Al Resch, Executive Newsphoto Editor, Associated Press, N.Y., N.Y.

Herbert Walker, President, Newspaper Enterprise Association, N.Y., N.Y.

William J. Sumits, Chief of Photo Lab, *Life* Magazine, N.Y., N.Y.

George Karas, Photo Lab Production Manager, *Life* Magazine, N.Y., N.Y.

Arthur Rothstein, Technical Director of Photography, *Look* Magazine, N.Y., N.Y.

Murray Becker, Chief Photographer, Associated Press, N.Y., N.Y.

Irving "Doc" Desfor, Camera Columnist and Photo Art Director, Associated Press Newsfeatures, N.Y., N.Y.

Max Desfor, Supervising Editor, Wide World Photos, N.Y., N.Y.

George Gaylin, Picture Bureau Manager, United Press International, Washington, D.C.

David Wurzel, Division News Picture Manager, United Press International, Boston, Mass.

Jack Young, Division News Picture Manager, United Press International, Atlanta, Ga.

Walter Ranzini, Picture Assignment Editor, N.Y. *Daily News*, N.Y., N.Y.

Harry Warnecke, Manager, N.Y. News Color Studios, N.Y., N.Y.

Dr. Louis W. Sipley, Director, American Museum of Photography, Philadelphia, Pa.

Beaumont Newhall, Director, George Eastman House of Photography, Rochester, N.Y.

James Colvin, Director of Public Relations, Encyclopaedia Britannica, Chicago, Ill.

Dr. Paul Garber, Curator of the Air Museum, Smithsonian Institution, Washington, D.C.

Al Madsen, Chief Photographer, *Chicago Tribune*, Chicago, Ill.

Ralph Frost, Chief Photographer, *Chicago Sun-Times*, Chicago, Ill.

Tony Berardi, Chief Photographer, *Chicago American*, Chicago, Ill.

Robert Keogh, Chief Photographer, *N.Y. Journal American*, N.Y., N.Y.

Sam Sansone, Chief Photographer, *Los Angeles Examiner*, Los Angeles, Cal.

Lonnie Wilson, News Photographer, *Oakland Tribune*, Oakland, Cal.

Harry Collins, Manager and Owner, Brown Brothers, N.Y., N.Y.

Owen Johnson, Chief Photographer, *Houston Post*, Houston, Tex.

Andrew "Buck" May, Manager News Bureau, Harris & Ewing, Washington, D.C.

Robert Clark, United States Information Agency, Washington, D.C.

Major William Lookado, Chief, Air Force Information Pictorial Branch, Washington, D.C.

Professor Cliff Edom, School of Journalism, University of Missouri, Columbia, Mo.

Jack Price, author, *News Photography*, Mount Airy, Md.

E. J. Ezickson, Editor, Wide World Photos; author, *Get That Picture*, N.Y., N.Y.

William C. Eckenberg, News Photographer, *N.Y. Times*; Professor, School of Journalism, Columbia University, N.Y., N.Y.

Ben Price, Picture Editor, *N.Y. Herald Tribune*, N.Y., N.Y.

George Smallsreed, Jr., News Photographer, *Columbus Dispatch*, Columbus, O.

Ralph Johnson, Editor, Associated Press, Boston, Mass.

Jozefa Stuart, Magnum Photos, N.Y., N.Y.

Tom O'Reilly, Chief Photographer, *Toledo Blade*, Toledo, O.

Ed Hannigan, Editor, *U.S. Camera Magazine*, N.Y., N.Y.

Arthur Goldsmith, Executive Editor, *Popular Photography Magazine*, N.Y., N.Y.

Dan Dougherty, Publicity Director, Fox Movietone News, N.Y., N.Y.

Jack Muth, Manager, Actualités Fox Movietone, Paris, France

Chick Peden, Editor, Hearst Metrotone News, N.Y., N.Y.

Jerome J. Ossip, Photographic Officer of the 509th Composite Group, 20th Air Force, First Atomic Bombardment Group of World War II, New Rochelle, N.Y.

Rubin Sadofsky, Collector of Rare Books and Periodicals, Brooklyn, N.Y.

George J. Gloss, Brattle Book Shops, Boston, Mass.

Mrs. Ethel Arwé, Collector of Rare Books and Periodicals, Boonton, N.J.

Peter Hunter, Press Features, Amsterdam, Holland

Jerome Walker, Executive Editor, *Editor & Publisher*, N.Y., N.Y.

Monroe Stroecker, Chief Photographer, *Detroit News*, Detroit, Mich.

Frank Gilloon, Gilloon Picture Agency, N.Y., N.Y.

James Quigney, Quigney Associates, N.Y., N.Y.

Eugene Pulliam, Jr., Publisher, *Indianapolis News*, Indianapolis, Ind.

Acknowledgment is gratefully given to the following people who gave of their knowledge, guidance, and time helping the author prepare the new material used in the 1978 Dover edition:

Gertrud M. Faber, my wife

Eugene Ostroff, Curator of Photography, Smithsonian Institution, Washington, D.C.

Joseph Costa, Lecturer in Journalism, Ball State University, Muncie, Ind.

George Karas, Chief of the Photolab, Time-Life, Inc., N.Y., N.Y.

Herb Orth, Deputy Chief of the Photolab, Time-Life, Inc., N.Y., N.Y.

Doris O'Neil, Chief of the Picture Collection, Time-Life, Inc., N.Y., N.Y.

Hal Buell, Assistant General Manager for Newsphotos, Associated Press, N.Y., N.Y.

William Lyon, Vice President, Newspictures, United Press International, N.Y., N.Y.

John Durniak, Picture Editor, *Time* Magazine, N.Y., N.Y.

Irving "Doc" Desfor, Photography Columnist, Associated Press, N.Y., N.Y.

Con Keyes, Picture Editor, *Los Angeles Times*, Los Angeles, Cal.

John Duprey, Director of Photography, *N.Y. Daily News*, N.Y., N.Y.

Miss Josephine Cobb, National Archives, Washington, D.C.

Herb Schwartz, T.V. News Cameraman, CBS-TV, N.Y., N.Y.

Irving Haberman, Photographer, CBS, N.Y., N.Y.

Moneta Sleet, Jr., Chief Photographer, *Ebony* Magazine, N.Y., N.Y.

Basil Phillips, Picture Editor, *Ebony* Magazine, Chicago, Ill.

Harold Blumenfeld, former Executive Newspictures Editor, United Press International, Hallandale, Fla.

Les Gaver, Chief of Audio Visuals Division, N.A.S.A., Washington, D.C.

Roy Meredith, author of *Mr. Lincoln's Camera Man: Mathew B. Brady*, N.Y., N.Y.

David Eisendrath Jr., Photographic Consultant, N.Y., N.Y.

Hayward Cirker, President, Dover Publications, Inc., N.Y., N.Y.

The author is greatly indebted to the management and to the librarians of the picture files of the newspapers, news photo services, picture agencies, and news magazines for their patience and willingness to help with this historical project.

The credit line near the bottom of each illustration indicates the organization which owns the photograph and has given permission for its use.

Acknowledgment is given to the Royal Photographic Society of Great Britain, London, England, for permission to use the portrait of Roger Fenton; to the Museum of the City of New York for the picture made by Jacob Riis; to the Library of Congress, Washington, D.C., for the portraits of Mathew Brady and Jacob Riis. The picture of the San Francisco Earthquake was secured from Edward Rogers and the *Oakland Tribune*. It is also available from the California Historical Society, San Francisco, California.

Special credit is given to Mr. Harry Amdur, President of Modernage, Inc., New York, N.Y., who had the interest and took the time to make photo copies and improved prints of the illustrations in this publication. His staff worked diligently to eliminate the years of wear and tear that showed on many of the original prints of the great news photos.

Bibliography and Suggested Reading

Adams, James Truslow (ed.). *Album of American History*. New York: Charles Scribner's Sons, 1948.

Ahlers, Arvel. *Where & How To Sell Your Photographs*. New York: Amphoto, 1975.

Arnold, H. J. *Photographer of the World: A Biography of Herbert Ponting*. London: Hutchinson & Co., 1969.

The Best of Life. New York: Time-Life Books, 1973.

Buckland, Gail. *Reality Recorded*. North Pomfret, Vermont: David & Charles, Inc., 1977.

Buell, Hal and Sol Pett. *The Instant It Happened*. New York: Associated Press, 1972.

Burrows, Larry. *The Compassionate Photographer*. New York: Time-Life Books, Inc., 1972.

Capa, Cornell (ed.). *The Concerned Photographer*. New York: Grossman Publishers, 1972.

Chattopadhyay, Samaresh. *Photojournalism '73*. Calcutta: Land & Life Publishers, 1973.

Coleman, Harry J. *Give Us a Little Smile, Baby*. New York: E. P. Dutton & Co., 1943.

Collins, Alan C. *The Story of America in Pictures*. New York: Doubleday & Co., 1941.

Downey, Fairfax. *Disaster Fighters*. New York: G. P. Putnam's Sons, 1938.

Duncan, David Douglas. *Self-Portrait: U.S.A.* New York: Harry N. Abrams, Inc., 1969.

———. *War Without Heroes*. New York: Harper & Row Publishers, 1970.

Editor & Publisher International Yearbook 1976. New York: Editor & Publisher Co., 1976.

Editor & Publisher Magazine (weekly) 1961–77. New York: Editor & Publisher Co.

Edom, Clifton. *The Great Pictures* (annual 1948) 1948–51. New York: Garden City Publishing Co., Inc.

———. *Photojournalism: Principles & Practices*. Dubuque, Iowa: William C. Brown Co., 1976.

Eisenstaedt, Alfred. *The Eye of Eisenstaedt*. New York: The Viking Press, 1969.

———. *Witness to Our Time*. New York: The Viking Press, 1966.

Evans, Harold. *Pictures on a Page*. New York: Holt, Rinehart & Winston, 1978.

Ezickson, Aaron J. *Get That Picture!* New York: National Library Press, 1938.

Faber, John. *Great Moments in News Photography*. New York: Thomas Nelson & Sons, 1960.

Faber, John. *Humor in News Photography*. New York: Thomas Nelson & Sons, 1961.

Gernsheim, Helmut. *Creative Photography*. New York: Bonanza Books, 1974.

———. *The History of Photography*. London: Oxford University Press, 1955.

———. *Roger Fenton, Photographer of the Crimean War*. London: Secker & Warburg, 1954.

Gidal, Tim M. *Modern Photo-Journalism*. New York: Collier Books, 1973.

Hall, Norman. *Press Pictures of a Decade*. London: Photography Magazine, 1960.

Harper's Weekly, 1860. New York: Harper & Brothers.

Headliners Awards, 1934–1977. Atlantic City: National Headliners' Club, 1977.

Hicks, Wilson. *Words and Pictures*. New York: Harper & Brothers, 1952.

Hoffmann, Heinrich. *Hitler Was My Friend*. London: Burke Publishers, 1955.

Hood, Robert. *Twelve At War*. New York: G. P. Putnam's Sons, 1967.

Horan, James D. *Mathew Brady, Historian with a Camera*. New York: Crown Publishers, 1955.

Hurley, Gerald and Angus McDougall. *Visual Impact in Print*. Chicago: American Publishers Press, 1971.

Illustrated London News (weekly), 1855. London.

Impressions (quarterly), 1957–59. New York: Fairchild Graphic Equipment, Inc.

Jackson, Mason. *The Pictorial Press: Its History & Origin*. London: Hurst & Blackett, 1885.

Kalish, Stanley and Clifton Edom. *Picture Editing*. New York: Rinehart & Co., 1951.

Keeler, Charles. *San Francisco Through Earthquake & Fire*. San Francisco: Paul Eider & Co., 1906.

Kertész, André. *Day of Paris*. New York: J. J. Augustin, Publisher, 1945.

———. *André Kertész, Sixty Years of Photography*. New York: Grossman Publishers, 1972.

Kinnaird, Clark. *It Happened in 1945*. New York: Essential Books, 1946.

Leekley, John and Sheryle Leekley. *Moments the Pulitzer Prize Photographs*. New York: Crown Publishers, 1978.

Life Library of Photography. *Photojournalism*. New York: Time-Life Books, 1971.

Linthicum, R. and Trumball White. *Complete History of the San Francisco Horror*. Chicago: W. R. Van Sant, 1906.

Logan, Richard H. *Elements of Photo Reporting*. New York, Amphoto, 1971.

Louis, Joe. *The Joe Louis Story*. New York: Grosset & Dunlap, 1953.

Lucie-Smith, Edward. *The Invented Eye*. New York: Paddington Press, Ltd.

Maloney, Thomas (ed.). *U.S. Camera Annual*, 1935–60. New York: U.S. Camera Publishing Corp.

Meredith, Roy. *Mr. Lincoln's Camera Man: Mathew B. Brady*. New York: Dover Publications, Inc., 1974.

Morgan, Willard. *The Complete Photographer—An Encyclopedia On Photography*. New York: National Educational Alliance, 1949.

Mydans, Carl. *More Than Meets the Eye*. New York: Harper & Brothers, 1959. (Reprinted by Greenwood Press, Inc., 1975.)

National Press Photographer Magazine (monthly), 1960–77. (Name changed September 1974 to *News Photographer*.) Bowling Green, Ohio: National Press Photographers Association.

National Press Photographers Association & University of Missouri School of Journalism. EPM Publications Inc. *Photojournalism/76*. McLean, Virginia. 1976.

Newhall, Beaumont. *The History of Photography*. New York: Museum of Modern Art, 1949.

New York Press Photographer (annual), 1960–77. New York: New York Press Photographers Association.

Photo Market Survey. Little Falls, New Jersey: School of Modern Photography, 1971.

Pollack, Peter. *The Picture History of Photography*. New York: Harry N. Abrams, Inc., 1958.

Price, Jack. *News Photography*. New York: Round Table Press, Inc., 1935.

Rayfield, Stanley. *How Life Gets The Story*. New York: Doubleday & Co., 1955.

Riis, Jacob. *How the Other Half Lives*. New York: Dover Publications, Inc., 1971.

Rogers, Agnes. *The American Procession*. New York: Harper & Brothers, 1933.

Rothstein, Arthur. *Photo Journalism*. New York: American Photographic Book Publishing Co., Inc., 1956.

Schulman, Sammy. *Where's Sammy?* New York: Random House, 1943.

Schuneman, R. Smith (ed.). *Photographic Communication.* New York: Hastings House, 1972.

Sipley, Louis Walton. *Collector's Guide to American Photography.* Philadelphia: American Museum of Photography, 1956.

————. *Frederick E. Ives.* Philadelphia: American Museum of Photography, 1957.

————. *A Half Century of Color.* New York: Macmillan Co., 1952.

————. *The Photomechanical Halftone.* Philadelphia: American Museum of Photography, 1958.

Snyder, Louis L. and R. Morris (eds.). *A Treasury of Great Reporting.* New York: Simon & Schuster, 1949.

Spina, Tony. *Press Photographer.* Garden City, New York: Amphoto, 1969.

Stern, Philip Van Doren. *The Breathless Moment.* New York: Alfred A. Knopf, 1935.

Szarkowski, John. *From the Picture Press.* New York: Museum of Modern Art, 1973.

Taft, Robert. *Photography and the American Scene.* New York: Macmillan Co., 1938. (Reprinted by Dover Publications, Inc., 1964.)

Thomas, Gordon and Max Morgan Witts. *Enola Gay.* Briarcliff Manor, New York: Stein & Day, Publishers, 1977.

Tissandier, Gaston. *A History & Handbook of Photography.* New York: Scovill Mfg. Co., 1876.

Tsumura, Hideo. *All Asahi Press Photography.* Tokyo: Asahi Publishing Co., 1956.

Walsh, Patrick. *Empire State Building Crash, July 28, 1945.* New York: Fire Department, 1945.

Ward, Baldwin H. *Year, Mid-Century Edition.* Los Angeles: Year, Inc., 1950.

"Weegee" (Arthur Fellig). *Naked City.* New York: Essential Books, 1945. (Reprinted by Da Capo Press, 1975.)

———— and Mel Harris. *Weegee by Weegee: An Autobiography.* New York: Ziff-Davis Publishing Co., 1961. (Reprinted by Da Capo Press, 1975.)

Witts, Max Morgan & Gordon Thomas. *Enola Gay.* New York: Pocket Books Inc. 1977.

Whiting, John R. *Photography Is a Language.* New York: Ziff-Davis Publishing Co., 1947.

World Press Photo Yearbook (annual), 1966–77. The Hague: Teleboek bv. Amsterdam, Publishers, under the auspices of World Press Photo Holland Foundation.